TRAFFORD TANZI

THE DRAMATIC ATTITUDES
OF MISS FANNY KEMBLE

THE SEDUCTION
OF ANNE BOLEYN

D1635847

Claire Luckham

PLAYS

TRAFFORD TANZI

THE DRAMATIC ATTITUDES
OF MISS FANNY KEMBLE

THE SEDUCTION
OF ANNE BOLEYN

OBERON BOOKS
LONDON

This collection first published in 1999 by Oberon Books
(incorporating Absolute Classics)
521 Caledonian Rd, London N7 9RH
Tel: 0171 607 3637 / Fax: 0171 607 3629
e-mail: oberon.books@btinternet.com

Trafford Tanzi was first published in 1983 by Samuel French Ltd.

A catalogue record for this book is available from the British Library.

ISBN 1 870259 68 8

Cover design: Andrzej Klimowski

Typography: Richard Doust

Printed in Great Britain by MPG Ltd., Bodmin.

Contents

For

Josh, Hannah, Belle, Russell and Rosa

INTRODUCTION

All Claire Luckham's stage writing is characterised by vibrant intelligence, emotional depth, and strong theatricality. The writing breathes live theatre. In *Trafford Tanzi* there is the parallel with the live entertainment of the wrestling ring. In *Fanny Kemble* she uses the theatre itself and the job of an actress to convey serious ideas. *Trafford Tanzi* with its bold, highly original form, gave her a reputation as a populist writer, but it was the intelligence of the content as much as the form that made this play a success. Above all Claire Luckham concerns herself with character. "I want to write about character and change," she has said, but continues, "What you go on about wanting to write, is probably not what you actually *do* write!" Each of the three plays in this book is about a woman in some sense alone, about this woman's journey, her struggle and the way she changes. But each play is at the same time about vastly more than this, and wonderfully, each play is as comic as it is profound. Most importantly of all, the plays in this book have been hugely enjoyed by audiences.

Trafford Tanzi

In the late seventies the Everyman Theatre, Liverpool was closed for rebuilding. During this period the company toured productions, and in particular established a reputation for lively shows designed to play in the wilder pubs of the city, where the patrons had come to drink, not to see theatre, and where they definitely retained the right to abuse you if you were no good. When the theatre re-opened the tradition of pub shows was retained, and Claire Luckham, previously a stage manager, was given a slot. *Tuebrook Tanzi* was the result, specifically conceived to survive the pub atmosphere. In Leicester the play became *Tugby Tanzi,* in Manchester *Trafford Tanzi.* It kept this name at the Edinburgh Festival and then in London, since when it has played all over the world, changing its title appropriately.

Perhaps the reason the play does not seem dated twenty years later is that it was never about a specific message. Rather it aimed to open up a subject, to get people discussing and to show them that ideas could be part of popular entertainment. Today, in spite of the Gladiators and similar television heroines, audiences are still entranced by an active female protagonist, and the play has often been identified as feminist. More accurately, perhaps, the author's subject is the forcing of a human being into a role through family and social pressures. This is a theme common to much of Claire Luckham's work.

She speaks with some poignancy of how the play was seen as a tragedy in Japan. Audiences watched the impossibility of a heroine having both a marriage and a career, the impossibility of both retaining convention and moving into the future. More universally they saw a play suggesting that any positive choice in life necessarily also involves loss. This is theatre as philosophy.

The Dramatic Attitudes of Miss Fanny Kemble

The "attitudes" of the title play upon a double meaning. In the first act we are shown the stylised gestures that were the visual language of acting in the early-nineteenth century and before. The contemporary handbook for these[1] was written by Henry Siddons, husband of the great actress, Sarah Siddons. The scene in which the elderly Sarah instructs her niece, the young Fanny Kemble, in how to portray Juliet is both touching and gloriously funny in performance.

In the second act we are concerned much more with the moral attitudes growing in Fanny's mind as she experiences the injustices of the slave plantation inherited by her American husband. The original source material for this is Fanny's own *Journal of a Residence on a Georgian Plantation*.[2] Claire Luckham synthesises the two meanings of the "attitudes" to produce a vital study of the moral power and purpose not just of theatre but of all imaginative art. This is the real subject of the play,

[1]*Practical Illustrations of Rhetorical Gesture and Action* (1807), available for consultation in the British Library, London.

[2]Available in various editions.

though of course it also embraces issues of race, love, class, slavery, and the job of acting.

The play presents exciting challenges to a company. The style, both in terms of design and performance, moves from the stylised high comedy of the stage of Covent Garden, to the raw sometimes violent naturalism of the cotton fields. In the original production the polished boards of Robin Don's set split open to reveal the mud-filled trenches, slaves knee deep in water. Claire Luckham wrote the play to be performed by eight actors, four black, four white, (plus a speaking stage manager), but it has subsequently been presented using a larger cast, and with varying doubling. In an Australian student production the slaves were played successfully by white actors. The leading role of Fanny needs a skilled and adventurous actress – in the original production the distinguished Brenda Blethyn. Beyond these challenges, the play works for an audience as an exhilarating and gripping story.

The Seduction of Anne Boleyn

Claire Luckham wrote this play as a love story. Her early working title, *The Most Happy*, refers to Anne's personal motto, seen on a coin. The optimism of the sentiment, written when Anne's feelings for Henry were at their strongest, is as touching as it is ironic.

Everyone knows Anne Boleyn had her head cut off. From arrest to execution was a swift sixteen days. What is perhaps less well known is that the relationship preceding this lasted in all about nine years, of which seven were spent in apparently voluntary sexual self-denial. This was as long as it took Henry to arrange his divorce from Katherine of Aragon (to whom he was married for over twenty years). Henry was determined that his son and heir should be legitimate, so he could not risk sleeping with Anne, the intended mother, until they were married. Anne herself was very devout and determined not to become simply Henry's mistress as her sister had been. What interests Claire Luckham are the human aspects of this story. The play deliberately avoids much of the politics (except of

course where they specifically impinge) and more significantly any sense of stage historicity. The language is deliberately modern and emotionally expressive rather than ceremonial. Even the public "seduction" is a family scene rather than a court occasion.

The character depiction in the play is subtle and full of insight. Claire Luckham dissects the conventional view of Anne as a manipulative minx to show the influence of both her family (fervently devout mother, politically astute father) and her education. The later painful isolation borne of her high principles is particularly acute.

The play also examines the disillusionment of Henry. At first he is playful and energetic, a fit man, long before the overweight portraits we know so well. He is also devout and Luckham suggests he genuinely believes the religious reasons for divorcing Katherine rather than merely having contrived them for his own convenience. By the end of the play he is bleakly frustrated, psychologically ill-equipped to cope with that frustration, and savagely ready for the self-indulgent consolations which followed. The supporting characters, Anne's family, Katherine, and the unfortunate musician Smeaton all receive similarly insightful definition. In each case Claire Luckham's research was meticulous.

The play is a joy for actors – all the parts are rich and interesting, and the ensemble is a study of power in human relationships that is entirely modern in sensibility. It therefore pleases audiences who know little of the history, as well as enthusiasts.

I very much hope that the publication of these plays will lead to many more productions.

Patrick Sandford
Southampton, 1999

TRAFFORD TANZI

Characters

THE REFEREE

TANZI'S MUM

TANZI'S DAD

PLATINUM SUE

DEAN REBEL

TRAFFORD TANZI

DOCTOR GROPE
the psychiatrist

This version was first performed at the Contact Theatre, Manchester, on 7 October 1980, with the following cast:

THE REFEREE, Richard H. Williams

TANZI'S MUM, Victoria Hardcastle

TANZI'S DAD, Rob Hyeland

PLATINUM SUE, Fionn O'Farrell

DEAN REBEL, Neill Pierson

TRAFFORD TANZI, Noreen Kershaw

Directed by Chris Bond

It was presented by the Traverse Theatre Company at the 1981 Edinburgh Festival and subsequently toured Birmingham, Belfast and London with the following cast:

THE REFEREE, David Fielder

TANZI'S MUM, Victoria Hardcastle

TANZI'S DAD, Edward Clayton

PLATINUM SUE, Eve Bland

DEAN REBEL, Patrick Field

TRAFFORD TANZI, Noreen Kershaw

Directed by Chris Bond

The original production of *Trafford Tanzi* was presented in-the-round with the wrestling ring as the central focal point. When not directly involved in the action the actors remained in the ringside area and encouraged audience participation.

ACT ONE

The wrestling ring. The audience should be able to purchase drinks at
reasonable prices. The piano player vamps a few requests. The REFEREE
climbs into the ring and takes a microphone from one of the corner posts. He
uses it for all official announcements.

REF: Gentlemen, gentlemen; ladies and gentlemen: top of
the bill tonight Contact Promotions proudly present, for
the first time in any wrestling ring, a man and a woman
fighting to the finish. The woman, ladies and gentlemen,
is the reigning European Ladies Champion, Trafford
Tanzi. The man, the ever-popular Dean Rebel. Stay in
your seats for the fight of the decade. But first, to
commemorate this great occasion, ladies and gentlemen,
have you ever asked yourselves what it takes to become
a champion? Are they born or are they bred? How did
Trafford Tanzi happen upon her speciality hold, the
Venus Flytrap? In ten dazzling rounds Contact
Promotions will attempt to answer these questions, and
many more. Contact Promotions present the exclusive
Trafford Tanzi Story. Told, ladies and gentlemen, with the
help of members of the wrestling fraternity.

*(Music: J. A. V. Fucik's "Entry of the Gladiators". The cast take a fast
bow in character as their names are called.)*

Allow me to introduce to you, that lucky lady, Tanzi's
Mum. Tanzi's Dad. All the world loves a villain – only
joking, only joking. Her friend and confidante,
Platinum Sue. The man who taught her so much: Dean
Rebel. And the little lady herself, the reigning
European champion: Trafford Tanzi. The music tonight
is provided at very short notice by Theolonius Monks
and his electric upright. All the other parts will be
played by my good self.

(Music finishes.)

Ladies and gentlemen, the Trafford Tanzi Story. See Tanzi
grow from nappies to netball. Watch her fall in love,
discover the harsh realities of the wrestling world, invent

that deadly hold the Venus Flytrap. See her use it to destroy her enemies as she climbs to the top of her profession. The Trafford Tanzi Story, her hopes, her fears, her early years. Can I have the contestants for Round One.

(*TANZI and MUM go to their corners.*)

In the red corner, ladies and gentlemen: Trafford Tanzi. There she is, and she's just toddling. She's one year old. A baby.

(*TANZI falls over and goos.*)

In the blue corner, her opponent for Round One, her Mum, a mum in a million. Seconds away, Round One.

(*Bell.*)

MUM: Come here. Come on, come here. Tanzi.

(*TANZI totters over to her.*)

Mummy's little girlie. (*She pushes TANZI over.*) Tanzi were always a disappointment to me.

(*TANZI clambers to her feet again as MUM takes the microphone and sings.*)

Mum's Song

I wanted a boy (*She "head mares" TANZI.*)
I wanted a lad,
I wanted a boy (*Another "head mare".*)
And so did her dad.
When you first have a thought like maybe,
I just might be having a baby,
You don't stand at the sink, thinking
Pink, pink, pink, pink, pink.
No, you sit on the loo, cooing,
Blue, blue, blue,
For a boy because boys are important,
And when he does things that he oughtn't,
Like playing with his willie,
Well, I know it's very silly,
But you smile, and you forgive him 'cos you know,
One day he'll grow
Into a man.

(*Speaking over the instrumental; ogling the REF.*) And men are
wonderful, aren't they? They're strong and clever and
decisive and they can do things and talk about things
and they give me goose pimples just thinking about
them and...
(*TANZI comes between her and the REF.*)
(*Singing.*)
I wanted a boy (*"Head mare".*)
And look what I got,
Well I got a girl (*"Head mare".*)
All covered in snot.
And when at last the stork comes calling
And his bundle is pink – appalling!
You lie there feeling low, going,
No, no, no, no, no.
And then you have a little cry, sighing,
Why? Why? Why?
'Cos a boy is for adoring,
But a girl is just plain boring,
Unless she's very pretty,
Which she isn't more's the pity,
And you can't forgive her 'cos you know,
She'll never grow
Into a man.
(*Speaking as before.*) And men are wonderful, aren't they?
I mean they tell you what to do, and how to do it, and
when they've got any left they give you housekeeping
money and...
(*TANZI comes between the REF and MUM with an interesting
"nose dropping".*)
Oh, Tanzi! I wanted a boy. Frock!
(*MUM takes a frock from SUE and dresses TANZI as she sings the next.*)
To dress all in blue,
What use is a girl?
Well, what can she *do*?
(*TANZI dribbles over the ropes through this next.*)
(*Speaking.*) Ah that's better, nothing like real nylon. She
almost does me credit. The trouble I took with her.

The white oh-so-white matinée jackets. The frilly knickers.
Little frocks with "Tanzi" sewn on them in pink silk.
Nothing was too much trouble in them days. Oh, it
seems a shame to hit her.

REF: Right, no contest. No contest.

MUSICIAN: Oh Christ! (*He has been dribbled on.*)

MUM: No, wait a minute – you're not dribbling, are you,
child? Are you? Would you credit it! All down her dress
with the pink motif.
(*MUM "posts" TANZI. TANZI falls.*)
Can I have her din-dins please?
(*The REF hands MUM a large tin of baby food and a spoon. TANZI
gets excited.*)
Now, Tanzi, wait. Wait till you've got your bib on. Bib
on first.
(*SUE hands MUM the bib. TANZI complains. MUM punches her in
the stomach. TANZI falls.*)

REF: Hey, you didn't use your fist, did you, missus? I have
to ask.

MUM: Did you see me use me fist?

REF: Er – no. No, carry on.
(*TANZI is crying.*)

MUM: Tanzi. Tanzi, oo-oo! Mummy's little girlie. Din-
dins. Nicey foo-ood. Open mouth for Mummy, there's
a good girl.
(*TANZI opens her mouth. MUM puts food in. It's horrible.*)
Good girl, three more mouthfuls and we're finished.
(*TANZI shakes her head. She grabs the tin and spits the food back in.
She takes a handful and likes the feel of it. She smears it on her face. Then
another on MUM's face. Then one on the REF's. Then starts throwing
it at the audience.*)
Look at her. Look at her. Spoilt brat. Tanzi. Tanzi! Tanzi
doesn't love her mummy no more. Tanzi, Mummy's got
sweeties for you. Sweeties. (*To the audience.*) Haven't you
got any paper you can rustle? Sweeties!
(*TANZI approaches.*)
Come along, Tanzi, there's a good girl. Food; sweeties.
(*TANZI hands over the tin.*)

Ta. (*She takes the tin with one hand and "Irish whips" TANZI with the other.*) Oooh, look at her! The dirty little girl. (*She puts an "anklelock" on her and twists through this next.*) Tanzi doesn't love her mummy no more. The nasty, dirty, little girl. (*"Step-over leglock" and "Stamp".*)
(*TANZI bursts into tears. Bell.*)

REF: Ladies and gentlemen: the winner in Round One, Mum. A big hand for Mum please, showing us all how to do it. Thank you.
(*MUM takes a bow and then sweeps up the food during this next:*)
Round Two. Can I have the contestants for Round Two, please? In the red corner, Trafford Tanzi. In the blue corner, Platinum Sue. Girls, come here.
(*They come to the centre, the REF turns his back on TANZI and chats up SUE.*)
Now listen, I want nothing you're going to be ashamed of after. No scratching, hair pulling, biting, agreed?

SUE: Yes, Mr Referee.

REF: Good girl.

TANZI: Aren't you gonna ask me then?

REF: Yeah, when you can wriggle your arse like that. Tanzi is at school. She's six years old. Just six. Seconds away, Round Two.
(*Bell. TANZI holds her hand out to shake hands. SUE takes it down to the ground and stamps on it.*)

TANZI: Fwaugh, fwaugh.
(*TANZI returns to her corner, comes back with a lollipop. She offers it to SUE. SUE takes it and "Irish whips" her. TANZI gets up. SUE points in the air. TANZI looks up. SUE "claims" her leg. TANZI "break falls".*)

REF: One... er... two... er... three... er...

SUE: One, two-koo, three-ee,
Tanzi hit rock bottom,
She tried to knock the champion out,
But found her chance was rotten.

TANZI: Why can't we be friends, I want to be friends.

SUE: Because we can't.

TANZI: But why?

SUE: Me mam says we can't, so there. You've got a snotty nose and dirty knees. You're a tomboy. Only play boys' games. I play house and all the girls' games. You're a slut, so there.

TANZI: I will play if you want.

SUE: I can't. Your mouth's dirty.

TANZI: It's not.

SUE: You swear.

TANZI: I don't.

SUE: You do.

TANZI: Don't.

SUE: Do.

TANZI: Don't.

SUE: Do.

TANZI: Well, what do I say then?

SUE: I don't know. But me mam says you do, so there.

TANZI: Well, what's swearing then?

SUE: Well... dirty words.

TANZI: You don't know-ow, you don't kno-ow.

SUE: I do. I do. I do.

TANZI: I do because me mam tells me dad not to, so there.

SUE: Oo, what's he say? Go on. Tell us.

TANZI: Promise to be friends?

SUE: I might. Yes. Go on. Go on.

TANZI: Well, in the morning when he can't find his socks he says, "Bloody Hell!"

SUE: Ooh!
(*They both run round the ring yelling, "Bloody Hell" and "Poo-poo-poo" etc.*)

TANZI: And I know that's swearing 'cos me mam tells me dad to stop fucking swearing.

SUE: Oo! Oo! Bloody Hell! Fucking swearing!
(*They play pat-a-cake through this next:*)

SUE *and* TANZI: (*Together.*) Salami, Salami,
 All the boys is barmy,
 Sla-ate, sla-ate,
 All the girls is grea-eat!
 (*TANZI slaps the REF on the last one.*)

TANZI: 'Ey, 'ey, 'ey, we could have a gang.

SUE: What for?

TANZI: Fighting the boys.

SUE: Girls don't fight, me mam says so.

DEAN: (*Outside the ring.*) That's it, you tell her, Sue.

SUE: Ooh! Ooh I will! I'll tell on her. I'll tell our Miss on you. You've been swearing.

TANZI: But... but we're friends, you said.

SUE: I can't. Me mam says I can't. And, and Miss'll send you up to Head Miss and you'll get the slipper for fighting and swearing, so there.

(*TANZI tries not to cry. She grabs a dolly off SUE and pulls its arms and legs off and stamps on it.*)

SUE: She's got my dolly! She's got my dolly!

REF: Now, Miss, calm down, calm down...

(*Bell.*)

The bell's gone. Round Two to Platinum Sue.

SUE: Piece of cake. (*She climbs out of the ring.*)

REF: And as for you, my girl, watch it, or I'll have to issue you with a public warning. You wash your mouth out with soap and water, we want none of that filthy language in...

(*TANZI has been swilling her mouth round. She spits the content on to the REF.*)

You... you...

DAD: No, no. You're getting it all wrong. She's getting it all wrong. My little girl wasn't like that at all. She was, she was (*He takes the microphone.*) beautiful.

(*MUM plays a violin and the REF dons a pair of headphones and reads "Sporting Life" as DAD sings.*)

Dad's Song

Tanzi, Tanzi; buttercups and Tanzi,
She was so beautiful as she grew;
Little frocks and cotton socks, pretty as a chocolate box,
My little girl with her eyes of blue.
Now Daddy's got a great big thirsty,
Daddy's mouthie's very dry,

Tanzi fetch your Mummy's pursie,
Needn't tell her why.
Daddy take the funny money,
Tanzi put the purse back,
Put that ruddy purse back, Tanzi,
Do you want a smack?
Tanzi, Tanzi: buttercups and Tanzi,
She was so beautiful as she grew;
Little frocks and cotton socks, pretty as a chocolate box,
My little girl with her eyes of blue.
Now Tanzi sit on Daddy's knee-knee,
Bless her little cotton socks,
Daddy's backed a little gee-gee, on the goggle box,
Tanzi make her Daddy lucky,
See his little horsey run.
Jesus Christ it's going backwards,
Now look what you've done.
Tanzi, Tanzi: buttercups and Tanzi,
She was so beautiful as she grew;
Little frocks and cotton socks, pretty as a chocolate box,
My little girl with her eyes of blue.

REF: Thank you, thank you, Tanzi's Dad. Ladies and gentlemen, Round Three, Tanzi meets the school psychiatrist. In the red corner, Trafford Tanzi. She is now eleven, she's eleven years old. In the blue corner... oh, excuse me, it's me.

(*He hands the microphone to MUM and hastily changes into DR GROPE. SUE assists dressed as a nurse.*)

MUM: In the blue corner, the school psychiatrist, Doctor Grope. Seconds away... Round Three.

(*Bell. Grope gets TANZI in a "headlock".*)

GROPE: Aha. Got you. Name?

TANZI: What?

GROPE: Name, stupid. What's yours?

TANZI: Tanzi.

GROPE: Tanzi what? ("*Stamp*".)

TANZI: Tanzi.

GROPE: Yes, but Tanzi what? ("*Stamp*".) Your second name.

(*GROPE turns her away from MUM who is reffing for this round and gouges her eye.*)

I've got to send in a psychiatrist's report – (*He runs her face along the top rope.*) – on why Tanzi whatever-your-name-is, can't read. (*He stamps again and drops her on the floor.*)

TANZI: Green.

GROPE: (*Putting his knee in her back and pulling her up by her cheeks.*) I should think you are.

TANZI: That's me name.

GROPE: (*Changing to a "nerve hold" and bringing her to her feet.*) Oho, how green was my valley, eh?

DAD: (*Outside the ring.*) Stop him, love, that's our name too.

MUM: Shush.

GROPE: (*Walking her across the ring with "nerve hold".*) Joke, girl. Laugh.

(*Grope tightens his hold: TANZI screams.*)

Haven't you got a sense of humour? No greens is good greens, what? I never used to like my greens at school either.

(*TANZI breaks free and takes a swing at him. He grabs her lower lip and forces her up on tiptoe.*)

Temper, temper. Naughty, naughty. We're never going to find out why you don't read if you carry on like this. Right. (*GROPE signals for SUE to hold up a reading card which has a daft picture and "Jane helps Mum wash the dishes" written underneath. He changes back to the "nerve grip".*)

I'd like you to look at this card. Now what do you see? (*He applies pressure.*)

TANZI: (*Shrieking.*) A girl...

GROPE: Yes. And what is the girl called? (*Pressure.*)

TANZI: Jane. Jane... Jane. Jane.

GROPE: Quite right. Good, very good. Mustn't stint on the praise. (*He pats her on the head and then "rabbit punches" her to her knees.*) Now, Tanzi, pay attention, what's the next word? (*"Nerve hold" and pressure.*)

TANZI: Helps. Helps. Helps. Helps.

GROPE: Very, very good Now... (*Pressure.*)

TANZI: Mum!

GROPE: Oh, did you hear that? I'm beginning to wonder if they've sent me the right girl. Let's have a look at your teeth. (*He forces her mouth open.*) Never mind. (*He takes her nose and lifts her to her feet by it.*) Now, Tanzi, I want you to be a clever girl and do all the rest in one go. (*He slaps the hand holding her nose.*) Come on, don't be shy.

TANZI: (*Reading.*) Dig for gold.

GROPE: Excellent, I... what? Wait a minute. (*Reading.*) "Wash the dishes." What did you say? Say it for me.

TANZI: Dig for gold. (*She "Irish whips" him.*) Discover the source of the Nile. Fly to the moon. (*"Monkey climb" on him.*) That's it, that's what Jane helps her mummy to do. Take a meteoric readings of the stars.
(*She throws him at the ropes and attempts a "tomahawk chop" as he comes off them but he "grope ducks" and puts "nerve hold" back on her.*)

GROPE: Now then, my girl, I can see that we've got some learning to do.
(*He changes the hold to a "headlock" and throttles her with his left hand.*)

DAD: (*Outside the ring.*) Mum, Mum, he's got her by the throat.
(*GROPE changes his hold.*)

MUM: Are you choking her?

GROPE: Would I? I'm the school psychiatrist, I'm just teaching her to read.
(*He starts throttling her again.*)

TANZI: No, ow, yes, "Jane helps Mum wash the dishes."
(*Bell.*)

GROPE: (*Throwing her down and stamping on her.*) Ja, ja, that is right, Jane help Mum vash ze dishes. Oh. (*He changes back to the REF.*)

MUM: The winner in Round Three. Doctor Grope.

DAD: (*Climbing into the ring.*) You know what you are, don't you?

GROPE: Jealous, are we?

DAD: A bleeding great bully.

MUM: Break it up, break it up. My husband was always supporting Tanzi. Until she came home from school one time.

TANZI: Mum...

MUM: She says...

TANZI: Can I have a career?

MUM: Well! I thought... I'll let her dad sort it out.

REF: Ladies and gentlemen, Round Four. Tanzi is sweet
sixteen. (*He wiggles his hips.*)
(*TANZI wolf-whistles.*)
Watch it, you. In the blue corner – watch you don't let
her get away with anything – Tanzi's Dad.

TANZI: Come on, you great pudding, you're holding up
the action.

DAD: Action, did you say? She wants some action. I'll give
you action and all. Ready?

REF: Seconds away, Round Four.
(*Bell. DAD and TANZI circle.*)

DAD: (*As they do.*) You're late, where've you been?

TANZI: Same as every night, at school...
(*They change direction.*)

DAD: Answer me, my girl, I haven't come back early from
the pub to hear you say at school. Come on, out with it.
(*"Ref's hold".*)

TANZI: It's the truth...

DAD: (*Putting TANZI in a "backhammer".*) Pull the other
one. I'm...

TANZI: (*Reversing "backhammer" on him.*) Listen. I can't work
here because me mam...

DAD: (*Reversing "backhammer" on TANZI.*) Has the telly on all
the time and you can't concentrate. I've heard it all
before. (*He stamps and forces it higher.*)

TANZI: It's true.

DAD: (*Forcing her down on to the floor through this.*) I'll tell you
whether it's true or not, my girl. You can't pull the wool
over my eyes like you can your poor old mum. Do you
hear me? (*He stamps on her elbow.*) A career!

TANZI: But, Dad...

DAD: And don't you "but, Dad" me either. I know where
you've been going after school, don't think I don't. Girls!
(*"Crutch hold" and lifts her up into an "aeroplane spin".*) What
else is there for them to do except go sneaking around in

25

the dark with the lads. Disgusting, I call it. Makes me all hot inside thinking about it. In the back alleys, round the back of the garages. On the railway banks. Never mind they give you those badges: "I don't play on the railway." No. But we do, don't we? (*He has overdone the "spin" and now staggers to his knees.*) I've seen you waiting outside the Gents at Oxford Station and...

(*He throws her off with a "body slam", retreats into a corner and splashes. TANZI rolls out from under it. DAD lies prone.*)

Ooh-er... Tanzi... how can you do it to your poor old dad.

TANZI: (*Going to him.*) Dad, Dad, I didn't mean to upset you.

DAD: (*Grabbing her foot and bringing her down. "Anklelock".*) There, I knew it! Filth. You've been having filth.

TANZI: No, no, Dad.

DAD: (*Applying pressure to various "leglocks".*) Say yes, will you girl? Say yes and put me out of my misery. Tell you what, say yes and I'll forget all about you wanting a career. Right? Give you fifty quid. Fifty notes, to spend on yourself. Get the lot. Nice outfit, make-up. Get yourself a decent feller. One that'll want to marry you, not fiddle about with you up them back alleys. Come on. It's all your mum and dad ever wanted.

TANZI: But it would be the same as up them alleys except I'd be married.

(*TANZI tries to raise her head through this next but DAD keeps slamming it back.*)

I don't want to get married.

(*Slam.*)

I want me independence.

(*Slam.*)

I want a career.

(*Slam.*)

I want to be somebody!

(*Slam.*)

DAD: Somebody! A slut, the way you're going on. A wife is somebody, isn't she? Are you saying your mother isn't somebody? Somebody? Marriage is the best career money can buy.

TANZI: I want some exams.

DAD: (*Trying to turn her over into a "Boston crab".*) Filthy bits of paper! Right! You want exams. You pay for 'em. (*"Boston crab".*) You earn your own living. See how you like that. (*He sits back.*)

REF: Do you submit?

TANZI: Yes, yes, yes.

(*Bell. DAD gets off and parades. TANZI bursts into tears.*)

REF: In Round Four, a submission to Dad by means of a Boston Crab. Come on Tanzi, oh not the waterworks for God's sake, quick, quick, can I have the contestants for Round Five please. Tanzi is now luscious eighteen and working down the local chippy. In the blue corner, the ever-popular, Dean Rebel!

(*DEAN's music. Heavy rock. He comes through the audience signing autographs and kissing impressionable women, vaults into the ring and combs his hair.*)

Seconds away. Round Five.

(*Bell.*)

TANZI: (*In the red corner still crying.*) Ye-es.

DEAN: Liver dinner for one with chips, rice, peas, meat and potato pie, a sausage and a pancake roll. Oh and stick a bit of fish in to round it off.

(*TANZI sobs loudly. DEAN does a flash "roll" across the ring and comes up on the ropes beside her.*)

What's the matter, lady? You're crying over the fish. I mean, I'm not fussy but I don't go for too much salt with it. Come on, cheer up, it might never happen. Here, wanna use me hanky? (*He removes it slowly from his trunks.*)

You know I don't like to see a girl crying. You take it.

TANZI: No-o.

DEAN: All right. I'll do it for yer. Come on, come here.

(*She does so.*)

Better?

(*TANZI nods.*)

Hey-eye, you've got nice eyes. No, really you have. Much too good to waste frying chips. I mean, what did they ever know about love? Here, I'll just put me

hanky away. (*He puts it back in his trunks.*) Bit of a tight fit, what with the three-piece suite. Hey, now you're not telling me you didn't know what we kept hidden away down there?

REF: Watch your mouth, Rebel.

DEAN: Don't be nosey. (*"Nose mares" him.*) Feelin' better? Hey, that's better and better. I mean, I could see you was tasty but not well, delicious. What's yer name?

TANZI: Tanzi.

(*DEAN holds out his hand. She takes it. He throws her into the ropes and clinches with her as she bounces back.*)

DEAN: Hi, Tanzi.

TANZI: Hi.

DEAN: Don't bother to wrap yerself up. I'll eat you now.

TANZI: Not too close, Rebel. Is that your name?

DEAN: Yeah. (*He puts a "backhammer" on her.*) Dean Rebel; I'm in training to be a professional wrestler.
(*He throws her to the ropes again. This time she hangs on.*)
Come over here and try me folding body press.

TANZI: No.

DEAN: I can see it's time for a touch of the old romance.
(*He produces a bunch of flowers from his trunks.*) Flowers, for the one I love.

DAD: (*Outside the ring.*) That's the ticket.

TANZI: Flowers! Jesus, d'you think I'm soft or something. Go give 'em to your old lady.
(*She kicks them out of his hand. The REF catches them. DEAN falls back and does a "neck spring" on to his feet again.*)

DEAN: Well, vinegar as well! (*He takes the microphone.*) You're a cracker, Tanzi, we were made for each other.
(*DEAN sings and jives with TANZI whilst the rest of the cast form a backing group.*)

Dean's Song

Tanzi, Tanzi, you're so sweet,
Pansies couldn't grow so neat,
You're the apple of my eye,

Come on pretty baby let me hold you tight and call you
 sweetie pie.
(*Chorus of grunts.*)
If you let me kiss your hand,
I promise you I will understand,
Take care to show you my respect,
Treat you right, and hold you tight like I do with every
 girl I get.
(*More grunts.*)
Your silence makes me that much bolder,
I'm comin' up to kiss your shoulder,
Tanzi, as I kiss your chin,
Promise me we can live in sin.
(*Yet more grunts.*)

TANZI: (*Singing.*) Dean, oh Dean, you're awful sweet,
Guess you've swept me off my feet,
I never knew, till we came together,
How much a lonely girl like me, needs a feller.
(*Grunts. DEAN bends her over into a kiss. The REF takes the microphone.*)

REF: (*Speaking.*) One, two, three, four, five, six, seven, eight,
nine, ten.
(*Bell.*)
Break! Ladies and gentlemen, in Round Five, a knockout
to Dean Rebel. There will now be a fifteen-minute
interval while the lucky couple go off and get married
and the rest of us go for a drink and a piss. Back in
fifteen minutes. Thank you.
(*Interval.*)

ACT TWO

The wrestling ring. Pianist plays a request or two. The REF takes the microphone and gets into the ring.

REF: Welcome back to the continuing Trafford Tanzi Story. Can I have the contestants for Round Six please, Round...
(MUM enters the ring sobbing her heart out.)
Oh Gawd. What's the matter, missus?

MUM: Oh, mister. Oh! You don't understand. I'm crying because I'm so happy. To think of it. My little girl, my Tanzi, married. (*She breaks down again.*) The wedding night. The honeymoon! Oh, mister, you're not a married man are you?

REF: No. No... I... er... I...

MUM: You don't know what you've missed. Don't you ever have any regrets? Don't you regret it?
(REF sings a version of Edith Piaf's "No Regrets". Afterwards DAD enters the ring. MUM and the REF disentangle themselves.)

DAD: The lucky couple on their way. Just finishing off the honeymoon. What passion. That's the word for it, pulsating passion. Crumpled sheets. The lot. I haven't seen anything like it since, since me own! (*He throws himself on MUM.*) Oh, Mum!

MUM: Oh Des! Des!
(They embrace passionately.)

REF: Break it up. Break it up. This is a family show.

MUM: (*Disentangling herself from DAD.*) Those that can do! Those that can't ref!
(MUM and DAD leave the ring.)

REF: Round Six. Can I have the contestants please for Round Six. And in the red corner, ladies and gentlemen, the very lovely Mrs, that lucky girl, Mrs Dean Rebel! And in the blue corner...
(Empty.)
And in the blue corner... And also in the red corner, her old man, Dean Rebel.
(TANZI and DEAN are asleep in the red corner.)

Seconds away, Round Six.
(*Bell. The REF bounces around while TANZI wakes up.*)

TANZI: Oh! It's so early in the morning! The dew is still on the grass. What a morning! The morning chorus!
(*The cast oblige.*)
Oh it's so beautiful! I'm such a lucky girl. Dean's a professional wrestler now and he lets me help him train. I'm learning such a lot. He says I can write his autobiography for the *News of the World.* Listen! (*She has a notebook and pencil strung round her neck. Reading.*)
"The most important part of a wrestler's career is his training." De-ean? De-ean? Wakey-Wakey. Time to get up.

DEAN: No. No. (*Seeing TANZI.*) Oh yes. Yes. Oh, Tanzi.

TANZI: Oh, Dean.

REF: Oh, Jesus.

TANZI: I've cleaned your shoes. I've ironed your towel. I've oiled the stopwatch and I've packed the knapsack with tea and sandwiches for two and the weights for weight-training.
(*She drags the knapsack over.*)

DEAN: Good girl, I'm ready. (*He picks up the knapsack. It's very heavy.*) Right, you carry the knapsack, we don't want me straining on my shoulders, do we?
(*He puts it on her. She staggers.*)
A wrestler's muscles should be flexible at all times: write that down, Tanzi.

TANZI: A wrestler's muscles... (*She writes it down.*)

DEAN: Have you got the stopwatch?

TANZI: Oh yes, Dean. (*It's round her neck.*)

DEAN: Good girl. Now when I say "go" I want you – to press – the little button, on the top. Do you understand?

TANZI: Er... Yes, Dean.

DEAN: Right. Ready, steady: Go!
(*TANZI starts the watch. DEAN sets off jogging round the ring. TANZI follows.*)
Oh that's better. What a morning, eh? Just so good to get that oxygen in yer lungs. Tanzi love, that's what all this is about. Oxygen.

(*TANZI is falling behind.*)

I just feel fantastic, you know that, Tanzi? Top of the world. Never felt better in me life. Moving like grade A well-oiled clockwork. (*He does knee bends.*) Up. Down. Try it, Tanzi.

(*TANZI does knee bends and keeps it up through this next.*)

Chest easy. Hamstrings cool. Tanzi, write this down: a wrestler would be nothing, nothing, without the loving support of a good woman, his wife.

(*TANZI writes and knee bends. DEAN embraces her and they both fall over and snog.*)

REF: No contest. No contest.

(*Bell.*)

Now you two, get this into your heads. The paying public don't want to know about marital bliss, they've paid their money to see the fighting. The blood and thunder. Didn't you ever beat her up, Dean? Come on, give us the dirt!

MUM: (*Outside the ring.*) Beat her up? What for? My Tanzi was perfection. A credit to her mother. If there were anyone at fault it were him. Men never know when they're well off.

DEAN: Come here.

MUM: What?

DEAN: I said come here.

MUM: (*Going to him.*) What for?

DEAN: I thought so. You've got a spot just this side of yer nose. Here, let me squeeze it...

MUM: Well...

REF: Round Seven and in the blue corner, Platinum... waaaaaaugh!

(*The REF, MUM and DAD provide backing.*)

The Beauty Business

SUE: (*Singing.*) Hey man,
Who's that
Funky chick?
Hey man,

Makes your
Heart beat quick.
Hey man,
And she
Knows a trick
Or two.

BACKING GROUP: Three, four, five.

SUE: Hi-de hi I'm going places,
Meeting guys with famous faces,
Watch me put them through their paces
I know how the race is
Won
Like my style and like my suntan,
Like the way my hair is done man
Pay the bills and you will see
That life is fun and fancy free
For me.

BACKING GROUP: She's got the disco be-eat
She's got the disco be-eat,
She's in the Beauty Business.

SUE: She can't stop,
She will bop,
Till she drops.
Hey man
That chick's
Really cool.
Hey man
See the
Fellers drool
Hey man
And she's
Played the fool
Before.

BACKING GROUP: Five, six, seven.

SUE: She's got the disco be-eat,
She's got the disco be-eat,

ALL: She's in the Beauty Business,
She's in the Beauty Business.

REF: (*Speaking.*) Seconds away, Round Seven.

SUE: Tanzi pet! Lovely to see you!

TANZI: Oh. Er... hullo. Do I know you?

SUE: Of course you do. Mind you, a lot of people don't recognise me since I went into the beauty business, funny, isn't it?

(*The REF laughs ingratiatingly. SUE conducts him and then cuts him off.*)

I'm Sue, your best mate from school, remember?

TANZI: Oh yeah. I do.

SUE: Oh yes, it all comes flooding back, doesn't it? Little pests we were. Some of the things we used to get up to.

(*SUE bops. The REF joins her.*)

Salami, salami,

All the boys are barmy.

TANZI: Yeah.

Sla-ate, sla-ate,

All the girls is gre-eat.

What's happened to you?

SUE: You're married now, aren't you, pet?

TANZI: Yes, how did you know?

SUE: Well, there's your hair (*She grabs it and pulls.*) all anyhow. No make-up. ("*Face bar*".) Carpet slippers. (*She stands on TANZI's feet and pushes her backwards.*) You look like something the cat's sicked up.

TANZI: Well, I was just popping out to the shops for some tea.

SUE: I wouldn't let myself go like that! I mean, you don't want him looking at anyone else, do you? Not that I don't envy you, mind. Of course I've had my chances. (*She sticks her finger in the REF's ear and wiggles it.*) But you know my mum, she brought me up particular about marriage. (*She slaps his face.*)

TANZI: I s'pose we can't all be lucky. Hey, my feller is terrific.

SUE: Bit of all right? Gives you a bonus with the wages, does he? Yeah, I know what you mean though, I'm in love at the moment. Ever since I turned professional with the beauty business. I carry the boards round between each round at wrestling. Well, I met this feller – middleweight – muscles all over the place. Turns me knees to jelly.

TANZI: Oh. What's his name?

SUE: I'm not gonna tell you that, am I? Well, seeing as we're best mates – it's Dean.

TANZI: Dean?

SUE: Dean Rebel. Of course he's married. Got ever such a boring wife he says, possessive, y'know. Even insists on going training with him...

TANZI: Noooooooo...! (*'Irish whip: forearm smash: two-footed dropkick'.*)

REF: One... two... three... four... five... six... seven... bell... eight... bell... nine... bell... bell... bell...
(*Bell.*)
Oh there now, that was a piece of luck.

TANZI: Why you...

REF: Bad luck, I mean, Tanzi, well, saved by the bell, wasn't she? (*'Ref's hold'. The REF 'head mares' her.*) And anyway, it's time you stopped living in cloud cuckoo land.
(*TANZI breaks down.*)

MUM: (*Climbing into the ring.*) A girl needs her mother at a time like this. Tanzi, Tanzi love, come to Mum.

TANZI: Mum... Mum...

REF: Seconds away, Round Eight.

MUM: There, there: Mummy's here now.

TANZI: He doesn't love me. He doesn't care. After all I've done for him. The training and...

MUM: There, there, now dry your eyes.

TANZI: How could he do it? Mum, Mum, let me come home. I want to start all over again.

MUM: Tanzi-duck, think.

TANZI: Think? I am thinking.

MUM: But not along the right lines, dear. Look, sweetheart, Dean may be a swine, a brutish monster but so are all men. And we love them for it. The sooner you learn the facts of life the better.

TANZI: I hate him!

MUM: Don't say that! Remember, Dean's your husband. You promised to love and obey him.

TANZI: I'll divorce him!

MUM: Oh you always think of yourself first, don't you? What about the disgrace to us? Your parents?

DAD: (*Out of the ring.*) That's right.

TANZI: Let me come home.

MUM: Life's not a bowl of cherries, Tanzi. You've made your bed, now lie on it. Besides, your dad can't afford to keep you.

TANZI: I'll get a job. I'll earn my living.

MUM: Tanzi, Dean loves you in his own way.

TANZI: Mum!

MUM: It's true! Men are like children, when they meet temptation, they succumb. That Sue may not be my cup of tea but she knows how to look after herself. You've let yourself go, my girl, nobody wants something that looks as if it's been thrown on the rubbish tip. And anyway, what choice have you got? You've got to stand by him. (*The REF hands MUM the microphone and then leaves the ring. MUM sings Tammy Wynette's "Stand By Your Man". At the end of the first verse the REF enters the ring in a cowboy rig-out. Much business. MUM sings the second verse.*)

TANZI: Mum. I'll go... I'll go back to Dean.

MUM: That's my brave girl! You need a man to look after you at a time like this. Women are nothing alone. (*TANZI "posts" her.*) Ow! What you doing? That hurt.

TANZI: Practising? ("*Double roll*".) I'm going back to Dean ("*Head mare*".) but I'm going to work as well. (*She throws MUM to the ropes.*) I've done all the training, and I'm going to be a wrestler as well. (*There is a sequence of throws ending with a "flying tackle" during which:*)

DAD: (*Out of the ring.*) Women wrestlers! Looks like something out of the zoo, dunnit?

DEAN: Yeah. And they're dirty as well. Sneaky like one of them little plants, they look all nice and pretty and then, snap, they've got hold of your finger. What are they called? (*TANZI has MUM in a "pinfall".*)

REF: One... two... three. Break. (*Bell.*)

TANZI: Venus Flytraps! Thanks, Dean. That's what I'll call it.

REF: In Round Eight, by means of a Venus Flytrap, the winner, Trafford Tanzi.

Tanzi's Song

TANZI: (*Singing.*) In Blackpool and Crawley and Leicester,
The fighters are tough and are hard,
In Middlesbrough, Lincoln and Chester,
You're fighting for every damn yard,
In Newcastle, York and in Preston,
You stay on your guard.
A fighter must always be training,
A fighter must always be fit,
A fighter must always be travelling,
A fighter must never submit,
A fighter must always be working,
If she stops then she's gonna get hit.

REF: (*Speaking on the microphone; distantly.*) In Round Six the winning fall by means of a Venus Flytrap, the new Northern Area Ladies Champion: Trafford Tanzi.

TANZI: (*Singing.*) You fight using head mares and armlocks,
You fight using smashes and chops,
You fight using dropkicks and headbutts,
You fight and don't ever stop,
You fight till you're bruised and you're aching,
You fight till you drop.
A fighter must always be... etc.

REF: In Round Five: her opponent is unable to continue! The winner by means of a Venus Flytrap: the new British Ladies Champion: Trafford Tanzi.

TANZI: A fighter must always be... etc.

REF: In Round Two, by means of a Venus Flytrap, will you welcome please, the new European Ladies Champion: Trafford Tanzi!
(*TANZI takes a skipping rope from a corner and goes into a fancy training routine. DAD climbs into the ring with a large Mothering Sunday card.*)

DAD: Well done, Tanzi. Never knew you had it in you. You've made your old dad proud, fancy becoming European Ladies Champion after only one season. Fancy that! (*He catches the rope to stop her skipping.*) Now look, Tanzi. (*TANZI starts skipping again and DAD has to join in.*) I know you're very busy but just stick your marker on this. It's a Mothering Sunday card, I know you want to make it up with your mother and it's the little things that count. I'm sure you wouldn't want her to feel neglected in your hour of triumph.
(*DAD stops skipping. TANZI has to stop.*)

TANZI: Oh. Ta, Dad. (*She signs the card.*)

DAD: Right. I'll see she gets it.

TANZI: Ta.

DAD: No, no, don't mention it. After all, I'm only too glad to be of use.

TANZI: Wait a minute: we've had Mothering Sunday.

DAD: Have we? Oh well never mind, it'll do for next year. (*He starts to climb out of the ring.*)

TANZI: Hold on.
(*TANZI grabs the top rope and pulls: DAD somersaults back into the ring.*)

REF: Round Nine, and in the blue corner: Tanzi's manager.

TANZI: Manager? I haven't got a manager.

DAD: (*Pulling the contract out of the middle of the card.*) Listen to the Ref, Tanzi. He knows what he's talking about. I'm your manager now. And I've got the paper to prove it.

REF: Seconds away, Round Nine.
(*Bell. They circle. TANZI stamps and changes direction through this next:*)

TANZI: Don't be soft, Dad, I'm over twenty-one.

DAD: No, look, here's your marker.

TANZI: But you said that was a Mothering Sunday card.

DAD: Well, in a way it is, love. Your mother'll be made up when she hears the terms. Most thoughtful of you, Tanzi. Most generous. Fifty per cent. I couldn't have asked for better meself.

TANZI: Dad!

DAD: Tanzi, be reasonable. After all, you're only a slip of a girl, slip of a woman. And this isn't a picnic in the park you know. This is the cut-throat world of commerce. You need someone behind you you can trust. Otherwise there'll be blood all over the place. And anyway, I've already fixed up your next fight. Mud wrestling. In Hamburg. Naked. We'll make a fortune.

TANZI: Right!

> (*"Ref's hold". TANZI gets DAD in a "backhammer". She takes the contract and "head mare" DAD with his arm still in the "backhammer".*) (*Ripping up the contract.*) This is what I think of your contract, Dad. (*She scatters pieces of contract on him.*) (*TANZI ropes DAD and "flying tackle". Bell.*)

DAD: But, Tanzi... please... I'm your old dad. I'm family. And what about your mum? I've got to support her.

TANZI: Tough bananas, Dad.

> (*TANZI "dropkicks" DAD out of the ring.*)

REF: In Round Nine, her father is unable to continue. Ladies and gentlemen, Round Ten and in the blue corner, Tanzi's long-suffering husband – Dean Rebel.

> (*DEAN's music. He interrupts it.*)

DEAN: Shuuuut up!

REF: Seconds away, Round Ten.

> (*Bell. TANZI climbs into the ring.*)

DEAN: Hallo, Tanzi!

TANZI: Dean!

DEAN: Well. Where've you been then?

TANZI: Training!

DEAN: You're always bleeding training! Aren't I important no more, Tanzi? Tanzi?

TANZI: Dean, I...

DEAN: I've said I'm sorry. What more do you want? Blood?

TANZI: Don't be...

DEAN: Don't you bring that up again. Sue's over and done with. I love you, Tanzi. Don't you love me no more?

TANZI: Look, if I don't train, I won't get anywhere, will I? I'll lose me title. You should try it as well.

DEAN: What?

TANZI: Training. You lost your last fight.

DEAN: Well, that was arranged.

TANZI: Oh was it now? And who was always telling me he was above that sort of thing. "A wrestler must always fight to win, Tanzi", I wrote that down. Tell you what, I think you're slipping.

DEAN: And whose fault's that, eh? You thought about that? Look, I come home after a hard day's work, do I find a hot meal waiting for me? No, there's a note on the table. (*He produces it and reads.*) "Your salad's in the fridge." Well that is not how a champion is maintained, y'know.

TANZI: Oh that's what I'm s'posed to be, is it? A servicing unit? Anyway, salads is good for you, and if you don't like 'em, you know what you can do. Get off your arse, and you try cooking something for a change. And we could share the housework too, y'know, it's not impossible.

DEAN: (*Ripping up the salad note and scattering it on the floor.*) Course we could. If I wanted to. But I don't, see? Why should I keep a dog and bark meself.

TANZI: What's that supposed to mean?

DEAN: Look, don't be more stupid than you are. Cooking, that's your job; looking after the house and that. I haven't got a sock that hasn't got a hole in it. It's embarrassing, that's what it is. I can't go round to my mother's no more. What would she say if she knew, I ask you?

TANZI: Now look; we've been through all this, and I can't do it all. No more than you can. Not the training, the fights, the travelling and that. And everything here. It's just not possible.

DEAN: Well, Tanzi, my love, that's all I wanted to hear, that is. If you can't be both, then you've got to do one thing or the other. We can't have no compromises, either you decide to be my wife, my old lady; y'know, do all the things, apple pie on Sundays, afternoons in bed: or off you trot. Be a lady wrestler, but don't expect no support from me. Lady wrestler! It's unnatural. The only place ladies should wrestle is in bed. I'll fight you there if you like.

TANZI: That's the only place you think I've got a chance?

DEAN: Yeah. What's it to be, then?

TANZI: I don't know.

DEAN: Right: well I'll decide.

TANZI: No, you bleeding won't.

DEAN: How many times have I told you not to swear? I'm your husband. I'll decide.

TANZI: No.

DEAN: Am I gonna have to thump you?

TANZI: No. Yes! But in the ring, and I'll tell you what, if I lose, I'll give up wrestling and be a housewife.

DEAN: Hey, now you're talking.

TANZI: But if you lose, you give up and be a housewife.

DEAN: What?

TANZI: What's the matter? Lost your bottle? Scared of losing?

DEAN: No chance. Right: you're on.

(*They leave the ring.*)

REF: Gentlemen, gentlemen: ladies and gentlemen, that concludes the Trafford Tanzi Story, that is it. The main event follows immediately. For the first time in any wrestling ring, a man and a woman, fighting to the finish. This will be a catchweight contest of eight five-minute rounds, two falls, two submissions or a knockout to decide the winner. In the blue corner the ever-popular, Mr Dean Rebel!

(*DEAN's music. He enters flanked by PLATINUM SUE and DAD who lead chants for DEAN. He climbs into the ring and does a flashy warm-up.*)

In the red corner, the reigning European Ladies Champion: Trafford Tanzi.

(*Music changes to Wagner's "Ride of the Valkyries". MUM leads chant for TANZI.*)

And remember, ladies and gentlemen, the loser of tonight's contest has agreed to quit the wrestling ring and become a housewife.

(*He calls them together and gives them the chat and examines their hands and boots. SUE carries round a board with Round One written on it.*)

Seconds away, Round One.

(*Bell. Throughout the fight, MUM, DAD and SUE chant and counter-chant, exchange insults, encourage and abuse the audience etc., particularly*

between the rounds. DEAN and TANZI to the centre of the ring: "Ref's hold". DEAN puts a "full Nelson" on her. He kisses her neck. She jerks her arms backwards and breaks free. They circle. "Ref's hold". DEAN puts TANZI in a "wristlock". He kisses his way up her arm. She turns the "wristlock", steps through his hands and breaks out. TANZI "Irish whips" DEAN: he does a "head spring" and lands on his feet. He claps derisively.)

TANZI: Come on, you.

(DEAN throws TANZI to the ropes, catches her in a "bear hug" as she comes off them. Squeezes.)

DEAN: I like it, I like it.

(TANZI forces his head back until he's on his knees, jerks his head back and stamps and then throws him down face-first.)

REF: One... two...

(DEAN gets up. They lock hands. He forces her back to the ground to a "pinfall" position.)

One... two...

(TANZI gets one shoulder off. DEAN forces it back again.)

One... two...

(TANZI gets the other shoulder off. DEAN forces it back.)

One... two...

(TANZI "bridges". DEAN climbs on top. TANZI holds "bridge". DEAN jumps up and lands on "bridge". "Bridge" holds. DEAN jumps again. TANZI "unbridges" and catches him in a "body scissors" on his way down. Squeezes. DEAN turns so he is sitting with his back to her. Forces backwards. TANZI slams him back. Forces again. TANZI slams again. DEAN twists to side, struggles one arm through her legs. Then the other. Wriggles through till only his head is in the "scissors". TANZI stops him with a hand under his chin. DEAN "bridges" and slips out. "Criss cross". TANZI runs to the ropes. DEAN runs the other way. They run back and forth. TANZI drops flat in the middle of the ring. DEAN jumps over her, bounces off ropes into a "head butt". DEAN goes down.)

One... two... three... four...

(DEAN gets up. TANZI sends him to the ropes again. She goes for another "head butt" but DEAN dives over the top in a "forward roll". Catches her legs as he goes and gets her in a "folding press". But:)

Ropes.

(They separate. They circle, TANZI goes for "Ref's hold" but DEAN "claims" her leg. "Leglock". Applies pressure, then steps over it and jumps on it. DEAN puts a "figure four leglock" on.)

DEAN: Ask her.

REF: Submit?

TANZI: No... no...

(*DEAN stands up and leans back on it.*)

REF: Submit?

TANZI: No.

(*TANZI knocks his legs apart until he does the splits and falls over. They're both in agony. The REF untangles them with difficulty. DEAN "posts" TANZI. And again. He goes for a third one, this time she steps up on post, turns, dives round and behind him, grabs his legs and tips him backwards into a "folding body press".*)

REF: One... two...

(*Bell.*)

Break!

MUM: That bell was early! It was early... etc. etc. etc.

(*DEAN and TANZI go to their corners. Towels, drinks, etc. SUE carries a board with Round Two on it.*)

REF: Seconds away, Round Two.

(*Bell. "Ref's hold". TANZI puts DEAN in a "Jap stranglehold". He forces it off and puts it on her. She tries to force it off one way, DEAN wrenches it back on. She tries the other way, he wrenches it back on again. She "undresses" it, wriggles through, steps out of it and puts it back on him. He "undresses" it, wriggles out but as he steps out of it, she pulls his arm up into his bollocks and jerks him round the ring by it.*)

Break... break... break!

(*TANZI eventually lets go. DEAN drops. The REF lectures TANZI. DEAN gets up. DEAN "arm rolls" TANZI fast and hard. Twice. Then "Ref's hold" into a "full Nelson", spins her out into a "head mare". "Ref's hold", TANZI puts an "armlock" on. DEAN tries to "forward roll" out, TANZI forces him back to the ground. DEAN "neck springs" up and out, twists and "Irish whips" her. TANZI sends him to the ropes and "cross buttocks" him as he comes off. "Ref's hold". DEAN puts a "backhammer" on TANZI. TANZI "back somersaults" out and grips him round the waist. He flails behind him. One way, then the other. She pokes a foot between his legs. He goes for it but she grabs his hands through her legs, flips him over. His legs come up, she threads hers through, "bridges" backwards.*)

One... two... three. Break!

(*Bell.*)

In Round Two, the first fall, by means of a bridged folding bodypress, to Trafford Tanzi!

(*SUE slags DEAN off rotten. DAD changes sides. SUE carries Round Three board round.*)

Seconds away, Round Three.

(*Bell.*)

DEAN: Right, Tanzi, you asked for this.

TANZI: Come on, fight fair.

(*TANZI offers a handshake. DEAN takes it and "arm wrenches". "Head mares" her twice. Hard. She lands badly. DEAN "posts" her and follows in with "forearms smash". "Posts" her the other side. Follows in with two "forearm smashes". Second one illegal. The REF talks to him. DEAN picks her up and "body slams" her. She gets up. He "forearm smashes" her twice. Second one illegal. The REF talks to him. TANZI gets up. "Ref's hold". TANZI puts a "headlock" on. DEAN lifts her up and "knee drops" her. He kicks her in the back when she's down. The REF talks to him. TANZI gets up. DEAN "forearm smashes" her. TANZI smashes him back. DEAN smashes her back into the corner and goes berserk. Six or seven smashes while she's in the corner and the REF is trying to pull him off. Eventually he does so.*)

REF: (*On the microphone.*) In Round Three, a first public warning to Dean Rebel.

(*TANZI goes for "Ref's hold". DEAN "claims" leg. He turns her over and puts a "single leg Boston" on.*)

DEAN: Ask her.

REF: Submit?

TANZI: No.

(*DEAN puts a "full Boston" on.*)

DEAN: Ask her.

REF: Submit?

TANZI: No... no...

(*TANZI pushes up with her hands. DEAN sits back and forces her down again. TANZI pushes up again. Flicks her legs. DEAN "forward rolls" out. TANZI lies prone. The REF counts to eight. TANZI gets up. DEAN "posts" her and goes berserk again. The REF eventually pulls him off. DAD tries to climb into the ring. DEAN smashes him out.*)

REF: In Round Three a second and final public warning to Dean Rebel.

(*TANZI gets up. DEAN lifts her into a "backbreaker". Stamps.*)

TANZI: Yes... yes... yes...

(*Bell. DEAN still stamping it on. Eventually he drops her.*)

REF: In Round Three, by means of a backbreaker, an equalizing submission to Dean Rebel.

(*MUM works on TANZI's back. DAD complains she should be looking after him. SUE carries Round Four board round.*)

Seconds away, Round Four.

(*DEAN goes for "Ref's hold", TANZI "claims" leg. DEAN goes down. TANZI sits down with her feet forcing his legs apart. She bashes on her own knees to force his legs wider. DEAN yells. He offers his hand. TANZI takes it and heaves, stretching him wider, and wider. TANZI holds one of his legs. She marks the canvas with her finger to show how wide she's going to stretch him, stands up and throws herself backwards with one leg whilst standing on the other. DEAN is in agony. Eventually he gets up. They lock hands. He takes her hands down to the canvas. He treads on one while he turns her into an "armstretch". She somersaults out forwards and "stomach throws" him over the top of her. They both lie prone.*)

One... two... three... four... five... six... seven...

(*DEAN gets up first. TANZI follows and DEAN lifts her into another "backbreaker" as she's getting up.*)

REF: Submit?

TANZI: No... no... no...

(*She "bicycles" out. She throws him to the ropes and "cross buttocks" him as he comes off. DEAN takes the count as TANZI climbs up the ropes at the corner post till she's standing on top. DEAN groggily gets to his feet.*)

Shall I? Shall I?

(*She jumps from the top rope in "flying tackle". She lands across DEAN's shoulders and they fall backwards, him underneath.*)

REF: *One... two... three. Break.*

(*Bell.*)

In Round Four, a second and winning fall to Trafford Tanzi by means of a Venus Flytrap. The winner: Trafford Tanzi!

(*Everyone goes bananas and then leaves the ring except for the REF and DEAN. Music: Wagner's "Ride of the Valkyries".*)

And a big hand for the gallant loser and soon to be a housewife, Mr Dean...

DEAN: (*Grabbing the microphone.*) Tanzi! Tanzi, I wanna rematch. I wanna a rematch...
(*The REF takes the microphone back. DEAN goes.*)

REF: Thank you, thank you, ladies and gentlemen: you'll see no more. You're very kind I'm sure, I thought we had a bunch of intellectuals in when we started tonight but you're obviously students or alcoholics. If you enjoyed yourselves tonight tell your friends, if you didn't keep your mouths shut. The bar is open till eleven. (*Or*: We drink in the (*name of local pub*) round the corner.) Goodnight, thank you and God bless!

The End.

THE DRAMATIC ATTITUDES
OF MISS FANNY KEMBLE

.

Characters

STAGE MANAGER/SERVANT

SARAH SIDDONS, Fanny's aunt

SIR THOMAS LAWRENCE, the artist

AN ACTOR

AN ACTRESS

CHARLES KEMBLE, Fanny's father

MARIA KEMBLE, Fanny's mother

FANNY KEMBLE

SALLY, Fanny's daughter

PIERCE BUTLER, a wealthy American

MARGERY, an Irish servant

JO, a slave

PSYCHE, a slave

JACK, the headman, a slave

MR KING, the overseer

MACREADY, the actor

The play can be performed with a cast of eight, and should be multi-racial.

Act One is set on the Stage of Covent Garden. Act Two takes place largely in America: first in the Butler's house in the North, then on their plantation in Georgia. In the last scene Fanny returns to Covent Garden. Fanny was born in 1809 and first went to America in 1832.

The play was commissioned and first performed at the Nuffield Theatre, Southampton.

The Dramatic Attitudes of Miss Fanny Kemble was first performed on 15 November 1990 at the Nuffield Theatre, Southampton, with the following cast:

A MUSICIAN, Neil Brand

A STAGE MANAGER, Richard Betts

AN ACTRESS and later PSYCHE, Josette Bushell-Mingo

SARAH SIDDONS and later MARGERY, Marcia Warren

SIR THOMAS LAWRENCE and later JACK, Burt Caesar

CHARLES KEMBLE and later MR KING, Jeremy Sinden

AN ACTOR and later JO, Joe Dixon

MARIA KEMBLE and later HARRIET, Nicola Blackman

FANNY KEMBLE, Brenda Blethyn

PIERCE BUTLER, Peter Woodward

Director, Patrick Sandford

Designer, Robin Don

Lighting Designer, Stephen Watson

Costume Designer, Frances Tempest

Deputy Stage Manager, Catherine Hartley

Musical Arrangement, Neil Brand

ACT ONE

PROLOGUE

A stage bare except to one side a prop table, some chairs, a small table, also some wicker costume skips. To the back and turned away from the audience is a balcony.

Someone, somewhere sings a melody that might have originated on a plantation in the South of America. Strong music that evokes the sadness of the slave situation. The ACTRESS enters and speaks the prologue.

ACTRESS: Ladies and gentlemen, our author begs you to consider...

The Times We Live In!

Ladies and gentlemen our author... wants,

Our author wants...

Us to flit away with her?

To vamoose off to rain forests, away from ozone layers,

To whales that gambol in the waves,

And butterflies and heroin?

No herons – sorry – heroines!

Heroines as in good girls and heroes and...

She's mad!

Split down the middle like an amoeba;

Divided.

Only screaming 'cause the halves don't fit.

One's for Now,

Feet on the ground Now, the Future –

The practical scientific Future.

The other...

She's scared, scared to death poor thing,

Of things scientific –

Like modified genetics and gases –

That pervade the air and...

And chemicals that burn the skin and...

Viruses that, mutant viruses that mutilate and...

Wars pending –

(You always get "wars pending" in prologues)

She's most scared, definitely, most scared,
Of people without imagination
Like they've had a lobotomy,
People controlling... buttons... well, us!
So she, our author, wants most passionately,
To get back to Tradition –
Traditional values and stories and safety and where the
 hot chocolate is.
Help her!
(*The STAGE MANAGER enters.*)

STAGE MANAGER: Stand by for rehearsals.

END OF PROLOGUE.

(*MRS SIDDONS and SIR THOMAS LAWRENCE reveal themselves. They cross the stage. MRS SIDDONS uses a walking stick. They both address themselves to the audience.*)

SARAH SIDDONS: Mrs Sarah Siddons. Actress. Retired...

SIR THOMAS: Sir Thomas Lawrence. Portrait painter to society, and long term devotee of the extraordinary talents of Mrs Siddons.

SARAH: ... on her way to visit her youngest brother, Mr Charles Kemble – Actor, Manager and Proprietor of Covent Garden.

(*MRS SIDDONS and SIR THOMAS reach the other side of the stage and exit.*)

(*CHARLES KEMBLE rehearses the ACTOR and the ACTRESS in "Romeo and Juliet" on the acting area.*)

STAGE MANAGER: Go rehearsals.

CHARLES: Romeo, a few words about the part. You represent the sentiment whilst Juliet is the passion of love. That is to say the pathos is his whilst the power is hers. We see him at the start of the play in love with Rosalind. Now shall we take the first few lines? "Romeo. Sad hours seems long."

(*MRS SIDDONS enters.*)

SARAH: "What sadness lengthens Romeo's Hours?"

(*MRS SIDDONS progresses across the stage in a theatrical manner.*)

CHARLES: Sarah!

(*SARAH becomes self-effacing.*)

SARAH: Do continue. I'll wait.

CHARLES: Dear Sarah! I wouldn't dream of it!

(*CHARLES kisses SARAH, before dismissing his cast.*)

CHARLES: That is enough for today, folks. (*To the ACTRESS.*)
Sorry we didn't get round to using you, dear girl.

SARAH: So sorry, my dears!

CHARLES: Would you like to be introduced?

SARAH: How delightful!

(*SARAH holds out her hand. The ACTORS kiss it in turn.*)

CHARLES: May I present a most talented young man
engaged to play Romeo – and an equally talented young
lady engaged for Juliet. Mrs Sarah Siddons and Sir
Thomas Lawrence, the artist. How are you, old chap?

ACTOR: You've no idea what this means to me!

ACTRESS: I've dreamed about meeting you. I never
thought I would.

SIR THOMAS: "She who will make tragedy stand once
more with its feet up on the earth and its head above the
stars, weeping tears and blood."

BOTH ACTORS: Oh, yes! Yes!

(*SARAH looks the part. CHARLES abruptly dismisses the ACTORS.*)

CHARLES: Excuse us. We have business to talk about.

(*The ACTORS exit.*)

SARAH: Adieu!

CHARLES: Stage Management!

(*The STAGE MANAGER appears with a small table. On it is a
decanter and three wine glasses. CHARLES and SARAH sit. SIR
THOMAS sets up his easel. He draws throughout.*)

SARAH: My dear Charles, forgive my curiosity.

CHARLES: So good to see you!

SARAH: That delightful young man, is he an actor?

CHARLES: Brilliant. Stunning. Truly the best.

SARAH: And you are rehearsing *Romeo and Juliet* ?

CHARLES: The definitive production. By the time I'm
finished with that play there will be no more to say
about passion. Passion will be fully exploded.

SARAH: He was African.

CHARLES: Such a good actor.

SARAH: Romeo is Italian, surely?

CHARLES: Hot blooded.

SARAH: Not black – not a black Italian?

CHARLES: I don't see why not.

SARAH: There were no black Italians.

CHARLES: How do we know?

SARAH: History tells us.

CHARLES: Have you ever been to Italy?

SARAH: I don't see what that has got to do with it.

CHARLES: My point exactly. Shakespeare never went either. Have we any idea how many Italians he even knew? How many do you know? You see it is all conjecture, dear Sarah. Shakespeare's picture of Italy is entirely subjective; an Englishman's fantasy. Something the dear chap conjured up out of his amazing imagination. Not, therefore, necessarily true. How do we know there weren't black Italians? The Romans took both black and white slaves, and slaves become freemen in the course of...

SARAH: As long as he can act!

CHARLES: I promise you won't be disappointed. You know my favourite story, as a child? The one about the Roman trader with the Anglo-Saxon children that he took to the slave market in Rome? They were very pale with light gold, flaxen hair. A complete contrast to the other children on sale. Almost like seeing albinos. Well they caught the eye of Pope Gregory the First, and he asked about their origins, and on hearing that they were Angles he said...

SIR THOMAS: "Not Angles but angels!"

CHARLES: Thank you, Sir Thomas. My line, I believe.

SARAH: Don't be childish, Charles.

CHARLES: Childish! When a man steals one's punchline?

SARAH: To the business you wanted to see me about!

CHARLES: It's confidential. Could you ask him to remove his easel?

SARAH: Really, Charles!

CHARLES: I'm not having my affairs bandied around all the pissoirs from here to Kensington Palace.

SIR THOMAS: Dear Sarah, I will be forced to depart.

SARAH: If you depart I shall depart with you.

(*SARAH struggles to her feet.*)

CHARLES: Stage Management, Mrs Siddons' coach, if you please.

SARAH: I will expect a full apology, Charles.

(*MARIA enters. She dances whenever possible. She wears points and a three-quarters-length net skirt as though she has just performed "Swan Lake". She speaks with an exaggerated French accent.*)

MARIA: Mon cher!

SARAH: Maria!

MARIA: Beloved sister Sarah! With Sir Thomas!

CHARLES: Sarah is leaving.

MARIA: What is the matter?

SARAH: Your husband is insufferable.

CHARLES: Charming.

MARIA: And dear, dear sister, it is such a long time since I see you.

SARAH: Thank him for that.

CHARLES: Is the carriage there yet?

MARIA: I need the help – badly. The big sister advice. We have family problem.

SARAH: Charles, what have you been keeping from me?

CHARLES: Nothing.

MARIA: Nothing! We have the little girl who need the father's discipline. The father don't like discipline.

SARAH: Ah, he spoils her!

MARIA: In discipline he is the bad father.

CHARLES: Maria will you please shut up. The child has character. She must be allowed character. Now, Sarah, I will see you to your carriage. And I'll insult Sir Thomas a hundred times if that's necessary to get you there.

SARAH: No. Wait.

(*SARAH settles herself.*)

I want to sort this out. I am sure that Sir Thomas
understands that you are artistically temperamental.
What is the problem?

MARIA: Is Fanny, she break her mummy's heart with the
badness. He is in the theatre – working. All the time
I am struggling with the wretched girl. You must talk to
her. You can make her...

(*SARAH cuts MARIA short.*)

SARAH: Fetch her.

(*MARIA exits.*)

CHARLES: Really, Sarah, this is quite unnecessary, the
child...

SIR THOMAS: ... has character.

CHARLES: Precisely. She's the prettiest thing you ever saw.

SARAH: She's clearly got you twisted round her little
finger. Thomas, how do I look? I want to impress.

SIR THOMAS: A trifle more angst.

CHARLES: Don't be too hard on her!

SIR THOMAS: Magnificent! You'd terrorise a thousand tigers.

SARAH: And afterwards we'll talk about your business, Charles.

(*MARIA and the STAGE MANAGER can be heard calling FANNY.
MARIA enters. She shrugs. FANNY throws open the lid of a laundry basket.*)

FANNY: Hello.

(*There is general consternation.*)

SARAH: Arise child, out of that basket.

FANNY: Shan't.

MARIA: Your Aunt Sarah wish to talk to you. Go and curtsy.

FANNY: Shan't.

MARIA: You see!

SIR THOMAS: How old is she?

CHARLES: Six.

SIR THOMAS: Enchanting.

SARAH: Sh! Frances Anne Kemble!

(*SARAH becomes sorrowful. She strikes the Attitude.*)

Ah, Fanny, what are all these bad things I hear?

FANNY: Don't know.

SARAH: I am sad, Fanny, very, very sad.

SIR THOMAS: "I smell blood. I swear it."

FANNY: Aunt Sarah?

SARAH: Out of that hamper!

FANNY: Aunt Sarah, you got beautiful, beautiful eyes.

MARIA: Do as she say!

FANNY: Daddy, hasn't Aunt Sarah got beautiful eyes. Like… like…

SIR THOMAS: The eyes on a peacock's tail!

FANNY: Marshmallows.

MARIA: You see, you see. Nothing can make the difference to her. Last week she is the devil. I go with all the children for a walk. I having the baby and the little brother, and the supper to make when we come home, and the washing is out and is coming to rain. Have to be quick. Come quick I tell Fanny, come quick. No more chattering. Fanny she keep on. Come quick before the baby get cold, I tell her. No reason with this girl. Stick her chin like this; – "come when I want". Bloody minded. Slow as the oxen. Come fast! Feet go slow, slower. More I want, she… The anger inside me at this "won't come, won't come". Boiling up. The children must do as the mother say. Not Fanny, she run off. Like that – gone. I love her. I love her. Charles know I love her. Gone. Don't know where. No find. Look everywhere. No daughter. Tears all down the face, I am pulling hair out, I am crying, thinking my little girl gone for good, kidnapped, throat cut, dogs eat her up. I am hysteria. No stop crying. In the middle of the night message. You not believe this. Fanny is found, sleeping in the house of the sewing woman. She say she is running from home because the mother is a little bit cross. That child has heart of stone, ebony you say. What next? Punishment. Shut her in chicken shed, only give bread and water. She must learn. Yes? What she do? Sing! Sing night and day.

SARAH: Well what have you to say to that, Fanny?

FANNY: I was going to jump in the pond and get drowned. I was. Like the lady in the play.

SARAH: Kill yourself? That is very bad. Fanny, I hope you realise how bad that is?

CHARLES: We would cry so much if you were dead, Fanny.

FANNY: I would see you in heaven with the angels.

MARIA: Silly girl. The suicide not go to heaven, Fanny. They put suicide in ground at the crossroad with stake through the heart.

FANNY: Auntie, what is a suicide?

SARAH: A bad person that wants to kill themselves to make everyone that loves them sad. We love you, Fanny. We won't love you if you kill yourself because we'll know you don't love us. Do you pray child? Do you ask God to make you a good girl?

FANNY: Yes, but he makes me worse and worse.
(*FANNY starts to cry.*)

CHARLES: I can't stand her crying. You know I can't bear it, Maria. Please stop her.

MARIA: She will not listen to me.

SARAH: How if I tell you a story, Fanny? About my two daughters? You know what they did when they were your age? They went away to school. Yes, they did. I wanted them to be educated to marry a prince – if one should come along. So I found a school in a far away place where they speak French like your Mama, and they learn how to become like princesses.

FANNY: I want to be a princess.

SARAH: Well you will have to go to school in Paris. How will you like that?

CHARLES: I can't allow that.

SARAH: You asked for my advice.

CHARLES: I would never see my darling.

SARAH: Don't be so sentimental, Charles. Mrs Rowden's in Paris is just the place for her. And you can go and visit. After all we are considering the child's future. Her mother says she is out of control therefore she must be sent away to learn control. Mrs Rowden is a most religious woman, the education she offers is accordingly excellent.

She turns unruly little girls into comely maidens fit to marry into the very best society. And you do want her to marry well, don't you?

MARIA: Oh thank you, Sarah, thank you. We must pack.

(*MARIA drags FANNY off. FANNY breaks free to return to SARAH. She kisses her.*)

SARAH: We have to work so hard in this family to counteract the popular if puritan belief that classes actors along with marionettes and monkeys, and unless we do so, we can never hope to be accepted in the best society.

(*FANNY exits.*)

How I long for our profession to be accorded the respect it deserves. Now Charles, to the business you wanted to see me about.

CHARLES: This place.

SARAH: What? Dear old Covent Garden?

CHARLES: Dear old Covent Garden simply drinks money. Insatiable. I can't make ends meet. I've tried everything: Comedy, Tragedy, Opera, Pantomime, Dance, Spectacle. However well I do I never do well enough. Grimaldi, Young, Kean, have all worked for me. But I can't keep them; I can't pay them enough. Nothing is ever enough for Covent Garden. We've done melodramas, used naturalistic sets – real fountains, real chickens, real crap. No but – This production of *Romeo and Juliet* is destined for great things. Not ready yet, but when it is ready... I am a little worried by my Juliet. I've not been able to detect much real passion... I'm afraid I'll have to post-pone and briefly – I want you to fill the gap.

SIR THOMAS: Yes! Our beloved Mrs Siddons!

SARAH: The spirit is willing but the flesh is weak. I fear I could not sustain the Attitudes, and Juliet has that long speech at the end: –

"Farewell! God knows when we shall meet again.
I have a faint cold fear thrills through my veins,
That almost freezes up the heat of life!"

SIR THOMAS: She is eternal youth!

CHARLES: No, not Juliet. I will persevere with *Romeo and Juliet* while you do a new play. Old Lady Randolph in *The Douglas*.

SARAH: I have retired.

CHARLES: One night. One night would do it. The exclusive element, you see. I'm positive that your fans would pay royally to see you for one night only.

SIR THOMAS: We will pay gold and silver to see her. We will bring diamonds and rubies and pile them at her feet.

SARAH: Sir Thomas, we must go. Would be so kind as to help an old lady up?

SIR THOMAS: Dear lady!

(*SARAH gets to her feet. She is magnanimous.*)

SARAH: Charles, I believe in families. We should stand by one another and help when needed. Therefore I will do as you ask. Farewell.

CHARLES: Sarah, allow me to see you to your carriage.

SARAH: No. You must go to work.

(*SARAH waves to CHARLES and exits on SIR THOMAS' arm.*)

STAGE MANAGER: Stand by to continue rehearsals.

(*Rehearsals for "Romeo and Juliet" continue.*)

ACTOR: "I fear too early: for my mind misgives
Some consequence, yet hanging in the stars,
Shall bitterly begin his fearful date
With this night's revels."

(*MARIA enters. She dances. The ACTOR falters. CHARLES continues the lines. CHARLES glares at MARIA.*)

CHARLES: "...and expire the term..."

ACTOR: "...of a despised life closed in my breast,
By some vile forfeit of untimely death."

CHARLES: What is it my love? Can't you see I'm rehearsing?

MARIA: I will wait.

CHARLES: Continue! "But he that hath steerage –"

ACTOR: "But he that hath..."

CHARLES: Damn it, Maria. What is it?

MARIA: Oh beloved husband, be not cross. Our daughter is back.

CHARLES: (*Delighted.*) My little Fanny? Why didn't you tell me?

MARIA: Rehearsals!

CHARLES: We've finished for today chaps. Where is the little darling? Stage Management – pink champagne. Rose-petal pink for the girl. The prettiest...
(*To the ACTORS.*)
Join us for a glass, won't you? Wait till you see my daughter! She is a delight.

ACTOR: How long has she been away?

ACTRESS: As long as it took to get an education. Where is she?

CHARLES: Maria?

MARIA: Husband, be brave and promise not to show the disappointment.

CHARLES: Disappointment? What disappointment?

MARIA: (*Calls.*) Fanny!
(*FANNY enters.*)
Walk and show him how he waste the money. In the circle.
(*FANNY walks in a circle.*)
See! The deportment is diabolical. Who would know she have the father play the Shakespeare and the mother dance before the Prince Regent in the glass bell? She look like she come from the marriage made by the scrubbing floor woman and the man clean out horses.

FANNY: Mama!

MARIA: Is true.

CHARLES: Come here, my sweet! Wasn't there something about sending you away to elevate you from out of the ranks of the theatrical profession and into society. I don't remember deportment being mentioned in hushed tones – or any tones. Deportment is irrelevant.

MARIA: How can she go in society? If she is a slouch?

CHARLES: How was religion, Fanny? Did you receive a sound grounding in the Bible?

FANNY: A chapter of the Bible every day – off by heart. And more if we needed correction. Our copy books were simply stuffed with sermons. And we went to church three times on Sundays.

CHARLES: Stage Management, provide me with a Bible. And what else did they teach you?

FANNY: Arithmetic, French, Italian, Needlework, History, Dance... some acting.

MARIA: Some acting?

CHARLES: We stipulated no acting. Didn't we my love?

MARIA: No acting.

FANNY: I played Hermione in *Andromaque*. That's Racine, in French.

CHARLES: The language is immaterial.

MARIA: We should have the money back.

FANNY: No, no, Mama. Mrs Rowden said I wasn't any good.

CHARLES: No good! Who does she think she is? Twenty-eight members of my family are in the profession. Of course you were good.

(*The STAGE MANAGER hands CHARLES the Bible. CHARLES opens it at random.*)

We'll see how good an education in religion they gave you. Deuteronomy, Chapter 15, Verse 11. "For the poor..." Carry on Fanny.

FANNY: "For the poor..."

(*FANNY pauses. Then she reels off the rest of the verse.*)

"For the poor shall never cease out of the land of the Lord: therefore I command thee, saying thou shalt open thine hand unto thy brother, to the poor and to the needy in thy land. And if thy brother, an Hebrew man or an Hebrew woman, be sold unto thee, and serve thee six years; then in the seventh year thou shalt let him go free from thee, thou shalt not let him go away empty: thou shalt furnish him liberally out of thy flock, and out of thy floor, and out of thy wine press: of that wherewith the Lord God hath blessed thee thou shalt give unto him. And thou shalt remember that thou wast a bondsman in the land of Egypt."

(*CHARLES applauds.*)

CHARLES: She knows the Bible as though it was Shakespeare, doesn't she, my darling?

FANNY: Papa, Mrs Rowden says the poems of Lord Byron are unsuitable for a young girl, but I adore them. Papa can I read Lord Byron?

CHARLES: Unsuitable? A poet unsuitable? Isn't
　　Shakespeare a poet? They'll be saying he is unsuitable
　　next. Fanny, as you grow up, you will find that very
　　many people are afraid of the world of the imagination.
　　Don't you ever be afraid. And don't listen to people who
　　seek to contaminate with their own small-mindedness.
　　Go and read Lord Byron and to hell with the lot of them.
　　(*FANNY exits.*)
MARIA: The deportment. What about the deportment?
CHARLES: Any ideas?
ACTRESS: You can get an iron vest with a collar, and a bit
　　you tie round your waist. You have to wear it for at least
　　four hours a day. It works.
MARIA: Too slow.
ACTOR: Well, plenty of actors swear by the army. Bit of a
　　stupid suggestion, I know. It's the drilling, you see.
CHARLES: Maria?
MARIA: Yes, it is good. I like the drill sergeant.
CHARLES: Stage Management, find me a drill sergeant for
　　my daughter! Right, that's settled. Fanny is back. She's
　　educated, she's beautiful and as soon as she has
　　deportment, she will be perfect.
MARIA: I have to leave her with you, dear husband.
　　I must go to the country. Stage Management, my rods!
　　The carp are rising.
　　(*MARIA exits. Calling for FANNY as she goes.*)
　　Fanny, Fanny kiss Mama bye-bye.
　　(*FANNY is drilled across the back of the stage, during the following section.*)
CHARLES: And we must plow on with rehearsals. Romeo,
　　where are we up to?
ACTOR: "O, she doth teach the torches to burn bright!"
CHARLES: Ah!
ACTRESS: Can I say something?
CHARLES: Dear girl, speak.
ACTRESS: I don't want to be pushy. I do understand these
　　things take time. But we have been rehearsing for ages,
　　and so far I haven't done anything. When it comes to
　　Juliet's scenes we seem to pack up for the night even if it

is the middle of the day. You get toothache or something. And we never...

CHARLES: Dear girl...

ACTRESS: I'm not "dear girl". I'm playing Juliet. I know he is your understudy and you are rehearsing yourself into the play. But I'm not dear girl. I'm Juliet and I need some rehearsal time. I need help.

CHARLES: Help?

ACTRESS: Yes, help, help, help!

CHARLES: We'll come to your bits in good time.

ACTRESS: There isn't time. We should have opened years ago. If I'm not given time in which to rehearse, I'll leave.

CHARLES: I don't understand. Every day you see great acting. Can't you learn from that?

ACTRESS: No. They pay better at Drury Lane.

CHARLES: Drury Lane! What does that mean?

ACTRESS: It means that I'm leaving for Drury Lane because they care about actresses. They will give me more money – and more time.

(*The ACTRESS exits.*)

CHARLES: The bitch! Damn Drury Lane. Stab me in the vitals. They pay more so they get all the damn acts. No one cares about quality nowadays. The undercutting is worse than in a grocer's.

(*CHARLES watches FANNY drilling.*)

That's enough. Enough! She's not going into the bloody army. Fanny, come here my love and soothe your poor old father's brows. How is Lord Byron?

FANNY: Wonderful, Papa. I think he is just terrific.

"The Assyrian came down like a wolf from the fold,
And his cohorts were gleaming in purple and gold:
And the sheen of their spears were like stars in the sea,
And the blue wave rolls nightly on deep Galilee."

I keep thinking about what you said about imagination; it is terribly important, isn't it?

CHARLES: Naturally.

FANNY: More important than being like everyone else?

CHARLES: How do you mean?

FANNY: Respectable?

CHARLES: Damn respectability. Theatre has more to offer than mere convention. Remember that. Its heart is free.

FANNY: I've been thinking about what sort of person I want to be.

CHARLES: You are your own lovely person.

FANNY: No, Papa, I'm not lovely. I know what you want me to be. And I'm very grateful for my education, but I can't help what I've inherited from you. I've got an imagination and I want to be allowed to use it.

CHARLES: I won't have you going on the stage. Not unless I'm carted off to debtor's prison – which is more than likely. No, my darling, you are not going to have to earn your living. Someone is going to come along and love you for what you are... Then you will have a home and a family to take care of... Don't worry about the future. Besides you're still growing up; I had a letter from your Mama this morning, from the country. Your sister has a mild dose of smallpox. Your Mama thinks that this is a golden opportunity for you to catch it. These things are better over in adolescence. Your mother is a good example of someone who uses her imagination on behalf of her nearest and dearest. You see, there is a place for imagination in marriage.

FANNY: I can't get married, please don't ask me to.

CHARLES: Why on earth not?

FANNY: I know I wouldn't be a success as a wife.

(*Underneath this speech can be heard the same melody as was used at the beginning of the play.*)

I can't make myself happy so it would be senseless and stupid to think I could make anyone else happy. And then there would be children. Imagine having a mother like me! I'd be awful. I'd love them to distraction – and hate them too. I can't seem to stay on an even keel. I always seem to be stumbling over my emotions as though they were awkward pieces of furniture in a dark room. To be a good mother I'd have to learn to make sacrifices, wouldn't I? I'd try

but my temper would keep creeping out and it would
end up a disaster.

CHARLES: Enough. Enough!

FANNY: You know it's true. I don't want to be dependent on
you for the rest of my life. I won't ask to act, if you don't
want me to, I just want to use the part of me that feels
the most me. That's my imagination. You taught me how
important that was. I thought I could be a poet – or a
playwright – or both. I want to be a writer. I've written
one play already. It's historical – about Francis the First
– and it's in verse. Will you read it?

CHARLES: I have to thank Byron for this! Give me the play.

(*FANNY does so.*)

Now you must go to your Mama – or you will be too
late for the smallpox.

FANNY: Bye, Papa, I love you!

CHARLES: You never cease to amaze me! A play.

A whole play!

(*FANNY exits.*)

She has written a play! Now where were we?

ACTOR: Without a Juliet.

CHARLES: Stage Management.

(*CHARLES, once he has taken a cursory look at FANNY's play, gives
it to the STAGE MANAGER.*)

Take this and put it somewhere safe. Do you know
anyone who could play Juliet? Who is cheap? No,
I didn't say that. That's the wrong way round. We need
someone who can fill Covent Garden. Someone.
Something. A gimmick. Shakespeare performed as in
Shakespeare's time. Boys, rushes, tapestry. An all-male
cast. A boy as Juliet.

ACTOR: I can't do that.

CHARLES: What?

ACTOR: Make love to a boy.

CHARLES: What are imaginations for? Use your
imagination. No, I will... you can play Juliet.

ACTOR: What?

CHARLES: That way we save a salary. What's the matter with you? You're an actor, aren't you? You're behaving like a chorus girl. An actor transforms himself. Can't you face making love to me?

ACTOR: No, no. Not that. I don't think I'd be very good as Juliet.

CHARLES: Stage Management, take Romeo here up to the wardrobe and kit him up as Juliet. Think of yourself as a choir boy. You know how they outsing sopranos!

ACTOR: My voice has broken.

CHARLES: It's all in the mind. Get on with it.
(*The ACTOR exits. CHARLES is thoughtful. He gets out his text of "Romeo and Juliet" and reads.*)
"O, she doth teach the torches to burn bright!
It seems she hangs upon the cheek of night
As a rich jewel in an Ethiop's ear –
Beauty too rich for use, for earth too dear!
So shows a snowy dove trooping with the crows
As yonder lady o'er her fellow shows."
(*CHARLES tries out an Attitude. SARAH enters followed by SIR THOMAS.*)

SARAH: Prepare a feast! I come the bearer of bad news! Maria sends me to tell you.

CHARLES: Sarah, quickly, tell me.

SARAH: Charles, be prepared. Sit down. Stage Management, bring my brother a brandy. Sir Thomas, your handkerchief.

CHARLES: Sarah, please.

SARAH: Fanny has got smallpox.

CHARLES: That's good, isn't it? I sent her home to catch it.

SARAH: Maria misjudged. She thought it was a mild strain but Fanny... It's bad, Charles, very bad, not like Adelaide's at all. Charles, you must go at once.

CHARLES: Me?

SARAH: It's a bastard. You are her father. You will never forgive yourself if you aren't present at her death.

CHARLES: What? Die? She won't die.

SARAH: Suppose.

CHARLES: Suppose?

SARAH: You simply can't tell with these things. Remember my daughters? Two untimely deaths.

SIR THOMAS: Must have another handkerchief somewhere.

SARAH: You must go. And Maria needs your support. Poor darling Maria. We must go at once.

CHARLES: You go, Sarah. Tell them I'm coming. There are things here to sort out first. Tell them that I love them to distraction; I'll be with them as soon as I can.
(*SARAH turns to go.*)

SARAH: Men! Why can't they ever face up to their emotional responsibilities.

SIR THOMAS: Dear Sarah, allow me to escort you.

SARAH: You! You are such a sweetheart.
(*SARAH turns to CHARLES.*)
Hurry, Charles!
(*SARAH exits.*)

CHARLES: I will. Hurry!
(*CHARLES stands still. He goes back to what he was doing before SARAH's entrance.*)
"She doth teach the torches to burn bright."
(*CHARLES in the middle of an Attitude breaks down.*)
Not Fanny! Not Fanny. Dear little girl. God, dear God – not Fanny!
(*The ACTOR dressed as Juliet enters. He coughs to draw attention to himself. CHARLES turns and sees him. He laughs uproariously.*)

CHARLES: Good God, you look... You look...

ACTOR: (*Stiffly.*) Like what?

CHARLES: Judy. Punch and Judy. Sorry, sorry. Shouldn't have said that. A flower girl, market whore. No, no. I'm sorry. My daughter is at death's door. I'm scared. Dying.
(*CHARLES bursts into tears. The ACTOR comforts him, using the padding from his false breasts as a handkerchief.*)

ACTOR: I'm sorry.

CHARLES: I shouldn't say it, shouldn't. I adore her brothers and the little one, but she is my favourite. The best of the darling bunch.

ACTOR: Those that the gods love die young.

CHARLES: One toils night and day to earn a crust for one's family. The strategies I've been forced to dredge up in order to keep our small ship afloat. In the end nothing is enough. One's joy is snatched from one. Death with his scythe cuts down one's Benjamin in her prime. You must forgive me, I can't rehearse. I must go to her.

ACTOR: Shall I come with you?

CHARLES: Not dressed like that. Spare me, spare me. Oh ye gods – not my daughter!

(*MARIA enters followed by FANNY.*)

MARIA: Husband *voilà*!

CHARLES: Fanny!

MARIA: The flower has lost its looks but not its smell. Frances live, you see. But husband, we must be brave, the spot has mark the face. The complexion perfect, as the mountain hare on the glacier, like fresh water spring – is mud.

CHARLES: Fanny, Fanny, come to Papa. Damn the complexion. Thank God you are safe. Where's that handkerchief?

MARIA: Don't cry so much.

CHARLES: I never, never thought to see my darling again. Stage Management, champagne!

STAGE MANAGER: I'll see if there is any left.

CHARLES: Did you hear that, my love? We are almost out of champagne.

ACTOR: Mr Kemble, they've stuck bills of sale up on the outside of the theatre.

CHARLES: The bastards!

MARIA: *Espèce de crapaud.*

FANNY: Poor Papa.

CHARLES: They might have waited.

ACTOR: It's unbelievable.

CHARLES: We'll show them, we'll go down fighting.

ACTOR: Sir?

CHARLES: Here.

(*CHARLES hands the handkerchief back to the ACTOR.*)

Stuff these down your front again. On with the rehearsals! One last perfect performance before we're dragged screaming to the scrap heap.

MARIA: Charles! What is this, this fancy dress?
(*MARIA indicates the ACTOR.*)

CHARLES: Juliet, my darling. Doesn't he look wonderful? A peach. I am going to do my *Romeo and Juliet*, whatever it costs me. Our performance will live on in the history books. A theatrical legend.

MARIA: He is too old for Juliet. Is too beanstalk. Too old with beard. Too boxing muscle. Pantomime, husband. You want them talk about Juliet the dame? No, no. Is not good. Use the girl. Fanny is the innocent. She try. She save from death to play Juliet. Before her is great career.

FANNY: Mama!

CHARLES: We didn't educate the girl to play Juliet. We planned amazing things.

MARIA: So, but things not come out like in our head. Is all dreams. No marriage if there is the family disgrace. You want the husband in prison? The children beg in the street? Yes? The family of Fanny is the acting. Is the family business. When the ship go down all the family must pull the oar.

CHARLES: Do you think she can do it?

MARIA: If she have family talent.

CHARLES: We could try her out?

FANNY: Please, please let me. Papa?

CHARLES: No, no. It's impossible. I must play Romeo. I can just see the headlines; – "Actor Manager makes love to daughter!" I'm not risking a scandal like that.

MARIA: Hm is problem! You play Mercutio.

CHARLES: And give up Romeo? The whole production is based on my interpretation of Romeo.

MARIA: Then we lose Covent Garden. He can play Romeo like you want. Is good actor. She must play Juliet. I play Juliet mother. Yes, after twenty years. I come back to play the Lady Capulet.

CHARLES: I want to play Romeo.

MARIA: What is wrong with you husband? Screw loose?

CHARLES: I bow to your better judgement.

MARIA: Good.

CHARLES: Stage Management, present my compliments to Mrs Siddons, and ask her if she could find the time to attend my rehearsals. Tell her I require her to instruct my daughter, Miss Fanny Kemble, in the tragic role of Juliet.

STAGE MANAGER: Stand by for instructions given to Miss Fanny Kemble on the art of acting by Mrs Sarah Siddons.

(The cast exits. SARAH SIDDONS' arrival on stage should have as much pomp and ceremony as can be mustered. SIR THOMAS arrives first. He carries an easel, which he sets up.)

SIR THOMAS: The incomparable Mrs Sarah Siddons. She whose artistry is divine. I plan to sketch the incomparable Mrs Siddons as she addresses her niece, Miss Fanny Kemble, in the art of acting.

(The ACTOR appears. He has changed out of the Juliet costume.)

STAGE MANAGER: They are coming. They arrive!

(CHARLES enters followed by SARAH in a wheelchair.)

Mr Charles Kemble and Mrs Sarah Siddons.

(All bow.)

SARAH: Good morning!

(FANNY enters followed by MARIA, who carries a train that has been attached to FANNY's dress. They progress round the stage. FANNY curtsies to her aunt.)

SIR THOMAS: Miss Fanny Kemble with her mother and chaperone, Mrs Charles Kemble.

CHARLES: Fanny, I have invited your aunt here to talk to you about this venture that you are to undertake. Acting is a demanding art – and none knows this better than your aunt. Pray be seated everyone.

FANNY: Thank you, Papa.

CHARLES: Not you, Fanny.

FANNY: No, Papa.

SARAH: And what is it that you are about to undertake, Frances?

FANNY: (*Taken aback.*) Aunt Sarah, Papa has asked me to play Juliet – provided that I can act. I don't know if I can act.

SARAH: Act! And what pray do we mean by "act"?

FANNY: Um, going on stage and pretending to be someone we're not.

SARAH: And this being "someone we're not", is that what your father does for a living?

FANNY: (*Miserable.*) I suppose.

SARAH: Indulgence, child. Those that go on stage merely to be someone else are indulging themselves in childish games. Those that go on stage in order to participate in the art of the theatre are actors. Never forget the audience, child. In a theatre there are those on the stage and those in the auditorium, and the one cannot exist without the other, and together they make up the art of the theatre.

FANNY: Yes, Aunt.

SARAH: An actor doesn't pretend he is, he lives, made anew in the imagination of his audience.

FANNY: Yes, Aunt.

SARAH: And where does this rebirth happen, child?

FANNY: In a theatre.

SARAH: In the space between the player and the audience. The experience we call theatre is not rational or logical and therefore cannot be easily defined. It is a communication of feeling, and I believe this communication is a force for the good. Didn't Aristotle claim that theatre aimed at pleasure? Not frivolous pleasure but a deep-seated pleasure; where serious action is used to excite emotion in an audience with the intention of purging it and leaving the spectator strengthened. Theatre does not exist for the glorification of the actor but for the edification of humanity. Therefore we must approach acting seriously and give it due care and attention since it is our vocation.

FANNY: Yes, Aunt.

SARAH: Right. So first we have to absorb the part that
we have been given so that it becomes our own. And
since this part is the essence of the play, I have to
think about the play. When I have thought about the
part and absorbed the play, I then have to consider
how I will communicate what I have learnt to my
audience. The first theatre that I appeared in was the
Royal at Bath, there I managed to build a reputation.
Subsequently I was invited by Garrick to play at
Drury Lane. The Royal is a small theatre. Drury Lane
is large. I was foolish enough to think I could
survive at Drury Lane without altering my
performance, with the disastrous result that it was
five years before I had a second chance to play a
London theatre. During that time I worked on my
diction, my voice, my movement, costume, hair and
so forth – and, most importantly, on my Attitudes.
I was determined that when I had the opportunity to
play Drury Lane for a second time no one would be
able to ignore what I had to say.

SIR THOMAS: To have seen Mrs Siddons was an event in
anyone's life.

SARAH: Precisely. I made sure of that. I worked, I worked
damn hard. Your father is here to help you with voice.
Your mother will help with movement – and with
costume. I am here to supervise your Attitudes and to
take general charge of the acting – should you display an
ability. We will take Romeo and Juliet's first meeting.
I will lead you through it, and as I do so we will
discover the Attitudes so that when you come to do it on
your own you will be fully prepared, and we will be able
to judge whether you have ability or no.

FANNY: Aunt.

SARAH: Yes?

FANNY: I know what attitudes are, but – what are
Attitudes?

SARAH: An Attitude is an aid to the conveyance of
emotion – without which there would be no theatre.

We strike an Attitude on stage so that those right at the
back of the circle can see what we are feeling. It is not a
substitute for emotion, merely a vehicle. But what
vehicles they provide. Charles, Maria and you!
(*SARAH indicates the ACTOR.*)
Forgive me I don't know your name. Take up an
Attitude. Fanny, you are to name the emotion.
(*CHARLES, MARIA and the ACTOR all take up Attitudes.*)

FANNY: Oh yes! Yes!
(*FANNY approaches each in turn.*)
Mama, you look so happy, peaceful. Tranquil. Tranquillity.

MARIA: Is Tranquil Joy!
(*To the ACTOR.*)

FANNY: Are you acting? You look terrified. Terror.

ACTOR: Quite right.

FANNY: And Papa! Oh Papa, what have I done. I feel, I
feel guilty. Oh. You seem to suspect... Suspicion.
(*FANNY turns back to MRS SIDDONS, who immediately takes up
an Attitude.*)
Oh, Aunt! Rapture.

SARAH: Rapture. Excellent. Now, Fanny, what do you
know about the story of *Romeo and Juliet*?

FANNY: It's about love, lovers, I suppose.

SARAH: The power of Romantic Love. Have you ever been
in love, Fanny?

FANNY: I love Mama and Papa and brothers, John and
Henry, and Adelaide – and lots of other people.

SARAH: Stop! Please let us be more precise. Have you ever
felt a strong emotion for a member of the opposite sex?

FANNY: No. I love the poems of Lord Byron.

SARAH: As long as you love only the poems. It's clear to
me that you know nothing of love. We'll imagine that
what you feel for the poems of Lord Byron is somewhat
similar to what Romeo feels for his first lady love,
Rosalind. Juliet's feeling for Romeo you will have to
imagine. Dear Mr Siddons and I had a love like Romeo
and Juliet's. Love at first sight. A passionate desire for
unity both mentally and physically. Parents who were

opposed to the match. An elopement. Well, very nearly. Oh Fanny, we'll hope that one day you will find love – an enduring and romantic passion that brings joy to all the tiny details of life. However for the moment you will have to use your imagination. Romeo.

ACTOR: Yes, Mrs Siddons.

SARAH: Forgive me if I don't inquire into your romantic life. Tell Fanny, as Romeo, what you feel for Juliet at the start of this scene. Why are you propelled towards her as a moth to a flame?

ACTOR: I'm at the Capulets. They are giving a party. I'm not invited, in fact I know I could be killed, stabbed to death in a fight if they discover who I am. Therefore, I'm edgy. I'm also in love with Rosalind – which is why I've risked life and soul to be there. I'm looking for her. Trying to see her. Very anxious because she has just told me that she wants to be a nun. This is very bad news for me. And I don't expect her to be pleased to see me when I find her. It's all very risky. I see Juliet. It's as though my heart stops. I forget Rosalind on the instant. When my heart beats again I find I've given it to Juliet. I'm in love with a vision. She's not real. She can't be. I have to go up to her to see if she is real. I'm compelled to do this.

SARAH: Fanny, stand over here. (*To the ACTOR.*) What Attitude?

ACTOR: Reverence. This is almost a religious experience.

SARAH: Alright.

(*The ACTOR approaches Juliet.*)

Give him your hand. "If I profane..."

ACTOR: "If I profane with my unworthiest hand
This holy shrine, the gentle sin is this –
My lips, two blushing pilgrims, stand
To smooth that rough touch with a tender kiss."

SARAH: Juliet.

FANNY: "Good pilgrim, you do wrong your hand too much,
Which mannerly devotion shows in this.
For saints have hands that pilgrims' hands do touch,
And palm to palm is holy palmers' kiss."

SARAH: What do you feel?

FANNY: I... rather silly... embarrassed.

SARAH: I didn't mean what do you, Fanny, feel. What does Juliet feel? You have got to be attracted to this young man. I could be attracted to him. Love is universal. Love is life. Nothing to be embarrassed about.

FANNY: Sorry, Aunt.

SARAH: Have you thought what your Attitude might be?

FANNY: Suppressed anxiety.

SARAH: Anxious in case he doesn't like you?

FANNY: Yes, and excitement.

SARAH: Good. So your Attitude is led by your eyes. They are watching this man, carefully. Expectant. How are you going to show excitement?

FANNY: I'm going to feel it.

SARAH: Try control. Be stiff. Give him your hand, keep him at arm's length. What comes next?

ACTOR: "Have not saints lips, and holy palmers too?"

SARAH: What is he saying, Fanny?

FANNY: Something about lips.

SARAH: He is asking if he can kiss you. Well, can he?

FANNY: I...

SARAH: Not you, Fanny. Juliet. The lines. What does she say?

FANNY: "Ay, pilgrim, lips that they must use in prayer."

SARAH: So she says "no". Try it again.

FANNY: (*Negatively.*) "Ay, pilgrim, lips that they must use in prayer."

SARAH: No, no, no! She is saying "no" but meaning "yes". Whatever you do – don't put him off. Flirt with him. We must see this in her Attitude. I'll demonstrate. The Attitude should be one of eager expectation.
(*SARAH demonstrates with the suitable Attitude.*)
"Ay, pilgrim, lips that they must use in prayer."
Continue, young man.

ACTOR: "O, then, dear saint, let lips do what hands do! They pray: grant thou, lest faith turn to despair.

SARAH: Saints do not move, though grant for prayers' sake.

ACTOR: Then move not while my prayer's effect I take."

(*The ACTOR kisses SARAH.*)

SARAH: On the cheek.

(*The ACTOR corrects himself.*)

Thank you.

ACTOR: "Thus from my lips, by thine, my sin is purged.

SARAH: Then have my lips the sin that they have took.

ACTOR: Sin from my lips? Oh trespass sweetly urged!
Give me my sin again.

(*SARAH moves her head so that the ACTOR has to kiss her cheek. Once she has been kissed she reacts violently apparently almost fainting.*)

SARAH: You kiss by the book."

(*There is a flutter of applause from CHARLES, etc.*)

Do you see, child? The marking. The Attitudes have to
be clearly defined. Anxiety. Excitement. Flirtation.
Daring. Approval. All are there. They tell a story for the
audience to follow. Don't make it too complicated. Now
for an overall Attitude for the exchange. What do you
hope to show your audience?

FANNY: A girl talking to a man – for the first time.

SARAH: Exactly. Innocence. Show me Innocence.

(*FANNY does an Attitude for innocence. SARAH criticises.*)

Your hands a little more so.

(*SARAH rearranges FANNY.*)

And your eyes I fancy a trifle more open. One foot. That
will do. Now try the exchange for me using that as your
basic picture. Ready? Innocence.

(*FANNY takes the Attitude. The ACTOR approaches her again.*)

Anxiety.

ACTOR: "If I profane with my unworthiest hand
This holy shrine, the gentle sin is this –
My lips, two blushing pilgrims, stand
To smooth that rough touch with a tender kiss.

FANNY: Good pilgrim, you do wrong your hand too much,
Which mannerly devotion shows in this.
For saints have hands that pilgrims' hands do touch,
And palm to palm is holy palmers' kiss.

ACTOR: Have not saints lips, and holy palmers too?"

SARAH: Flirtation.

FANNY: "Ay, pilgrim, lips that they must use in prayer.

ACTOR: O, then, dear saint, let lips do what hands do!
They pray: grant thou, lest faith turn to despair.

FANNY: Saints do not move, though grant for prayers' sake.

ACTOR: Then move not while my prayer's effect I take.
(*The ACTOR kisses FANNY.*)

FANNY: You kiss by the book."
(*Delighted, FANNY does an Attitude. SARAH, CHARLES and MARIA thrill to it. They huddle together to discuss.*)

CHARLES: Enough. Dear Sarah, what a teacher!

SARAH: What a pupil!
(*FANNY addresses the ACTOR.*)

FANNY: You are wonderful.

ACTOR: Don't fall in love with me just because I'm playing Romeo. Don't confuse acting with life. I've been working for this for years. I want this part. I want to play the romantic hero. It's my ambition... and I'm good at it. I hope I will make hundreds of young women in that audience fall in love with me... Not you. I don't want to be in love. We've got a job to do. The reality is that I am an actor. I put my energy into acting. I don't have any emotion left for a private life. I do have a private life. I can't avoid it. I have a small room and a cat. The cat is as close to me as anyone is going to get. So don't.

SARAH: We are decided. She'll do.

SIR THOMAS: Wonderful creature.

SARAH: Maria, I hope you are going to keep her closely chaperoned.

MARIA: I am the Mama!

SARAH: Charles, when Fanny has performed Juliet, then we will be able to see if she succeeds me. Enough. The bones are tired. Dear niece fail me not! Come, Sir Thomas!

SIR THOMAS: Dear Sarah, forgive me just this once. The light is perfect. Allow me a moment.

SARAH: (*Sadly.*) Adieu, Sir Thomas!
(*SARAH turns to the ACTOR.*)

Young man!

ACTOR: Mrs Siddons!

(*The ACTOR bows and offers SARAH his arm. She takes it. They exit.*)

CHARLES: Don't make him late for performance, Sarah. Maria, costume!

MARIA: I fetch.

(*MARIA exits. CHARLES turns to FANNY. The ACTRESS enters. She carries a bunch of flowers.*)

ACTRESS: I've come to wish Fanny good luck.

CHARLES: You'll have to wait your turn. Fanny, I will see you on stage.

FANNY: Are you ever nervous, Papa?

CHARLES: Always! It's a big undertaking but you will be alright. Good luck, my darling!

(*CHARLES exits.*)

ACTRESS: Fanny.

(*The ACTRESS hands FANNY the flowers. MARIA enters to organise the STAGE MANAGER to set a screen for FANNY to change behind.*)

Good luck!

MARIA: (*To the ACTRESS.*) Good, you here. You help? We dress Fanny.

(*MARIA and the ACTRESS help FANNY change.*)

Come child. The costume has much thinking go into it. Must help you, Fanny. This is ball gown like the young ladies in society wear. I want to be simple, simple. We not pretend to be in Italian, in the heavy brocade. Pull my darling down, with the heavy, heavy. I say no to wig too. You are to be a modern girl, in modern costume for party.

ACTRESS: And it's white.

MARIA: Course it's white – for the innocence.

FANNY: I'm so scared. I'm terrified. I'll be sick.

MARIA: White. You look sick. We give the cheeks some rouge.

SIR THOMAS: You mustn't worry, Fanny. You're very beautiful. Your character and actions are marvellous to watch. I fell in love with Sarah Siddons when I was thirteen. I painted her then, and I've never tired of painting her. I tell you Fanny, you have the same

quality. Other artists find their inspiration in landscapes. They paint the clouds, the wind ruffling the leaves of a tree, light and shade. I find mine in the sheer variety of expression that flows across your aunt's face. And her amazing capacity to share her feelings with the world. One moment we see a storm at sea, the next the tropical splendour, the luxurious tranquillity of a coral reef. I was captivated by her daughters... All that is in the past. Now I want... I only pray that I will live long enough to paint you.

(*SIR THOMAS is convulsed by a fit of coughing. FANNY runs to him.*)

FANNY: Sir Thomas!

MARIA: Stage Management. Help Sir Thomas to bed. He is ill.

SIR THOMAS: (*In between coughs.*) Be... good, Fanny, be great. Be true. I love you, remember that!

FANNY: Oh, Sir Thomas, thank you. Thank you. Please don't die.

(*SIR THOMAS dies.*)

MARIA: Fanny, beware the men that fall dead at the feet. This man has the picture of Aunt Siddons in every corner of his brain. Is scrambled with Siddons. Now he say he love you! *La petite* Siddons. Is good he die. You must live – not like Sarah's daughters. Break the heart for love of him. You must go on stage, show the audience the actress – Miss Fanny Kemble. Come to me my little one. I pin flower on bodice for luck.

(*MARIA pins a flower on FANNY's bodice and exits, taking the ACTRESS with her. FANNY stands alone. SIR THOMAS lies dead at her feet.*)

FANNY: I can't.

(*SARAH SIDDONS enters to one side.*)

SARAH: (*In a stage whisper.*) Don't forget the Attitude.

(*FANNY goes onto the balcony. She takes an Attitude.*)

FANNY: "Ay, me!

(*The ACTOR appears.*)

ACTOR: She speaks!

O, speak again, bright angel! – For thou art

As glorious to this night, being o'er my head,
As a winged messenger of heaven
When he bestrides the lazy puffing clouds
And sails upon the bosom of the air.

FANNY: O Romeo, Romeo! Wherefore art thou Romeo?
Deny your father and refuse thy name,
Or if thou wilt not, be but sworn my love,
And I'll no longer be a Capulet.

ACTOR: Shall I hear more or speak at this?

FANNY: What's in a name? That which we call a rose
By any other name would smell as sweet;
So Romeo would, were he not Romeo called,
Retain that dear perfection which he owes
Without that title. Romeo, doff thy name,
And for thy name, which is no part of thee,
Take all myself!"

(*Lights go off balcony onto main area. CHARLES comes on very agitated. He is pacing. The STAGE MANAGER enters. He carries a newspaper. CHARLES sees the paper. He responds to it in an exaggerated fashion. Taking an extreme Attitude. The rest of the cast follow the STAGE MANAGER, with the exception of FANNY.*)

CHARLES: Must be, must be, must be – success! Read it.

(*CHARLES drops his Attitude. SIR THOMAS rises from his death bed to read the review.*)

SIR THOMAS: "The first act did not close till our fears
for Miss Kemble's success had been dispelled. The
looks of every actor conveyed that they were
electrified by the influence of new tried genius and
were collecting emotions as they watched its
development swell its triumph with fresh
acclamations. We dreamt for a while of being able to
analyse her acting, and to fix in our memory the first
moment of its power and grace, but her Attitudes
glided into each other so harmoniously that we at last
gave over enumerating how often she seemed a study
to the painter's eye, and a vision to the poet's heart."

CHARLES: "A study to the painter's eye and a vision to the
poet's heart."

MARIA: Read it again.

SIR THOMAS: "The first act did not close..."

CHARLES: No, no. Get me a drink. Champagne!

(*SIR THOMAS returns to his dead state.*)

We must celebrate. They love her. They love her. She'll make our fortune!

MARIA: Many, many men fall in love with our daughter. Is like fly in summer. The whole world want to meet the actress, our daughter – she was the hell to bring up – Miss Frances Anne Kemble!

(*The lights go up on the balcony. FANNY appears. Her acting is less mannered, more sincere.*)

FANNY: "What man art thou, that thus bescreened in night, So stumblest on my counsel?

ACTOR: By a name
I know not how to tell thee who I am.
My name, dear saint, is hateful to myself
Because it is an enemy to thee:
Had I it written, I would tear the word.

FANNY: My ears have not yet drunk a hundred words
Of thy tongue's uttering, yet I know the sound.
Art thou not Romeo, and a Montague?

ACTOR: Neither, fair maid, if either thee dislike."

(*The lights go down on the balcony and up on the stage. CHARLES addresses the STAGE MANAGER.*)

CHARLES: Get those two down off their sodding balcony and while you're at it remove Sir Thomas and arrange a funeral straightaway; I must talk to them.

(*The STAGE MANAGER exits.*)

ACTRESS: Blood, I smell blood. I swear it.

(*FANNY and the ACTOR enter.*)

CHARLES: You took your time.

ACTOR: I'm sorry.

CHARLES: You do realise, you two, that Romeo and Juliet are the biggest lovers of all time?

FANNY: Yes, Papa.

CHARLES: One would never have guessed. What are you thinking of? Where are your imaginations? This, this low key, naturalistic rubbish can't give your

audience an idea. It's garbage. You are not having a romance, are you?

MARIA: Passion. Must be passion. Not like boy, girl... Like talking how's the weather? So English. Italian. Must be Italian. Not nice English, dead as a churchyard passion. The audience freeze up, catch cold. Chilly churchyard.

CHARLES: Exactly.

ACTOR: Sorry.

CHARLES: Sorry! I'm sorry. Sorry is no earthy good. Can you explain what you are trying to do with him?

ACTOR: Trying to make him younger, I suppose.

CHARLES: What's age got to do with anything? Big emotion. Forget age. We want to be overwhelmed by his emotion. Romeo can no more prevent himself from making love to Juliet than breathe! Make love like that will you, damn it!

FANNY: Don't blame him. I suggested that perhaps we should relate more.

CHARLES: Relate? What about your audience? Stab me in the vitals. Relate to them. We want them to have wet dreams at the back of the circle. At the back! We can't have the provinces dozing in the stalls. And that's my best prognosis. Give them half a chance and they'll set fire to the theatre – if they don't bury you in bad eggs and soft fruit first.

FANNY: Tour? Are we going?

CHARLES: We open next week – in Bath.

FANNY: How wonderful!

(*FANNY addresses the ACTOR.*)

Won't that be wonderful?

CHARLES: He's not part of the deal. These provincial theatres have their own Romeos. He stays behind in London. We'll see how you manage without your romantic support.

FANNY: I can't...

ACTOR: Miss Kemble, I've really enjoyed working with you. It has been one of the most unforgettable experiences of my life.

FANNY: (*She speaks directly to the ACTOR. We should infer that she is commenting on their relationship.*)
"Thou know'st the mask of night is on my face,
Else would a maiden blush bepaint my cheek
Dost thou love me?
O gentle Romeo,
If thou dost love, pronounce it faithfully:"
CHARLES: Fanny, remember the back stalls.
(*FANNY attempts to pull herself together and projects.*)
FANNY: "Or if thou think'st I am too quickly won,
I'll frown, and be perverse, and say thee nay,
So thou wilt woo; but else not for the world.
In truth, fair Montague, I am too fond;"
(*FANNY exits in tears.*)
(*The ACTOR is left alone on the stage. He doesn't do a lot. MARIA enters with her fishing rods.*)
MARIA: Young man, do you want to learn to fish? Yes?
(*The ACTOR sighs.*)
Fanny writes letters to her Mama. Everywhere she go, Liverpool, Edinburgh, she is the success. Fêted, she is famous, roll out the carpet. She go to ball, dinner, party, weekend in the country house. Everywhere. This acting is a good thing for Fanny. She has chance to make the big society marriage.
(*Enter STAGE MANAGER.*)
STAGE MANAGER: Stand by to welcome the returning touring party.
(*CHARLES bursts onto the stage; he crosses to embrace MARIA.*)
CHARLES: She's a star. A chip of the old block; a true Kemble. Stage Management! Ice buckets! She's a little gold mine! Have you replenished the champagne?
(*CHARLES and MARIA exit.*)
ACTOR: What about the Romeos?
FANNY: Acting disgusts me! I wish I had not put foot on stage. Night after night the same old melodrama. I hate it. I loathe the Attitudes.
(*FANNY demonstrates.*)
We cheapen everything on stage. Orange groves become

crude backcloths. I use rouge to denote passion. It's all a pretence. A hideous, hideous make-believe.

ACTOR: And Shakespeare?

FANNY: Especially Shakespeare. His poetry is so, so majestic. It carries you away, on great wings, into the world of your imagination.

ACTOR: So?

FANNY: So?

ACTOR: Are you going to go on with it? This painted existence?

FANNY: I have to earn a living.

ACTOR: I was thinking... we could...

FANNY: My ambition is to buy a cottage in the country. You know the sort with hollyhocks... I want to be free to write. I've always wanted to be a writer.

ACTOR: ... marry. What about marriage?

FANNY: What a farce.

ACTOR: I meant, will you...

FANNY: That's impossible now.

ACTOR: Oh.

FANNY: I'll never marry.

ACTOR: Love. What about love?

FANNY: Dead and gone. I met a man. I can't tell you who he is because... because... We fell in love. Really, really deeply. I know he loves me. But he can't marry me because I'm an actress. His family, his position... all that bosh. I'm not good enough.

(*FANNY sobs in the ACTOR's arms. A rowdy crowd can be heard outside. CHARLES enters.*)

CHARLES: Stage Management. What's that damn racket?

STAGE MANAGER: It's the election, sir. Real life.

CHARLES: Damn politics! Always ruins the theatre.

(*CHARLES paces. MARIA enters and hovers anxiously.*)

MARIA: America?

CHARLES: America is the only solution.

MARIA: I don't want you in the America.

CHARLES: You shall have a new fishing rod. You've never tried salmon fishing. Now you can. You can holiday in Scotland. It will be good for the children's health.

MARIA: I don't want the salmon. I want the husband and the daughter.
(*FANNY draws attention to her grief. She does a small, rather feeble Attitude: heartbroken.*)
FANNY: "So we'll go no more a-roving so late into the night.
Though the heart be still a-roving and the moon be still as bright."
ACTOR: Byron!
MARIA: Come, Fanny, come to Mama.
FANNY: Why is love so awful?
MARIA: Fanny, Fanny, don't be like this. Forget the English aristocracy. We have *la guillotine* in France for this, this snob.
CHARLES: New York, Boston, Philadelphia... a tour of America will solve our finances forever. Fanny, you must come with me. We are a team. Acting together we will conquer the world.
FANNY: Nothing matters to me any longer. I don't care if I live or die.
MARIA: The heart will mend.
FANNY: I can't go to America with a broken heart.
MARIA: You are the great actress now, Fanny. You have duties. You bring joy in America. Is your destiny.
(*The lights go up on the balcony. SARAH enters on one side of the stage in a ghost-like fashion.*)
MARIA: Listen. The new continent is waiting!
CHARLES: Come, Fanny, America!
ACTOR: "Oh! wilt thou leave me so unsatisfied?"
ACTRESS: There will be a new Romeo.
SARAH: Anxiety! Fear! Take the Attitude, Fanny. Look for what it is that you have lost. Stay true to yourself.
(*FANNY stands on the balcony.*)
FANNY: "Hist! Romeo, hist! O, for a falconer's voice,
To lure this tassel-gentle back again!
Bondage is hoarse, and may not speak aloud.
Else would I tear the cave where Echo lies
And make her airy tongue more hoarse than mine
With repetition of my Romeo!

Romeo, wherefore art thou, Romeo?"
(*PIERCE BUTLER enters below.*)

PIERCE: It is my soul that calls upon my name.
How silver-sweet sound lovers' tongue by night,
Like softest music to attending ears!'
I, Pierce Mease Butler, do ask thee, Frances Anne
Kemble, to be my lawful wedded wife!
Blackout.

ACT TWO

The living room of a country house in the north of America. The wooden walls are painted white. Besides the domestic furniture, chairs, a table etc., an area is furnished for PIERCE's office. There are three entrances. One to the attic room upstairs. Another to the bedroom shared by PIERCE and FANNY. And finally a door to the outside world. During the course of the act the house and all its furniture move to a plantation in Georgia. Ideally this move should be achieved by the floor of the living room splitting into three sections, revealing three mud-filled ditches.

The STAGE MANAGER / SERVANT enters to check the set. The STAGE MANAGER exits.

STAGE MANAGER: (*Off.*) Go Act Two!

 (*PIERCE enters through the front door. He carries FANNY.*)

PIERCE: I've done it. I've done it. I've done it. I've got you all to myself! The fantastic, amazing, beautiful Miss Fanny Kemble is my wife! Plain Mrs Pierce Butler!

FANNY: The adoring Mrs Pierce Butler.

PIERCE: I, Pierce Butler, must be the smartest, best looking, not to mention the sexiest man alive.

FANNY: I can't do "adoring" while you're carrying me!

PIERCE: I, like Atlas, shall carry you where-so-ever you will.

 (*PIERCE puts FANNY down.*)

After you've done adoring.

 (*FANNY does "adoring"*)

FANNY: Adoring!

PIERCE: That's it. That's it. I'm the happiest man alive. You know I love you, Mrs Butler, I'm head over tails, crazily, madly, passionately, jealously in love with you. I tell you if you hadn't said yes I'd have gone into that there theatre pistols blazing. I'd have shot every man jack of them; Romeo, Mercutio, Benvolio, Paris, Friar Lawrence. You drove me to the end of my tether. You are a terrible woman.

FANNY: Oh, Pierce, how unkind. After everything I have sacrificed for you.

PIERCE: Oh, so you made sacrifices for me, did you?
It was a sacrifice marrying me, I suppose!

FANNY: I've only given up my career, my family and my
country for you, don't let that worry you.

PIERCE: Fanny, seriously, I can't think what possessed you
to marry me. I'm the luckiest man alive.
(*FANNY and PIERCE kiss.*)
Come on, let me show you the house. It is all yours now.
I hope you like it. I had the furniture made, and the
upholstery upholstered, all for you.

FANNY: I want to look. Oh lovely, lovely. I love it.
(*PIERCE indicates the door to the bedroom.*)

PIERCE: What do you think is in there?

FANNY: Dining room? Kitchen? Conservatory?

PIERCE: No.

FANNY: Breakfast room?

PIERCE: Nope.

FANNY: Why, Pierce, it must be the bedroom!

PIERCE: What? What did you say? I didn't quite catch it.
(*FANNY runs away from PIERCE. She stops to do the Attitude
for modesty.*)

FANNY: Modesty!
No, no, Pierce, do not make me say it again.

PIERCE: Repeat yourself or that room will remain
forever locked.

FANNY: Modesty forbids!
(*PIERCE flings open the bedroom door. He sweeps FANNY up and
carries her into the bedroom. The lights change. The STAGE
MANAGER / SERVANT enters carrying a tray with a pot of coffee
and two cups. He places these on the table.*)

STAGE MANAGER: Breakfast is served.
(*The STAGE MANAGER exits. PIERCE enters from the bedroom.*)

PIERCE: Coffee, Fanny!
(*FANNY enters from the bedroom; she goes to pour the coffee.*)
Happy?

FANNY: Perfectly.

PIERCE: Coffee to your satisfaction?

FANNY: Delicious.

PIERCE: It's quite something to make Mrs Butler happy. Tell me Fanny, why did you marry me?

FANNY: (*Laughs.*) Why did I marry you?

PIERCE: Tell me, tell me. I want an answer.

FANNY: I can't answer that. Because I love you?

PIERCE: And?

FANNY: Because you are handsome and rich. I suppose it's rich and handsome. Do you suppose rich is the important part?

PIERCE: Seriously.

FANNY: I suppose I'd have gone on quite happily acting, earning a living, being with Papa. Then you came along and suddenly it wasn't enough. It's as though you were... there's my imagination... and now you. You balance things. When I met you I found I needed the security of having another person. Someone I could love and admire. I suppose I was lonely with only my imagination for company. And I was always trying to imagine how it would be, but to know another person. You are all I want. In the future I shall use my imagination to help me think of ways of making you happy.

PIERCE: That will do. Now the office. I want to show you around. We'll start with my office, if you agree.

(*PIERCE opens the office door. We see a huge desk full of cubby-holes and little drawers, and a bookcase.*)

Come on, come here. Look, this is it. My hole puncher, my pens in my horn holder, inks, silver inkwell. Look my blotting paper. My rubber, ruler. My ledgers. One for household matters another for business. Drawers for letters, bills, important papers – my will for instance. And this drawer; I've emptied this drawer just for you. It will contain everything appertaining to you. What else? Paper clips!

FANNY: It's a beautiful desk. So grand.

PIERCE: Books within easy reach. Books on law. A dictionary, the Bible...

FANNY: Pierce.

PIERCE: My love?

FANNY: I need a desk.

PIERCE: My darling, whatever for? Look I'll show you how I've provided for you.

(*PIERCE and FANNY return to the main room.*)

This is your chair. Special chair with a footstool for those pretty feet, and a sewing table. Do you like the inlaid top? You shall have everything you need for your needlework. I've ordered a piano for you too – and a proper music stool, you'll be able to keep your music in it. And letter writing! You're right I hadn't thought of that. How would you like one of those charming little writing boxes? They become desks. You have them on your knee and open them. Portable desks. And, and your poetry. You'll need a book for that.

FANNY: But Pierce, you know I've undertaken to prepare my diaries for publication.

PIERCE: No Fanny, damn it. I'm a private person and so ought you to be – now.

FANNY: I will be. But I need a desk. I'm contracted. I think you'll find them interesting. They contain all my first experiences of America. I think of them as an English woman's view of matters American. And I love America – almost as much as I love you. Don't worry, I won't cause us any problems.

PIERCE: All the same it seems a bit much to me. I hope you'll let me see it before publication.

FANNY: Of course, my dearest. My only worry about it is that it'll be too bland. After all we do want it to sell. Actually I'm going to use the opportunity to propagate some of Dr Channing's ideas against slavery. I am appalled that slavery still exists here in the land of the free. That is a plus on England's side. We managed to get it abolished.

PIERCE: I'll have to see that part. Everything you write against slavery.

FANNY: Why?

PIERCE: And I must ask you to abide by my judgement.

FANNY: Your judgement? Don't you trust mine?

PIERCE: My darling, of course I trust your judgement but this is something you don't understand. People feel very strongly about this. You could drag us into a storm.

FANNY: Slavery is a great wrong. Surely we can take some controversy over something we care about. Anyway I don't see why there should be controversy. What I want to do is say how I feel and leave it at that.

PIERCE: If only things were that simple.

FANNY: No one minds an opinion.

PIERCE: This is an emotional issue.

FANNY: I must have the right to express my opinion.

PIERCE: Write what you want, darling. But let me have the final say.

FANNY: How can I?

PIERCE: People are quite likely to set fire to the house.

FANNY: But Pierce, they won't.

PIERCE: Oh won't they? You're my wife, remember. Not an eccentric English actress. You belong here, with me and people will hold me responsible for what you write.

FANNY: Don't you share my feelings?

PIERCE: About slavery? You simplify everything, make it all black and white.

FANNY: That's not funny.

PIERCE: I don't mean it to be. I don't think you fully understand the issues involved. Look Fanny, there is something you ought to know before we go any further. You know my family is well-off? What I earn as a lawyer only accounts for a small part of it. And I, we, stand to inherit from my aunt. She owns a plantation in the South.

FANNY: Explain.

PIERCE: I am. Some of our wealth comes from slavery.

FANNY: How could you marry me without telling me this?

PIERCE: I didn't think it was important.

FANNY: I loathe slavery, Pierce. No person should own another.

PIERCE: You see! You don't understand.

FANNY: I understand. I'm not a child; you have compromised
me. I find I'm involved with something that disgusts me.
How can I stay?

PIERCE: You're blowing this up – out of proportion.

FANNY: I won't be part of something I hate. Don't you
understand? I must leave. Go back to England. Let me
get out of here.

PIERCE: Fanny you can't do this.
(*FANNY does an Attitude: horror!*)

FANNY: Horror!
(*FANNY exits.*)

PIERCE: Damn!
(*PIERCE goes to the door as if to follow FANNY. He stops and turns.*)
Bring me some whisky!
(*The STAGE MANAGER/SERVANT brings a bottle of whisky and a
glass on a tray. PIERCE crosses and drinks. The lights fade. PIERCE
falls asleep. FANNY returns. PIERCE wakes. They look at each other.
FANNY crosses to the bedroom and locks herself in. PIERCE goes to the
bedroom and bangs on the door.*)
Fanny, Fanny – forgive!

FANNY: (*Shouts.*) I couldn't find a hotel. I'm leaving in
the morning.

PIERCE: Damn.
(*PIERCE sits and lights a cigar. The bedroom door opens. FANNY
stands on the threshold.*)

FANNY: I'm sorry.

PIERCE: I must ask you to trust my judgement.

FANNY: That means I can't write about slavery?

PIERCE: You must allow me to judge what is right.

FANNY: I must do what I think is right.

PIERCE: Go back to bed.

FANNY: Come with me.

PIERCE: No.

FANNY: Aren't my principles important?

PIERCE: I would have thought our marriage was important.
(*FANNY exits slamming the door.*)
If that's how you want it.
(*PIERCE doesn't move. After a pause the bedroom door opens. FANNY
enters. PIERCE ignores her. FANNY carries a bundle of papers.*)

She crosses to the fire and puts them in. PIERCE becomes aware of what she is doing.)

What the hell are you doing?

FANNY: Burning everything that I've written on slavery – since that's what you want. I won't include any of it in my book.

(FANNY does an Attitude: resignation.)

Resignation!

(FANNY exits. PIERCE leaps to his feet. He follows FANNY into the bedroom.)

PIERCE: My darling, my darling. You are the most wonderful, marvellous, amazing woman alive!

(The bedroom door shuts. The STAGE MANAGER / SERVANT enters and removes the whisky bottle, replacing it with a tray of breakfast things. The lights change. A BABY is heard crying. A woman sings an Irish lullaby. FANNY enters. She crosses to the table.)

FANNY: (*Calls.*) Breakfast!

(MARGERY appears; she carries BABY FAN, and holds SALLY by the hand. SALLY lets go of her hand and runs to FANNY.)

SALLY: Mummy, Mummy, Mummy, look what the fairies gave me for my tooth.

FANNY: Good morning. Hello, my precious. A silver button!

MARGERY: The wee folk were desperate for that tooth.

SALLY: Has baby had breakfast?

FANNY: Not yet. You go and get your daddy. Here, I'll take Fan.

(FANNY takes the BABY and settles down to feed her. MARGERY pours coffee, etc.)

MARGERY: I dreamt of home. My mother was feeding the pig and my little brother was spinning his top on the pig's back. It was smooth as marble, and the top went round and round.

FANNY: Have you made up your mind about America?

MARGERY: I don't feel the homesickness so much when I tell Sally the stories my mother would tell me. It seems like I'm back home in our kitchen. Then I feel as though my family are with me and home isn't so far away.

(As MARGERY prepares the cradle for the BABY she sings.)

FANNY: (*To the BABY.*) When I look at you, I wish I were
 home too, I wish they could see you. You never saw
 anything as beautiful as you. When you're grown maybe
 we'll take you.
 (*SALLY drags PIERCE on.*)
PIERCE: Where's my breakfast?
FANNY: Pierce, this babe is such a perfect mixture of you
 and me, things can only go well for her here.
SALLY: Mummy, aren't I mixture?
FANNY: Of course you are, my darling.
PIERCE: Mrs Butler and her children! The best sight in the
 morning. The best sight at midday and the best at night!
 How can a man be so lucky?
MARGERY: Sir, there's a letter for you that says it's
 important.
 (*PIERCE takes the letter.*)
FANNY: I think we're finished.
 (*MARGERY takes the BABY.*)
 Time for your breakfast, Sally.
PIERCE: What is the perfect family going to do today?
 Maybe they'll plan their rose garden. Oh!
FANNY: Pierce?
PIERCE: My aunt has died.
FANNY: My poor Pierce.
PIERCE: This means that my brother and I inherit.
FANNY: Of course.
MARGERY: That sounds grand.
 (*The scene changes throughout the following dialogue. As it does so we
 become aware of the melody sung at the beginning of the play.*)
PIERCE: It's a responsibility – and a challenge. My
 grandfather was Irish like yourself. He was a Major in
 the English army until he fell in love with an heiress
 from South Carolina. They married and settled on the
 Altamaha Delta. It was wild then, untouched – virgin
 forest and swamp. Grandfather built up the plantations
 until they were the most successful down south. He was
 an amazing old man. Tough as old boots.
MARGERY: Where's the Altamaha Delta?

FANNY: Georgia.

PIERCE: Cotton, is what he grew. There was a market then
for cotton but we make more profit from rice now. We
have between six and seven hundred slaves on the
plantations. That's a lot of mouths to feed.

FANNY: Sell them. At least your half. Surely your brother
would buy them?

PIERCE: And how do you imagine we'd live?

FANNY: But you're a lawyer.

PIERCE: We've been through this. I couldn't earn enough –
not for our requirements. You want trips to England, and
a new house... besides, this is the girl's inheritance.

FANNY: If I went back on the stage I could earn enough,
I think I could earn a decent living, for all of us.

PIERCE: Decent! The stage?

FANNY: But Pierce?

PIERCE: I'm sorry but the theatre is hardly respectable let
alone decent. It's not the sort of environment that we want
our daughters mixed up in. I'm sorry to have to hurt your
feelings but when I married you I ignored convention.
I love you – I wanted above all to marry you. But – hell,
Fanny, you must understand that for our daughters' sake
we need to preserve our position in society.

FANNY: I don't care about society.

PIERCE: I do. Besides, do you think I'm the sort of man
that could live on my wife's earnings?

FANNY: Why can't you?

PIERCE: Why can't I? Fanny! Everyone would laugh
for starters.

FANNY: This is hell. I should leave, I should leave.

PIERCE: Why don't you then?

FANNY: I love you.

> (*The scene change is now complete. FANNY and PIERCE are now on
> the plantation. MR KING, the HEADMAN, JO, PSYCHE and the
> SERVANT/STAGE MANAGER enter. We recognise that they have
> been singing the melody.*)

PIERCE: (*Introduces the slaves to FANNY.*) These, Fanny, are
some of my people, my slaves. I hope you'll meet them

all in our time here. This is Mr King, our overseer.
I hope you will appreciate that I am now responsible
for the slaves' welfare as well as our own. You are new
to them. They want to welcome you as my wife. Their
new mistress. It's their right, Fanny. They've been
looking forward to this moment for years. So smile Mrs
Butler. Even without knowing you they love you, and
they look up to you. Let them shake your hands, and
touch you. See how much pleasure they get from seeing
you. You are making them happy just by being here.
You don't have to act or anything, they'll give you their
love, free – for nothing.

PSYCHE: Wherefore Missus cry?

FANNY: I cry because... because I love you all. My heart
aches, it bleeds for you. I want you to know that I don't
hold with slavery...

PIERCE: Fanny, they won't understand. You'll have to learn
how to talk to them. Talking about slavery can only
make them unhappy. It is simply not fair to make them
dissatisfied with a system they can't change. I feel I've
taken a terrible risk in bringing you here, but I felt it
was important that you should see slavery for yourself.
I feel that if you learn about it at first hand then you'll
understand that in the end it is a necessity. And that it
isn't as bad as you think; a good master can provide his
slaves with a very decent sort of life.

FANNY: Tell me what I can do to help them.

PIERCE: Understand that they are not like us. Watch them,
and you'll see that they come from an inferior race.

FANNY: Please, don't ask me to agree with you.

PIERCE: Keep an open mind and you will see that I'm right.

FANNY: Pierce, how can I?

PIERCE: It's all in the Bible. You should know that these
are the sons of Canaan.

FANNY: Please, Pierce.

PIERCE: It's true. They are Ham's descendants. The Bible
tells us how Ham saw his father naked, against Noah's
wish, so Noah cursed him on his deathbed, saying that

his sons would be the sons of Canaan and be condemned
to serve the sons of Shem and Japheth for ever.

FANNY: But the New Testament says that we are all equal
in the eyes of God.

PIERCE: Dear Fanny, I can accept that you have a different
point of view at present, but I am confident that you will
come to see the justice of what I'm saying. I need your
support while we're down here. Trust me.

FANNY: Yes, Pierce.

(*FANNY does the Attitude for acceptance.*)

Acceptance.

PIERCE: Thank you, my love. You! Jo! See if you can
find a boat for Missus to travel on down the river. We
must make sure she is entertained while she's with us.
I want you to show her the scenery; the wild beauties
of the Altamaha.

(*PIERCE addresses the SERVANT/STAGE MANAGER.*)

You, make sure the children's nurse has everything she wants.

(*PIERCE addresses the HEADMAN and others.*)

You, come to my office. You fetch the luggage from
the boat.

(*All exit with the exception of FANNY, MARGERY and SALLY.*)

FANNY: Dear God. Please help me. Help me to show my
husband how wrong he is.

MARGERY: Madam, Madam. How I laughed. I must tell
you. You know I was out with the children, and you
know how the darkies swarm round you like they was
bees round a jam pot. "Missus", she calls me. "Missus!"
Seems they think master has two wives!

FANNY: I don't suppose they've ever seen a white servant.

MARGERY: There's always bosses and servants. Same as
there's always rich and poor. There's poverty back home
to make you weep.

FANNY: Maybe, but at least they have their freedom.

MARGERY: Freedom, you call it? When you're forever
pregnant with a drunken pig for a husband? I'm telling
you, you wouldn't feel free.

FANNY: You would be free.

MARGERY: Most women wouldn't know what you were
talking about.

FANNY: But Margery, they would be free.

MARGERY: Madam, they've made our Sally a swing. She
wants you to watch her.

(*A swing has been set up for SALLY. MARGERY goes to push her.
FANNY turns to watch.*)

FANNY: (*To herself.*) If I could, I would be away from
here. I would, I would go. But I can't, so therefore
I must learn everything I can about slavery – and to
be married to the owner of slaves is a huge
responsibility. I'll try and do what I can to help them.
To see our little Sally with an army of willing people
ready to do anything, absolutely anything to please
her, can't be good for her. It's lovely to have a
swing... but to have all this power over them!
Morally it would be far better to be a slave. Better to
stand in the market place and have people prod you,
bid for you and to think themselves capable of
buying you, far better than to be the person buying
another human being.

(*FANNY moves towards where PIERCE sits at his desk. He looks up
as she approaches.*)

PIERCE: How did you spend today, my love?

FANNY: I went for a walk.

(*The HEADMAN, JACK joins FANNY and walks beside her.*)

FANNY: I decided to visit the rice mill.

PIERCE: Ah, that engine is a good investment.

(*JACK and FANNY move off to relive the day.*)

JACK: Steam engine, Missus. Thirty horse power.

PIERCE: Our neighbours all send their rice to be threshed
here, so it pays for itself.

FANNY: And what's that?

JACK: Cook's shop. There the old woman cooks food for
all us.

FANNY: What does she cook? What do you eat?

JACK: Corn, grits that Massa buy.

FANNY: Everyone eats the same?

JACK: No, no Missus. Four slave settlements on island. One
settlement one cook. And Missus, infirmary for sick people.

FANNY: No one cooks in their huts?

JACK: No time for cooking. All the time for working – sun
come up, sun go down. Working. Missus, you see
blacksmith shop, and cooper shop?

FANNY: What do they do?

JACK: Make everything Massa want.

FANNY: Oh, like in an English village. Our villages are
almost self-sufficient.

JACK: Village? Slave where you come from, Missus?

FANNY: It's not the same.

JACK: Us slave make all things. We make dikes. Missus see
all fields with dikes. No dikes water come in, come every
place – no village.

FANNY: I am reminded of the pyramids.

JACK: Missus?

FANNY: Great tombs in Egypt, Jack, that were built with
slave labour. These plantations are amazing man-made
structures like the tombs.

JACK: Tomb?

FANNY: A burial place, Jack, far away.

JACK: We have burial place, Missus – way in the swamp.
(*JACK goes to lift a plank. FANNY moves to help him. JACK becomes
almost angry.*)
Let alone, Missus. What you want to lift wood? There
plenty nigger to do that!

FANNY: (*To herself.*) We continue along the dike. It runs
straight ahead. On one side a poisonous-looking swamp
separates it from the low-lying rice fields, each divided
with monotonous regularity from the others, by other
dikes, so the whole resembles a chessboard; on the other
side of our dike flows the river. We pass patches of
unclaimed forest. There huge Cypress trees grow out of
the exquisite undergrowth. A most beautiful species of
ivy clings to the lower branches. It glitters as though
varnished. The undergrowth contains every shade of
green imaginable, and every shaped leaf. Dark-coloured

Oak, Magnolia Bay, Wild Myrtle, Magnolia Gloriflora
and spiked Palmetto creepers on which a mocking bird
sits – and swings. Jack, this is all so beautiful!

JACK: Beautiful. Missus say so.

FANNY: The birds are wonderful. We've been living in
Philadelphia where they shoot everything – even the
Robins.

JACK: We no have gun for shooting.

FANNY: Such a pity. All these land and water fowl: duck,
partridge, snipe, goose, turkey. They are so good to eat.

JACK: Can make trap. Trap bird. Massa have gun.

FANNY: Yes.

JACK: Missus ask Massa slave can keep pig?

FANNY: Aren't you ever given meat?

JACK: (*Scared.*) Missus tell Massa Jack good nigger.
(*FANNY moves back to PIERCE. Their table is being prepared
for a meal.*)

FANNY: I think their diet should include meat. Pigs would
do very well here.

PIERCE: We don't like them keeping pigs. It's unnecessary
– they have enough food. Having a pig would amount to
owning property and that will only cause trouble.
(*The SERVANT brings food to the table.*)
Come and eat.
(*FANNY and PIERCE go to the table. JACK, JO and PSYCHE
stand at a distance watching.*)

FANNY: I don't think I can eat.

SLAVES: Missy eat, good food Missy. Missus must eat.
(*FANNY does the Attitude for grief.*)

FANNY: Grief!
(*PIERCE ignores her and eats.*)
I walked through the first village today.

PIERCE: I hope you noticed how decent the huts are.

FANNY: Two families to a hut, with moss for bedding. They
looked like sheds for animals.

PIERCE: Be fair.

FANNY: With an open sewer running down the back. These
people give us their health and labour for nothing.

PIERCE: Nothing? Is having a roof over your head and
 food, nothing? They wouldn't appreciate anything more.
FANNY: There are no beds in the infirmary either. They
 have to lie on the floor on a few filthy blankets, no
 pillows. Those that can, huddle on a bench in front of a
 fire that's pathetic. The windows are all boarded up to
 keep any draughts out. No one has given the place any
 thought. None at all.
PIERCE: You've upset yourself.
FANNY: I wish I could upset you.
PIERCE: What can I do to improve the infirmary?
FANNY: Oh Pierce, they should have beds, and clean
 blankets, and pillows. Glass in the windows. Most
 importantly they should be shown how to keep clean.
 The babies look as if they are never washed, with their
 heads all wrapped in cloths. I thought if I could give
 each mother a small coin for keeping her baby clean...
PIERCE: Good idea. You can help me improve things.
 Things were much worse before I took over. You know
 the women used to do the same work as the men? Come
 on, Fanny, let's not quarrel. We agree really.
 (*FANNY starts to eat.*)
FANNY: This fish deserves to be served displayed on a bed
 of parsley, on the finest porcelain, at the best dinner
 parties. Candlelight and champagne. Nothing is too good
 for it. It's the best fish I've ever tasted.
PIERCE: Good enough for a poem in its honour?
FANNY: To the white mullet of the Altamaha river – the
 heavenliest creature to use fins!
 (*PIERCE goes and fetches a little box.*)
 What's in it?
PIERCE: (*Opening the box.*) Be careful!
 (*PIERCE hands FANNY the box. She looks inside and shrieks,
 dropping the box.*)
FANNY: A centipede!
PIERCE: I took hours catching the thing.
FANNY: You know I can't bear them.
PIERCE: It was in our bed.

FANNY: I hate that. I hunt for them every night.

PIERCE: Thought I'd save you the trouble. Aren't you pleased?

FANNY: Oh Pierce!

PIERCE: Don't you like creepy-crawly things in your bed?

FANNY: I've never seen such horrid things. I'm sure they are poisonous.

PIERCE: Poor Fanny.

(*They kiss.*)

Come, I've de-centipeded the bed. Let's use it.

(*FANNY and PIERCE exit. The lights change. PIERCE re-enters.*)

PIERCE: Work! Jo.

(*JO enters.*)

You've got that boat to take Missus on the river?

(*FANNY enters.*)

Here we are, my darling. Jo is waiting to take you on the river.

FANNY: Thank you, thank you.

(*FANNY crosses to JO. PIERCE heads for his desk. The boat appears.*)

Jo, now we must use our imaginations and give the boat a name.

JO: Massa give Missus boat. He say it got name – The Dolphin. You want me teach Missus row Dolphin?

FANNY: Please Jo, but after you've shown me the river.

(*JO and FANNY get in the boat. JO rows.*)

JO: Jo work hard come know how the river is. River here don't want to be known. She hide herself. Much river hide in land. Land coming in this river, little pieces of land come in all the time. River go round this way, go that. Land can come down try to cross river. River big, no cross, make plenty little streams. Mud in them streams, dirty mud. Jo be clever not get stuck in mud. We get stuck in mud all we can do is wait for water, tide come up, lift Dolphin, set her free.

FANNY: What's that over there?

JO: Maybe root. Tree root. Maybe. Jo no go close. Maybe clever alligator. He say he is tree but he waiting to open mouth. Jo know clever critter, keep Missus safe.

FANNY: Jo, don't you ever want, don't you ever dream of being free?

JO: What for Jo want for to be free, Missus? Ain't no use Jo saying he want to be free, no use Jo think that freedom thing. Missus ask Jo. Missus want to be Jo friend. Missus Massa wife. I no want to think of freedom. No want to cause trouble. No want Missus go Massa, tell Massa Jo think bad thoughts. Massa think Jo bad slave. I no bad slave.

FANNY: No Jo, you're good. A good slave.

JO: That freedom thing cause pain in chest, won't go away. Why I want what I not have? Missus, I want pain? Because pain going to get in Jo's heart, get Jo's heart dead. No good thing.

FANNY: Jo, Jo, look! That sunset. Oh look at that pageant of fiery rays, growing from that bed of orange. And those golden clouds, the edges are too bright to look at. And those scattered wreaths of faintest, rosy bloom... Amber streaks with pale green lakes in between...

(FANNY and JO get out of the boat. The boat goes off.)

JO: Missus like picture?

(The HEADMAN, JACK, comes on with PSYCHE. He ties her up in preparation for a flogging. FANNY watches. She is horrified. She does the Attitude for disgust.)

FANNY: Disgust!

(The HEADMAN starts to whip PSYCHE.)

Stop.

HEADMAN: I've got to give her a flogging.

FANNY: You've given her enough.

HEADMAN: Twelve lashings is what a driver can give a slave. I headman, I can give three times more that. And I been told give this one one good lashing.

FANNY: Give me that whip – now!

(The HEADMAN gives FANNY the whip. PIERCE leaves his desk and joins them. He is followed by MR KING.)

PIERCE: What's the matter?

FANNY: This woman is being beaten.

KING: Mrs Butler, I'm sorry. Sights like these ain't for the delicate temperament of a lady. It's very regrettable that you should have come along.

FANNY: I'm glad I came along. At least I've put an end to it.

KING: Mrs Butler, I must ask for the whip back. My headman was only doing as he was told.

PIERCE: Fanny, the whip.

FANNY: Promise me he won't use it.

PIERCE: I can't do that.

KING: Flogging's something that happens almost every day on a plantation. One of the facts of life here. My headman does a good job, I can vouch for him. You see Mrs Butler, they understand a good flogging. There's no other way of reasoning with some of them. This slave here was shamming sick. I can tell when a slave is sick and when she shamming, she's still to learn that.

PIERCE: You see, Fanny. Mr King understands them in a way we can't hope to.

FANNY: This system is so foul, I don't blame a slave for shamming sick.

KING: It may surprise you to learn Mrs Butler, that I hate slavery with all my heart.

(*FANNY does the Attitude for surprise.*)

FANNY: Surprise!

KING: They call it the peculiar institution. Peculiar because it ain't an institution. Ain't no laws to protect the slave. He's here for his master to do what he wants with. And that's your fault, Mrs Butler, if I may say so. England's fault.

FANNY: How can it be?

PIERCE: Mr King!

FANNY: I want to know.

KING: You're English, ain't you? Afore you got to marrying Mr Butler?

FANNY: We've abolished slavery.

KING: Don't know about that but what we got here is what you give us, worse than cholera.

FANNY: How can it be?

KING: Sure is a sickness you give us, you started it off. When the slave was brought from Africa, weren't we part of England? A colony? Wasn't it the English that set up the plantations to grow their crops? And they brought in slaves as cheap labour. And we all know the profits were huge.

FANNY: But that was before Independence.

KING: I know that. We kicked you out but the sickness you left lived on in our blood like poison. You seen any whites working down here? Like your nurse? That's something you won't see. Work is something the slaves do. They'd prefer to starve afore they do what the slave does. You see a poor white is sick with slavery, a stinking rotten creature.

FANNY: Then you should abolish slavery like we have.

KING: That's my point, Mrs Butler. The English left the slave with as many rights as the common horse.

FANNY: What do you mean?

KING: Mr Butler, you can explain it better than I can.

PIERCE: The legal system in England never acknowledged slavery, so the slave never had any rights. When we got Independence nothing changed. A slave does not exist in law. They've nothing to protect them.

KING: Hypocrisy is a terrible thing, Mrs Butler. Don't know where you are with it. But I can tell you this – you won't get rid of slavery, not while a healthy negro can fetch a thousand dollars in the Charleston market.

FANNY: Money. Why does everything come down to money – pounds, shillings, pence?

KING: Dollars.

PIERCE: It's the way the world works, my love.

FANNY: But other things are more important. Things inside your head, for instance. Wouldn't the slaves' lives be better if they could read and write? I don't understand why it is illegal to teach them. I can't imagine my life without books. Wouldn't reading help them? They don't seem to be allowed anything – not even religion.

PIERCE: I think religion would do them a power of good.

KING: Church going is as good a way as any of spending
 your spare time.

FANNY: Then we should be allowed to have a church.

KING: Education is another matter entirely. I ain't in
 favour of that. There is no way that an educated slave
 can be a happy one. Remember, Mrs Butler, we've
 seven hundred negroes out there, and only us two white
 families down here. Don't want them to get edgy.
 I think we all understand what education for the slaves
 would mean. That's something else we learnt from the
 early traders. You got to do everything in your power
 to keep your slaves from being discontented. You gotta
 wipe out their past, wipe out their language, wipe out
 their customs, break up their family ties. It's called
 being cruel to be kind. Like gelding a horse. You don't
 want it to know what it ain't never going to get. If you
 give a slave education then all that work is undone.
 Might as well set fire to your house, and tie your wife
 and children to the bedstead. Ain't nothing going to
 stop a slave with education. I'll say goodnight now, Mrs
 Butler. Nice talking to you.
 (*KING exits.*)

PIERCE: He knows what he is talking about. Painful,
 I know.

FANNY: Pierce, it's dreadful.

PIERCE: It must be so difficult for you to understand. Why
 don't you visit some of our neighbours, see how they
 treat their slaves? You'll see that things aren't so bad
 here. I try hard to be fair, and to make their lives easier,
 but you've still got to have discipline. And they respect
 you for that. Fanny, don't try to remake the world. There
 is not a whole lot that we can do for the negro 'cept take
 our duty seriously, and I value some of the
 improvements you've made. It's good to see them take
 trouble to keep themselves clean. Come to bed.
 Tomorrow is another day.
 (*FANNY and PIERCE exit to the bedroom. The lights change. The
 SERVANT enters to clear the table and set breakfast. PSYCHE comes*

downstairs carrying the BABY. She is followed by SALLY and MARGERY. MARGERY sings. PSYCHE goes to put the BABY in the cradle. FANNY enters.)

FANNY: Good morning. Morning, my treasure.

SALLY: I want a story. I want a story.

MARGERY: I want doesn't get.

SALLY: Mummy, Margery won't tell me a story.

FANNY: And why's that?

MARGERY: She said "I want a story", and I said "I want doesn't get".

FANNY: So, what do you say, Sally?

SALLY: Please, Margery, please tell me a story.

FANNY: Yes, please, Margery. Let's have one of your wonderful stories while we have breakfast, and Psyche can listen while she rocks the cradle. You'd like a story, wouldn't you, Psyche?

SALLY: Psyche, Psyche, tell story.

PSYCHE: Me no have story, little Missus.

FANNY: Psyche? Psyche, you're crying. What on earth is the matter?

PSYCHE: Me no crying, Missus. Me happy nigger.
(PSYCHE attempts a smile.)
See smiling, Missus!
(FANNY looks at MARGERY. She raises her eyebrows.)

MARGERY: She wants to know who owns her.

FANNY: Mr Butler, surely.

MARGERY: It seems she belongs to Mr King. Now he is leaving she doesn't know if he is going to take her and her children with him. If he does she'll be separated for ever from her husband and the rest of her family.

FANNY: Oh Psyche, can't you ask?
(PIERCE enters from the bedroom.)

PIERCE: Morning, Margery. Where's my little one?

SALLY: Daddy, Daddy, we're going to have a story!

FANNY: Wait, Sally, wait. I've got to ask Daddy something.

PIERCE: Quickly then.

FANNY: Margery says that Psyche doesn't belong to you?

PIERCE: No, she belongs to Mr King. Now can we have our story?

FANNY: Does that mean he'll take her with him?

PSYCHE: Psyche smiling, Massa, Psyche smiling!

PIERCE: We must ask him. King!

(*MR KING enters.*)

Morning, Mr King. We've a question to ask you. Do you intend to take Psyche with you when you go? We're not keen to lose an excellent under-nurse.

KING: Well you don't have to worry. I'm expecting the work down South to be tougher and Psyche has two babies to look after, so I've sold her to your new overseer.

FANNY: That's wonderful, isn't it, Psyche? Go on, go and tell Jo.

(*PSYCHE exits.*)

PIERCE: Sally, you best take Margery somewhere away from us grown-ups if you want that story.

(*MARGERY takes SALLY off.*)

FANNY: Coffee, Mr King?

PIERCE: It is going to be a huge wrench for you leaving Georgia.

KING: I've lived here all my life. Still, I'll be my own boss and much as I like working for you, Mr Butler, that will be a sweet thing.

PIERCE: I'll be sad to see you go. 1 don't know what we would have done without your help here. Particularly when my aunt was still alive. I'd like to give you something to remember us by.

(*PSYCHE and JO enter.*)

FANNY: What is it, Psyche?

PSYCHE: Jo want to thank Massa King.

PIERCE: Ah, Jo, we were talking about you.

JO: Massa?

PIERCE: Mr King, I was talking about giving you something as a parting gift. I can't think of anything better than a good slave so I'm going to give you Jo.

KING: That's very generous of you.

PIERCE: Jo, you belong to Mr King now.

JO: Massa?

PIERCE: You're to go with Mr King.

JO: Massa! No!

PIERCE: Don't make a fuss. You're a good slave and Mr King will be glad to have you. Hasn't he looked after you well all this time?

JO: Jo live here, Massa. No send Jo from wife, children, mother... Jo no go away.

PIERCE: I said – don't make a fuss.

FANNY: Pierce! You can't separate a man from his wife because it suits you.

PIERCE: This is none of your business, Fanny.

JO: Jo no go. Jo die, Massa, Jo dead. Massa no! Please Massa, please.

PIERCE: This is absurd, I can't take something back that I've just given as a present. No, Jo, you'll have to go.

JO: Jo kill Jo. Jo dead.

(*JO exits wildly. PSYCHE goes down on her knees sobbing.*)

PIERCE: Good God! Go on Psyche, after him. Get.

PSYCHE: Please, Massa, please. Psyche good nigger!

PIERCE: Out! Git!

(*PSYCHE exits.*)

PIERCE: Sorry about that, Mr King. I'm sure he'll calm down. I'm afraid I was a bit ham-fisted.

KING: Mr Butler, I sure appreciate you wanting to give me a present, but I'm afraid I'm going to have to refuse this one. He ain't no darn use less he comes willingly. I don't mean no offence now.

PIERCE: Damn it. Damn the fellow for being so awkward!

FANNY: Awkward! Pierce, at least Mr King acknowledges Jo's feelings.

KING: Slaves ain't got no use for feelings, Mrs Butler. I meant that man has an unstable temperament. I can't use a man that's not reliable.

PIERCE: If you took him with you, you could put him with another woman. Sure he's a good breeder.

KING: If it's alright with you, Mr Butler, I don't want the bother of a temperamental slave.

FANNY: He loves his wife and children. That's not
 temperamental; that's admirable.

KING: In white folks, yes, Madam. But marriage isn't for
 slaves. They don't look after their little uns, we do that.
 Love ain't a word I'd choose to use in conjunction with
 the negro.

FANNY: How can you know that?

PIERCE: Mr King means they don't understand
 relationships the way we do.

FANNY: I don't understand this.

PIERCE: You and I love one another but that's way beyond
 them. They are like animals.

FANNY: Explain to me if you will, explain all the half-caste
 children on this estate? Mr King, where do all the children
 with strange pale skins come from? I am not blind, Pierce.
 I hope you've thanked Mr King for adding to our
 livestock. If you must give him another human being
 perhaps you should give him one he's sired. After all in
 any other society they would belong to him naturally. Or
 perhaps he's worried about their temperaments?

PIERCE: Fanny, stop it. Forgive my wife, Mr King. She's
 become overwrought.

KING: Mrs Butler.

 (*MR KING bows and leaves.*)

PIERCE: I'll join you. Fanny, I'm warning you. I'm
 warning you. You've gone too far!

FANNY: Too far? I'm only speaking the truth. Mr King
 went too far when he... it's preposterous, Pierce. You,
 neither of you, will recognise relationships between
 slaves. They're people like us. Aren't they? If they're
 good enough for Mr King to have children by...
 Or doesn't he recognise his children as people either?
 Are they animals too? At least animals care for
 their offspring.

PIERCE: I'm not excusing him, Fanny. Men are different
 from women. Can you understand that?

FANNY: What I understand is that Mr King says one thing
 and does another.

PIERCE: Between them, Mr King and his father have run this estate for thirty-seven years; they've kept the plantations going. Always done a good job. My grandfather trusted them. I can overlook a few slips. To call him an animal is impertinent. Damn you, damn you!

FANNY: I'm glad you're angry.

PIERCE: Don't torment me.

FANNY: You ask an awful lot from me. In fact, you ask the impossible. I can't sit round and watch innocent lives being ruined through, through thoughtlessness. When you do something like that, something cruel, I don't believe you think. I don't believe you want to hurt them. You just refuse to see what you're doing.

PIERCE: I see alright. I look at you now, and I remember you the way you were when I first saw you, playing Juliet. So young and fragile, dressed in white like a spray of flowers. We were destroyed when you died, it was as though we'd lost our youth; innocence had left the world. Grown men stood in the aisles with tears pouring down their cheeks. I knew then I had to marry you. I had to keep that freshness with me forever. I never thought you were going to be so damned right. Why must you be so right all the time? You're worse than a schoolteacher. Why can't you be happy? We should be happy. Isn't our marriage important?

FANNY: Of course it is, Pierce – but so are theirs.

PIERCE: I hate it when we quarrel.

FANNY: So do I.

PIERCE: Tell me you love me.

FANNY: Pierce, it's this place. Let's go away. I can't bear what it is doing to us.

PIERCE: It's only till the end of the season. By that time I'll have got this new overseer worked in. You won't ever have to come back. I promise you that. Now, I must go and soothe Mr King down.

FANNY: Please don't give him a slave.

PIERCE: If I find one without a family to think of, will that do, Fanny?

FANNY: I wish I could make you understand how much
I hate slavery. This is so difficult for me, Pierce. I want
you to be better than me. I want to look up to you.
I believe you to have more principal than me, more
knowledge, that you are altogether a better person. But
when I watch you going round this estate, doing your
work – being with them I... I can't admire. I'm frightened.
I can't love the man I see smoking, standing idle while a
gang of pregnant women hoe his fields. Please help me.
Try to see that they are people like us and they should
have rights like ours. You know how I am when I am with
child. Imagine that I'm one of them.

PIERCE: I can't. They are not, they will never be, the same.

FANNY: It seems to me that you have fallen off the pedestal
I put you on.

PIERCE: No, Fanny, don't say that.

FANNY: It hurts.

PIERCE: I have to go.

(*PIERCE exits.*)

FANNY: "Farewell! God knows when we shall meet again.
I have a faint cold fear thrills through my veins,
That almost freezes up the heat of life:
I'll call him back to comfort me."

(*FANNY strikes an Attitude.*)

Pierce!

(*MARGERY enters with PSYCHE.*)

MARGERY: Are you alright, Madam?

FANNY: I'm practising a new Attitude: impotent rage.

MARGERY: Madam?

FANNY: "What should he do here?"

MARGERY: Madam, Psyche wants another word.

FANNY: Psyche, you don't have to thank me.

(*FANNY crosses to hug PSYCHE.*)

PSYCHE: Psyche thank Missus.

FANNY: I only did what I had to.

PSYCHE: Want ask Missus ask Massa buy Psyche from new
man. He go anyone time, take poor Psyche. Massa buy
Psyche. Psyche stay with Jo all time.

FANNY: Alright, Psyche. I must think.

PSYCHE: Thank Missus. Missus good Missus.

FANNY: Margery, will you fetch my jewellery box?

> (*PSYCHE exits and MARGERY goes to the bedroom returning with the box.*)

> Jewels are the only things I have of any value. And these are things that Pierce gave me.

MARGERY: They're beautiful.

FANNY: (*As she puts jewels on.*) Margery, could you go and find that new overseer. I want to know what he wants for Psyche.

MARGERY: Yes, Madam, but those jewels...

FANNY: Please go.

> (*MARGERY exits and FANNY admires her jewels in a mirror. PIERCE enters.*)

PIERCE: I'm glad to see we're dressing for dinner.

FANNY: (*Jumps.*) Pierce!

PIERCE: Why else would you be wearing your jewels?

FANNY: Oh Pierce, these are the most precious things I have bar you and the children. But they wouldn't shine so much if I didn't use them when I could. Pierce, I want to buy Psyche.

PIERCE: She's not for sale.

FANNY: But she must be, he must sell her to me.

PIERCE: I thought you would want her so I bought her from him.

> (*FANNY strikes an Attitude for love.*)

FANNY: Love. All those unkind things I said. Pierce can you forgive me?

PIERCE: Things are so difficult, if only you would understand.

FANNY: Forgive me?

PIERCE: You are my dearest wife. Still I have to speak to you.

FANNY: I'm listening.

PIERCE: You show those jewels up. So beautiful, Fanny. Please don't listen to any more petitions. Block your ears, go out of the room, do what every you must, but don't listen.

FANNY: Don't listen?

PIERCE: We've tried that and it's failed. The more you listen the more difficult things become. The slaves can tell you anything and you'll believe them. They tell you stories, Fanny, tales.

FANNY: I don't just believe them; but I do believe the evidence of my own eyes.

PIERCE: Honestly, Fanny, my life has been hell these last few weeks. They'll tell you anything to get your sympathy. Our marriage doesn't stand a chance against this avalanche of, of requests. I won't say lies. "Missus do this. Missus do that. Please, please, Missus!" You must believe that I have their interests at heart. I do what I can. I care.

FANNY: You must allow me to do what I can.

PIERCE: Yes, they do. They do lie to you, Fanny. You're so gullible. They use you. I can't expect you to see that but I can try to protect you. What we understand as the truth has no meaning for them.

FANNY: I have to do something. My heart breaks...

PIERCE: Not the heart breaks!

FANNY: But...

PIERCE: Save that for the stage.

FANNY: Try to imagine what it must be like for them.

PIERCE: Imagine any damn thing you like! You're an actress, Fanny, you are trained to use your imagination in the theatre, on stage. There's no place for all this feverish imagining in real life. I've got to run this place – and run this place I will with or without your help.

FANNY: I am helping.

PIERCE: You're making my job practically impossible. Dramatising everything, the whole damn time. You can't help it. It's in your blood.

FANNY: I'm not dramatising everything.

PIERCE: Oh aren't you?

FANNY: And I'm proud of my inheritance.

PIERCE: Go on make a scene, make me feel like a worm. I've attacked the precious family.

FANNY: Of course I'm proud of my inheritance, Pierce. But imagination is not just something you use in the theatre.

Everyone should use their imaginations. Mine helps me to see your slaves as people. They are people whether you like it or not. Laugh at my imagination. At least I've got one. Yours has grown old, rusty, creaky because you don't use it. It hurts sometimes to imagine, to try to imagine what things are like for other people.

PIERCE: For other people, yes.

FANNY: They are like us. You can't pretend they're not human. Your grandfather has taught you that it is alright not to see them as people. Please, Pierce, try to. Unlearn your grandfather's way of looking, his attitudes, and try to see for yourself, make your own mind up. You're the one that is stuck in his inheritance.

PIERCE: There is nothing wrong with the way I see things.

FANNY: You won't allow yourself to feel. You won't use your imagination.

PIERCE: I am sick to death with you and your imagination. People have dogs that they imagine are human. I like dogs, and their owners can be my best friends. But a dog is a dog. They only think they are human because they spend all their time giving them human characteristics; reading all manner of bosh into a doggy nature, simply because the blasted dog can't answer back. I mean the dog would say it was a dog if it could! It is the same – you think that they can't talk to you on your level because they haven't the culture, rather the education.

FANNY: No, they didn't go to Mrs Rowden's.

PIERCE: But we have education, letters, music, art – culture – because we're white. It's happened because we've made it happen.

FANNY: Shut up, shut up! It's just not fair.

PIERCE: Not fair. Now you are being unreasonable.

FANNY: These people were taken from their home country. Everything has been stripped away from them. You heard Mr King saying you had to destroy their culture. They're cut off, beaten, made to serve – behave like animals – because if they don't they die. And then we, to justify all

this, say they are inferior. Of course they can't read – we won't teach them. That's forbidden. All the same some of them learn. Don't ask me how. One of your very best slaves reads. It hasn't made him disloyal.

PIERCE: I am a practical person, and I know that the only way to deal with my slaves is to treat them in a disciplined, sensible manner. While you! I can't have you going around treating them as though they were martyrs, some kind of superior being.

FANNY: They must be superior to have survived at all.

PIERCE: Fanny!

FANNY: Pierce, please don't be frightened.

PIERCE: Frightened? I'm not frightened. Look, Fanny, I've given you everything you've asked for. I'm loving, understanding, generous – to a fault. All I'm asking is that you stay out of this. Frightened? What the hell of?

FANNY: Thinking for yourself. Pierce. Think for yourself otherwise you are the slave. Bound to think as they taught you to, as they want you to. Break free.

PIERCE: I am going to change for dinner before you say anything else. This is absurd.

(*PIERCE exits.*)

FANNY: You haven't got a mind of your own.

(*FANNY does an Attitude for despair. We should be in no doubt that this Attitude expresses FANNY's feelings.*)

Despair.

(*The SERVANT enters to set the table for dinner. SALLY, MARGERY, MR KING and PIERCE sit round and eat.*)

This place becomes infested with rattlesnakes during the summer months. They don't become vicious until quite late in the summer. During the intense heats of July and August they coil themselves and spring at the slightest provocation. I hate to think of them in the trees. There is something too revolting in the idea of a serpent looking down on one from above. I don't think the dog days will be pleasant here. I hear the moccasin snake is nearly as deadly as the rattlesnake and that too is common all over the plantation.

(FANNY crosses to the table to address PIERCE.)

Pierce, I must ask you to vacate our bedroom. I would like to sleep alone.

(FANNY kisses SALLY and exits into the bedroom.)

MARGERY: Upstairs to bed!

(MARGERY takes SALLY off. MR KING gets up.)

KING: If I may make a suggestion, Mr Butler. You've got plenty more women to choose from...

PIERCE: Get out!

(MR KING bows and exits. PIERCE rings the bell.)

Psyche!

(PSYCHE enters. PIERCE glares at her.)

Whisky! Bring me whisky!

(PSYCHE exits. The lights change to denote morning. PIERCE remains in the same spot. MARGERY enters.)

Margery!

MARGERY: Sir?

PIERCE: I shall take charge of the children from now on. You will report to me for instructions. Do you understand?

MARGERY: But Madam?

PIERCE: I will tell her that she is not to interfere. I'm afraid that she has lost my confidence. I no longer think she is a suitable mother for my children. They are spoilt. Another thing, I won't have you telling them any more of your stories. From now on they will learn to read and write and to obey authority. Naturally I shall want you to base their education on a proper study of the Bible.

MARGERY: But sir, they must have stories.

PIERCE: No stories. I won't have you pandering to my wife's ideas about imagination.

(FANNY has entered and overheard this last speech.)

FANNY: My children won't be allowed to use their imaginations?

PIERCE: No.

(PIERCE points at MARGERY.)

And if she disobeys me I shall sack her. She can return to her beloved Ireland. Do you hear me? I will be obeyed in my house!

FANNY: But why are you doing this to me?

PIERCE: I doing this to you? You have abdicated your duties as my wife. I don't consider that I have a wife any longer. I share my house with a stranger. No, a traitor...

FANNY: Is this because I won't sleep with you?

PIERCE: You won't sleep with me. You won't do as I ask. You subvert my authority with the slaves – and with the children. You always know better than me. What sort of example is that for our children?

FANNY: I have my principles.

PIERCE: Principles are fine, in their proper place. But yours have destroyed our marriage. Your first thoughts should be for me, your husband – not your principles. Damn them. Why won't you sleep with me? What sort of wife won't sleep with her husband? Don't I deserve that? Or has everything ceased between us? Can't you bring yourself to... demean...

FANNY: I can't answer.

PIERCE: Too damn right. I gave you respectability, I married you – because I loved you. Now I am beginning to hate... You've spoiled everything, with your pigheadedness, your stubbornness. I won't have you near my children. Do you understand? I wont have them contaminated by you. I want us to separate.

(*FANNY does her Attitude for impotent rage, then she goes into submission.*)

FANNY: Please no, Pierce. I love my children. They are the dearest things in all the world. And you, Pierce, you are closer to me than anyone else.

PIERCE: Closer than your principles? Your imagination?

FANNY: I can't change what I am.

PIERCE: I can't love what you are.

FANNY: Let me stay.

PIERCE: If you must, but on my conditions. I must be obeyed in all things.

FANNY: Yes.

PIERCE: You can live in my house as long as you don't speak to me. I don't want to have to talk to you ever again. Do you understand?

FANNY: Yes, Pierce.

PIERCE: I must have full control over the children. You will not interfere at all. And in case you are tempted to, I will restrict the time that you spend with them. One hour a day should be sufficient.

FANNY: Pierce!

(*As PIERCE speaks FANNY descends into a pit.*)

PIERCE: I will give you enough to live on each month but if you break our agreement you will have to leave my house. In that event I will continue to give you money to live on, providing you live quietly and attract no attention. If you should seek to go back into the theatre and take up your old profession as an actress, I shall divorce you. I can't stay married to an actress.

FANNY: Yes, Pierce.

(*The family come to the table. MARGERY is crying. PIERCE says grace.*)

PIERCE: For what we are about to receive may the Lord make us truly grateful. I won't have you crying at table, Margery. Sally, don't look at your mother. And don't feed your mother scraps!

FANNY: Pierce, Pierce. This is intolerable. Intolerable.

PIERCE: (*Shouts.*) Then get out!

(*Blackout. The interior of the house vanishes. We are back in a theatre. We hear FANNY crying. MARGERY kneels by the pit with a handkerchief trying to comfort her. An actor, MACREADY, is seen sitting before a dressing table applying make-up. The STAGE MANAGER enters.*)

STAGE MANAGER: Sir, Mrs Kemble is here to talk to you about the part of Desdemona. Shall I show her in?

MACREADY: If you would be so kind.

(*The STAGE MANAGER crosses to FANNY. He lifts her up and persuades her to follow him. They enter MACREADY's space.*)

STAGE MANAGER: Miss Kemble, sir.

MACREADY: Dear Miss Kemble, forgive my dishabille.

(*We see that MACREADY is halfway through blacking up.*)

I find that my blacking up takes forever.

FANNY: Blacking up?

MACREADY: It's burnt cork. Forgive me, I forgot. You've been away. One can't imagine doing Othello these days without blacking up. Othello has to be as authentically black as possible. It's the new naturalistic realism, don't you know? Well, no you don't. Of which I, Macready, am the chief exponent. The Attitude is dead – in theatrical terms that is. Are you willing to learn?

FANNY: Acting without Attitudes?

MACREADY: Acting that comes from the heart.

FANNY: That's how I've always approached acting.

MACREADY: Good, good. We'll give it a try then. I must warn you now that the last actress that played opposite me as Desdemona complained that I nearly throttled her in the last scene. Preposterous, of course, but she claimed to have bruises on her neck to prove it. It was this damned stuff coming off me hands.

(*CHARLES KEMBLE comes on in a wheelchair.*)

CHARLES: Mr Charles Kemble on his way to read one of the plays of Shakespeare to his devoted public.

MACREADY: Charles!

CHARLES: Dear boy.

(*CHARLES catches sight of FANNY.*)

Who's that? Looks like my daughter. She's got old and fat.

FANNY: Papa!

(*FANNY does an Attitude for joy.*)

Joy.

CHARLES: I'd recognise that Attitude anywhere. Fanny, Fanny, my dear child what has happened to you?

FANNY: I'm going to get a divorce.

CHARLES: Unthinkable, unheard of. What's wrong with separation? Marriages are made for life, you know.

FANNY: Papa...

CHARLES: I don't want to know. Never come between a man and his wife. And don't bother telling him either. He's an actor, no point in burdening him with feeling. Besides you've broken his heart once already. So what are you going to do to keep body and soul together?

FANNY: I want to go into politics.

CHARLES: But what are you going to do to keep body and
soul together?

MACREADY: You'll have to earn some money first.

CHARLES: Too damn right. Go into politics if you wish, dear
child, but you'll find that no one takes actors seriously.

FANNY: There are things I want to change.

CHARLES: Push on, dear boy. I'll be late for my
performance. I'm reading *Romeo and Juliet*, Fanny.
Come and hear me. Take you back to your youth.
There are things we all want to change. Keep theatre
alive, Fanny. Get on with that! That's enough for anyone.
Damn politicians!
(*CHARLES dies.*)

FANNY: Is he asleep?

MACREADY: No, I think...
(*FANNY takes the script from her father's hands. MACREADY wheels
him off. The lights change.*)

FANNY: Good afternoon, ladies and gentlemen. This
afternoon I will read you Shakespeare's play *Romeo and
Juliet. Romeo and Juliet* is a tragedy. Stage Management, can
I have a table? Thank you!
(*The STAGE MANAGER carries a table on. FANNY places her script
on it.*)
And a chair.
(*FANNY takes up an Attitude for tragedy.*)
Tragedy! We all used to do Attitudes in the old days.
(*The STAGE MANAGER brings a chair on.*)
Thank you, dear. I want a glass of port and a rug of some
description. At the end of the play, Fanny... Juliet, goes
to see Friar Lawrence who gives her a potion. What we
would nowadays call a drug, like opium, something to
put her to sleep and at the same time make her look as
though she has died. She is going to deceive her parents.
Juliet's Attitude in this speech is one of fear.
"What if it be some poison, which the friar
Subtly hath minister'd to have me dead,
Lest in this marriage he should be dishonoured,
Because he married me to Romeo?"

Divorce wasn't something one considered then. My divorce caused me much pain. We are not here to discuss the modern equivalent to the end of love.
"For the sword outwears its sheath,
And the soul wears out the breast,
And the heart must pause to breathe,
And love itself have breath."
Lord Byron hit it on the head. Juliet is very courageous, very brave. There is nothing she won't do for love. At the end of the play she kills herself. Shakespeare never invites us to imagine what life would have been like for Juliet had Romeo lived. *Romeo and Juliet* is about the passion of love. Romeo is the sentiment of love, while Juliet is the selfish passion. Stage Management, more port. There is nothing in the damn play about old age. Nothing about arthritis and gout, and disappointment, and loss of love...
(*FANNY gets up. She shuts the book.*)
Tomorrow I read *King Lear.*
Blackout.

The End.

THE SEDUCTION OF ANNE BOLEYN

THE SEDUCTION OF ANNE BOLEYN

Characters

THOMAS BOLEYN

GEORGE BOLEYN

ELIZABETH BOLEYN

MARY CAREY

ANNE BOLEYN

HENRY TUDOR

KATHERINE OF ARAGON

SMEATON
a musician

The play takes place at Hever Castle and at Henry's Court.
I have not specified which court, nor have I anticipated any
massive set changes. Altogether the action takes place over
nine years.

The Seduction of Anne Boleyn was first performed on 23 April 1998 at the Nuffield Theatre, Southampton, with the following cast:

THOMAS BOLEYN, Jeremy Child

ELIZABETH (his wife), Tricia Kelly

GEORGE (his son), Noah Huntley

MARY (his daughter), Rachel Gaffin

ANNE (his daughter), Jessica Lloyd

HENRY VIII, Simon Robson

KATHERINE OF ARAGON, Maria De Lima

SMEATON, Thomas Frere

PRINCESS MARY, Hannah Stansbridge or Jane Downie
 or Rachel Darby

Director, Patrick Sandford

Designer, Juliet Shillingford

Lighting Designer, Nick Riching

Music arranged and composed by Simon Slater

Assistant Director (children), Fran Morley

Company Stage Manager, Nicky Wingfield

Deputy Stage Manager, Tom Ashcroft

Assistant Stage Manager, Louise Cobbold

Sound Operator, Jason Barnes

ACT ONE

Scene 1

Summer 1526. The Boleyn family, THOMAS, ELIZABETH, GEORGE, MARY and ANNE kneel in a row. A priest gives each wine and bread. They pray.

THOMAS: If a righteous man has one aim in life it is to better the lot of his family. It's all in the future – my children, grandchildren, great-grandchildren. I see myself as part of some great river called family, that conjoins and combines with other greater and lesser tributaries through marriage, commingling and uniting until the whole seems to form a great rush forwards, a mighty great mass of water, as it were, that spreads – outwards – can't be contained, covers the flood plain, submerging grass, rushes, bird's nests, until it becomes sea. Part of myself lives in the future. Dear God, our Father, help us to realise what can be.

(The family get up.)

George... George, what's the matter? Like a restless colt.

GEORGE: Nervous, Father.

THOMAS: Time you were married.

GEORGE: That's what I'm nervous of – "Go forth my son and procreate." Whenever you talk of family and marriage I think about procreation, and procreation seems a responsibility I'd rather not be taking on. I don't mean to be offensive.

THOMAS: Whoring doesn't count, I suppose?

ELIZABETH: Tom.

THOMAS: Well, the boy does like to whore.

ELIZABETH: Why should I like to hear about it?

GEORGE: It's not serious.

THOMAS: Time he started getting legitimate heirs.

GEORGE: I haven't got any illegitimate ones – yet – as far as I know.

THOMAS: Be flippant! But what about family? Our expectations? You are our expectation. You inherit.

GEORGE: I know that. I'm ready to be serious and marry whenever and whoever you want me to. Providing –

THOMAS: What?

GEORGE: Just so that you know that marriage is a duty rather than a pleasure.

THOMAS: Duty? Pleasure? Granted I can't easily find you a wife like your mother but there are plenty of women, good women who will make good wives. What's wrong with you? A good marriage is sacred to God who wishes for all of us to achieve contentment. I've talked to Lord Morely. Jane, his daughter, will be an excellent match for you.

MARY: He won't like her.

THOMAS: Mary, I think I have some right to expect your support.

MARY: Jane's all scraggy and she titters like a sick cat... she looks like duty and obligation..

THOMAS: George, you will visit Jane. He can make up his own mind – but remember she represents all that I desire in a wife for you. Now, Mary.

MARY: Yes?

THOMAS: You may think that Jane titters like a stray cat but she is a very fine catch, and if the Parker family refuse to have anything to do with the Boleyn family, I hope you realise it'll be because of the way one of us behaves.

MARY: Oh Lord!

THOMAS: Exactly.

ELIZABETH: Not everyone wants to connect themselves to a family where a daughter behaves as if there wasn't a decent proper way of behaving.

THOMAS: Your behaviour is outrageous. No better than the king's concubine.

MARY: I'm not his concubine. I can't be a concubine; I'm married – a husband – William. And I'm not outrageous or flamboyant – I'm discreet. Well, reasonably.

ELIZABETH: Irreligious, ungodly, however you describe it.

THOMAS: What would you call it?

MARY: Friendship.

GEORGE: Friendship!

MARY: I supported you. Is this friendly?

GEORGE: The king loves her.

THOMAS: Love, you think the king loves?

MARY: Why not?

THOMAS: I'm surprised at you. The family honour stands
– is ruined. Like a good shoe smirched with dung. I must
ask you to... end it, before any more scandal is...
attached, leaving us utterly disgusting.

MARY: What about the benefits?

THOMAS: I fail to understand you.

MARY: Money, Father! You know you've had honours –
and George. Why do you think you're a member of
the Privy Council? I'm sure that when Henry gives
you his blessing, this glorious marriage with Jane
Parker will happen.
(*GEORGE groans.*)

ELIZABETH: That doesn't make any of this right – in
God's eyes.

MARY: And William has had a grant of land every year for
the four years that Henry and I have been friends. He
would agree that flirting has proved a useful dowry. Why
can't my family thank me?

ELIZABETH: Flirting – a dowry!

THOMAS: Is that what you call it?
(*MARY is amused.*)

MARY: I'm a flirt. You don't like me being a flirt but that's
what I am. Don't children inherit abilities from the parents?

ELIZABETH: Now be disrespectful!

MARY: I must have inherited flirting from one of you.

ELIZABETH: Have you seen us – flirting?

THOMAS: We educated you the best we could. Sensibly
and at great sacrifice.

MARY: Sent me to Paris, to the French court where I learnt
– helped by good King François – to flirt.

ELIZABETH: You were supposed to learn about the intricacies of court life.

MARY: Flirting is court life, isn't it?

ELIZABETH: One of the trials, one of the temptations but not! – Anne's not a flirt.

MARY: Anne's not at court. Why not?

THOMAS: That was a pardonable mistake. Nothing to do with flirting. Her honour has not been questioned.

MARY: Henry Percy fell in love with you? You must have flirted with him.

ANNE: I did not.

MARY: You fancied him so you flirted with him.

ANNE: I did not.

MARY: Oh, Anne!

ANNE: I wasn't sent home from Paris. I never did what you did with François.

MARY: You'd never have had the opportunity.

THOMAS: That's enough.

ANNE: And if I had I would never have taken it.

MARY: Of course you would have taken it. The King of France!

ANNE: The King of France, the King of England. It wouldn't have made any difference. I would have thought of God – and his commandments.

ELIZABETH: Blessed child.

MARY: You must be very proud of the little saint.
 (*MARY exits.*)

THOMAS: Damn. I asked her here to beg her to stop.

GEORGE: She's not going to now.
 (*GEORGE follows MARY.*)

THOMAS: Damn it.

ANNE: Father, when can I go back to court?

THOMAS: When can you go back to court!? Not now, child. Not now.
 (*THOMAS exits.*)

ANNE: Mother, I want to be back at court.

ELIZABETH: I thought you were happy.

ANNE: I was. Till they came with court stuck all over them like burs. Why is happiness so, so puff puff it's

gone? It's as though someone has taken a knife and cut away a tiny piece of something, just enough for me to see that it is all a sham, a make-believe. And I should be like Mary.

ELIZABETH: No, darling.

ANNE: Why can't we both go to court?

ELIZABETH: Thomas must get George married before he can think about you.

(*ELIZABETH produces a mirror.*)

ELIZABETH: Let's tidy you up.

ANNE: I am tidy.

ELIZABETH: Look at you. You're wild. Dark eyes, mad like a black bird. I suppose you are tidy – on the outside. It's inside yourself you have to tidy up. All the muddle in that head.

ANNE: There is no muddle in my head. My hair must be coming unpinned, that's all. I'll do it.

ELIZABETH: That – bright, too clever by half, wilful look. You'll never get a husband with that. You'll send them all running.

ANNE: Mother! How can you say such an awful thing? It's terrible. I'll make a wonderful wife, a brilliant, perfect, amazing wife, a copybook wife. I understand exactly what it is a wife should be, you know that. You must tell father, what a good wife I'll make. I'll copy you.

Scene 2

Autumn 1526. KATHERINE comes on with her priest and her confessor and her altar boys who carry incense and crosses. She starts to pray. Possibly ending up flat on the floor with her arms extended.

Scene 3

The same time as the above. MARY stands screaming at HENRY.

MARY: I'm pregnant. And you tell me it's not your child. I haven't slept with my husband for three years. What do you make of that? There's only one person that

I've... I've... And you tell me it's not your child. Whose child is it then?

HENRY: I will not acknowledge it.

MARY: Goblins, I suppose?

HENRY: Or the devils?

MARY: How can you?

(*MARY crosses herself.*)

Three years. He hasn't touched me in three years. I wanted to be yours, all yours. I love you. I belong to you.

HENRY: You belong to William – your husband.

MARY: I belong to you. Henry, you knew you were committing adultery. I'm in love with you.

HENRY: I am the king.

MARY: What were we doing? This is yours! You, you idiot cruel person!

HENRY: What do you expect me to do?

MARY: I don't know. You're the pissing king. For the sake of common humanity –

HENRY: Common humanity?

MARY: I love you.

HENRY: Mary... I cannot fornicate with a pregnant woman.

MARY: Henry!

HENRY: And I will not. William must be... congratulated. You're his wife – I am only your friend. I won't recognise the child. Richmond was born before his mother married. How can I recognise a child born to a married woman? You can't ask me to admit to adultery.

MARY: You are abandoning me.

HENRY: We have to separate.

MARY: How can I have to go back and be a good wife? When I'm not... I can't be. I love...

HENRY: Shush, Mary!

MARY: Shush! How can you shush me?

HENRY: I want to kiss you.

MARY: Kiss?

HENRY: May I? May I sweetheart?

(*They kiss.*)

MARY: Oh Henry!

HENRY: It's not my baby.
 (*They kiss again.*)
MARY: Henry!
 (*HENRY crosses to THOMAS.*)
HENRY: Thomas, what do you make of Leviticus?
 (*MARY throws things after HENRY. MARY swears.*)
MARY: Piss, piss. Cat's piss! Help me not go crazy!

Scene 4

January 1527.
THOMAS: Leviticus? The bit about adultery?
HENRY: No.
THOMAS: Which bit then?
HENRY: Chapter twenty, verse twenty-one. Yes – "And if a man shall take his brother's wife it is an unclean thing; he hath uncovered his brother's nakedness; they shall be childless."
THOMAS: Interesting.
HENRY: Interesting. I'll say it is interesting. I've always known it was there, but it's been a while since I studied it "And if a man shall take his brother's wife it is an unclean thing." I took my brother's wife, you know, Thomas. Katherine was married to my brother, Arthur.
THOMAS: Didn't your fathers get a dispensation from the Pope?
HENRY: You know they did. Otherwise we wouldn't have been able to... and we wouldn't be in this pickle. What do you make of "They shall be childless."?
THOMAS: That is not applicable to you.
HENRY: "They shall be childless."
THOMAS: You have a child. The Princess Mary.
HENRY: Yes, you're right. It's frustrating, you know, Thomas, when I read it it is as though I recognise something. As though there was something on these pages which I should understand. And I can't for the life of me understand it. Are you pleased with the daughter-in-law?
THOMAS: Delighted. I was going to ask you...

HENRY: "They shall be childless." You know there is almost a truth in here. I had a son for three wonderful months – then gone. I've had other children. Babies born already dead. Mary is the only one out of seven, seven, Thomas, to survive. It is like an accusation. We should pray, you know, we should.
(*HENRY and THOMAS both go down on their knees.*)
Dear God, our Father, explain this to me. Help me to understand. Take pity on my ignorance.
(*Silence. They get up.*)
I've been doing penance for my, my cat's cradle with your daughter.

THOMAS: Best forgotten. I was going to ask...

HENRY: Don't ask. I miss her!

THOMAS: On another subject – A thought, sire, while I'm on my knees. I don't know if it is any use. What language was the Bible written in? Originally. Not Latin, was it?

HENRY: Hebrew.

THOMAS: A pity we don't understand Hebrew.

HENRY: It is. Is it?

THOMAS: My thought was – sometimes meanings change, very slightly, in translation.

HENRY: Change? Yes. Grateful Thomas, very clever. You mean in Hebrew that verse might... there might be another interpretation? Someone from the universities, a Hebrew scholar. Thomas, do me a great favour and find me one.

THOMAS: Might throw some light on things.

HENRY: Won't do any harm. Now what was it you wanted to ask?

THOMAS: A small favour. My youngest, Anne, is away from court, I wondered if you could persuade the queen to find her something.

Scene 5

March 1527. KATHERINE gets up from her prayers. She goes to her bed chamber, where her ladies start to undress her. ANNE enters. The undressing ceases. KATHERINE looks at ANNE. ANNE goes into a low curtsy, prostrates herself.

ANNE: Anne Boleyn, my lady.

(KATHERINE motions to the ladies to continue undressing her. ANNE continues to lie at her feet. Once KATHERINE is in her night-gown, she speaks to ANNE.)

KATHERINE: Some people are given little dogs as presents. Some people have furs or plate even, jewels are not unheard of, but the king must send me a new lady-in-waiting.

ANNE: My lady.

KATHERINE: Sister of a lady that we will not mention. In case her name should make me vomit. A little dog would have been far preferable. Do you speak Spanish?

ANNE: French, I speak French.

KATHERINE: So like the animal you are dumb in the feelings about Spain?

ANNE: I've tasted a jam – made with oranges –

KATHERINE: Jam! We will make a game that you are a dog. You will sit like a dog and listen. And when you hear a noise you will tell me.

ANNE: What noise?

KATHERINE: I am waiting, you understand, waiting. Every night is like this. I do not sleep, because all the time I am listening but if you are my ears and listen for me I will sleep. Maybe. What do you hear?

ANNE: The wind in the chimney. A dog howling. Your servants whispering in the next room. An owl.

KATHERINE: Singing?

ANNE: No, my lady. Hooting. Do you want me to sing?

KATHERINE: I do not admire the howling dog.

ANNE: I have a fairly tolerable voice.

KATHERINE: Listen.

ANNE: It might help you sleep.

KATHERINE: Nightmares – I will have nightmares. Always I attend compline, I take a little food, I try to sleep. Always nightmares. When I was a child I could sleep all night safe in the love of my mother.

(HENRY in his nightshirt heads for KATHERINE who has fallen asleep. ANNE wakes her.)

ANNE: My lady, my lady... I can hear laughter, dogs barking. Music. Oh your majesty and the sound, the swish of night-clothes against rushes...
(*The swish of night-clothes against rushes is echoed round the stage.*)
KATHERINE: The king comes! Ladies, ladies more light, more rushes, more pot-pourri. You –
(*Indicating ANNE.*)
My hair!
(*ANNE brushes KATHERINE's hair. HENRY arrives.*)
HENRY: At the witching hour I come, my queen! Is the woman who rules my heart ready to receive my homage in the small hours of the night?
KATHERINE: Oh, my king. You find me unprepared. Taken by surprise. But surprise that awakes and delights!
HENRY: Surprise is an element valued on the field of battle.
KATHERINE: You have not come here to do battle?
HENRY: Have I not always come to you before battle? Have I not always been your champion?
KATHERINE: I have always worn your colours in my hair?
HENRY: My queen!
KATHERINE: My king.
HENRY: Smeaton, we bring the queen presents. What do we bring her?
SMEATON: Three goose eggs, a tray of sweetmeat and cloth of gold. I have written a new song.
HENRY: A new song, my darling! A new song that's worth, worth... Ah, my darling!
(*HENRY holds out his hand to KATHERINE.*)
We will hear the song tomorrow. To bed. To bed!
(*HENRY drops his dressing-gown on the floor and KATHERINE and HENRY exit. Climb into the double bed or whatever. The curtains are drawn. SMEATON is left with ANNE. He raises his eyebrows. ANNE puts a finger to her lips. She picks up the gown. They move out of the bedroom.*)
ANNE: He looks older.
SMEATON: Who are you talking about?
ANNE: Not about the king!
SMEATON: Good, because personal remarks made about his age could be classified as treason.

ANNE: He reminded me of my father. It's the dressing-gown.

SMEATON: Are you Sir Thomas's daughter? And isn't he older than the king?

ANNE: Older? Yes. I didn't mean...

SMEATON: Why don't you say he looks like George? You are George's sister? And I should think everyone would like to look like George.

ANNE: But he doesn't.

SMEATON: You're supposed to be the sophisticated one! How is it in the queen's service?

ANNE: I'd better say it's fantastic, amazing and everything I ever wanted, otherwise you'll accuse me of plotting treason again. I forgot about the waiting.

SMEATON: Waiting?

ANNE: Waiting, waiting. I seem to spend all my time waiting.

SMEATON: You are a waiting woman.

ANNE: And praying. She prays enough for all of us.

SMEATON: She's famous for it.

ANNE: I mean, I admire her. It's just that it never stops.

SMEATON: The praying –

ANNE: And the waiting. Even at night.

SMEATON: Praying and waiting.

ANNE: Waiting and praying.

SMEATON: It's the same for me, being a musician. Well not exactly but you play once, you play some more, and then they want you to play again. We are not here to please ourselves.

ANNE: No.

SMEATON: We are honoured.

ANNE: Yes.

SMEATON: When I'm waiting I dream up new songs. I imagine they fly past like birds – and if I'm quick I can catch them.

ANNE: What should I think about?

SMEATON: Are you allowed to feed me? Mutton chops or eel pie would be favourite.

ANNE: She's fasting. If she'd known the king was coming then there would have been all kinds of delicious things. I could find some bread and cucumbers?

SMEATON: Ale?

ANNE: And ale if you'll tell me how my brother is.

SMEATON: I do not think he will be happy in his marriage. This Jane Parker. You must get him to fall in love with her or there will be big trouble.

ANNE: How do I do that?

SMEATON: A love potion.

ANNE: A love potion?

SMEATON: You can buy these things? Maybe find an old woman or a witch?

ANNE: What?

SMEATON: Your brother needs some strong magic. Dream up spells while you're waiting. You look clever enough to conjure up all sorts of magic.

ANNE: I do not. Don't say that – not if we're to be friends.

(*HENRY roars. He swears. Incoherently.*)

HENRY: Stupid, stupid woman! Cold, elephantine, nauseating, ungenerous, horrible, futile, useless pig. Don't you know how I hate a woman to make demands? Underous.

(*ANNE and SMEATON freeze.*)

SMEATON: It is a pity you're not a witch.

ANNE: Sh!

(*HENRY leaps out of the bed.*)

HENRY: Damn, damn... You... You... How can a man? How can she, they... expect me to... perform, on the body of... a whale. Fuck! Get out. Smeaton, Smeaton!

SMEATON: You could help your mistress. Poor woman. Take pity on her.

HENRY: I've been wading in a bog, through marshes...wet, rivers, streams... Stop that damned weeping! How do you expect a man to? Damnation! Smeaton!

(*As he goes HENRY complains to SMEATON.*)

A man can't perform when I am confronted with such a

suffocating, nauseating, mountainous tub of lard. Not a
man with sensitivity, feeling. A man easily dismayed.
(*He pauses. Grabs SMEATON. HENRY tortures SMEATON, who
cries out in pain. HENRY lets him go.*)
Damn it. Damn it. The thought that she was, might have
been my brother's. That another might – another man –
been there. Even if it was bloody Arthur! This is what is
abhorrent to me! Abhorrent.
(*HENRY exits. ANNE stands watching the bed. We hear KATHERINE
sobbing. The curtains part and KATHERINE comes out of the bed. She
stands and looks at ANNE. Pause.*)

KATHERINE: Prayer!
(*KATHERINE falls to her knees.*)
Fetch my chaplain.
(*ANNE exits.*)

Scene 6

March 1527. HENRY is helped to dress by GEORGE.

HENRY: George, George! Help me dress. Oh God!
George, sometimes the most torrid, horrible imaginings
– in my head. I see my brains! No, I feel birds on my
head. Great wings, claws, beaks – not ravens – crows,
scavenging crows, their beaks red with blood, dripping
blood! Feeding, feasting on my brains – yes. Wings, the
beat of their wings, cawing, squabbling as they
descend... and I think this is what it is like to be dead,
to be murdered and your body left for the birds... to be
only a body. I was never impotent, do you hear that,
George? Never! How am I going to get me a son?
(*HENRY goes down on his knees. GEORGE following him.*)
Dear God, look down on us with mercy. Help us through
our trials and suffering. Guide us.

GEORGE: Amen.

HENRY: Help me – George.

GEORGE: Drink – and exercise. I always think exercise is
excellent for driving the ghouls away.

HENRY: Ghouls? Are these ghouls, George?

GEORGE: Sound suspiciously like them. The sort of thing that gets in your head when you're not thinking of anything and confuses everything.

HENRY: Damn it, George, don't you worry about getting an heir?

GEORGE: Oh that! I've got a new dog...

HENRY: Dog?

GEORGE: Hunter. I was thinking of creating a new breed.

HENRY: You should be thinking of creating a new breed Damn it, where's Thomas?

GEORGE: Dogs are much more challenging. Waiting to see you. He's got something he wants to show you.

HENRY: Challenging! I hope you don't tell him that! Get him in, George. God help me, we'll talk about dogs some other damn time.

(*GEORGE exits.*)

Challenging! What sort of damn dog do you want to breed, George?

(*HENRY sighs. He goes to his book table and reads.*)

Work is supposed to be an excellent aphrodisiac.

"And if a man shall take his brother's wife it is an unclean thing; he hath uncovered his brother's nakedness; they shall be childless."

(*THOMAS enters.*)

"They shall be childless"!

THOMAS: Robert Wakefield has sent us a translation. I've got it here.

HENRY: Read it.

(*THOMAS reads from a scrap of paper.*)

"And if a man shall take his brother's wife it is an unclean thing; he hath uncovered his brother's nakedness; they shall be without sons"!

HENRY: Sons. Without sons! Not childless, son less. Without sons, Thomas! I am with sons or without?

THOMAS: Without – legitimate ones.

HENRY: What other sort matter? Let us give thanks. I should not be married to my brother's wife. If the marriage had been blessed I'd have sons. Advice is

required. Wolsey, Thomas. Send for the cardinal, we must hear what he has to say. If my marriage stinks, as it begins to, in the most foul and unimaginably disgusting way, then the Pope must give us an annulment. Thank you, Almighty God!

Scene 7

May 1527. ANNE teaches the princess some new dance steps. KATHERINE watches. She applauds.

KATHERINE: How do you find our daughter?

HENRY: Ludlow hasn't brought her on. She is still the same small unripe fruit that she was before she went. She reminds me of an apricot growing low down on a garden wall, away from the sun, still green and hard. Sour, sour, sour.

KATHERINE: Henry!

HENRY: We've got to engage her to one of the French spawn but even an optimist can see that we can't go any further. Our child is years away from bearing a man or children, carrying a sprog. Still with good grace and all that...

A kiss for your father, Mary. You're a good girl.

(*HENRY kisses MARY.*)

And now I want to be taught this new step.

(*HENRY and ANNE dance.*)

HENRY: You don't look like your sister.

ANNE: I am supposed to be different.

HENRY: It's not just a question of being dark and fair is it? I'm not being obtuse. You are different.

ANNE: She has all the good looks.

HENRY: While you are reputed to have the wit.

ANNE: It's a reputation I'd rather not have. I feel under an obligation to amuse all the time, and that's impossible. Particularly if you tend, as I do, to be a little melancholic. And sometimes I say things that I shouldn't. It's like having a double-edged blade in my mouth instead of a tongue.

HENRY: I shall remember not to try to kiss you. I shan't be kissing you. Do you mind me saying that?

ANNE: Why should I expect you to kiss me?

HENRY: Why indeed? Do me a favour?

ANNE: If I can.

HENRY: I've just had this wonderful notion, terrific idea; how would it be if I were to pretend that you were my sister?

ANNE: But I'm not.

HENRY: Your sister was extremely dear to me – for her sake I would like to look after you.

ANNE: Was?

HENRY: Was.

ANNE: Why not is? It's as though she is dead.

HENRY: Yes, yes it is, isn't it? I hadn't thought of that. What a clever little thing you are. You are clever. That's the nub of it; to me she is dead. William Carey's wife lives but not – don't be shocked – the woman I knew. And I miss that woman. It would be most friendly of you to allow me to think of you as my little sister. I'd feel less abandoned.

ANNE: She is the one abandoned.

HENRY: You think badly of me?

ANNE: It's not my place to judge.

HENRY: Not your place to judge! I should think it isn't damn well your place to judge.

ANNE: She's my sister. I don't like to see her discarded as though she were a...

HENRY: What?

ANNE: I don't know. Old gloves. Orange rind. Cob nuts – husks. Forgotten and flung on the floor.
(*HENRY glares at ANNE. He holds out his hand to KATHERINE.*)

HENRY: My love, dance with me!
(*KATHERINE and HENRY dance.*)

Scene 8

May 1527. GEORGE and SMEATON.

GEORGE: Ever write sad songs?

SMEATON: All I write.

GEORGE: I mean sad, sad songs?

SMEATON: They are sad and sad and bloody sad.

GEORGE: Not bloody sad enough. Not, not... I want to hear sad as infinitely, cataclismically.

SMEATON: This is a man with a new wife?

GEORGE: That's the saddest part of it.

SMEATON: Not right.

GEORGE: A man with a new wife should wear pink and skip, I know. I want a sad song to underline all the melancholic thoughts a man with a new wife has – like a leaky fountain.

SMEATON: Dribbling or splashing? The leak?

GEORGE: Where is the young man I was? You used to like him. I used to like him. We both liked him. The bugger has donned his hat and slipped away – too much down in his pillows, too many cats to put milk out for. He scrambled away like a beetle out of a puddle. Now look at me; my brows all furrowed... my breath smells. Jane wants me grown-up. She looks at me like some idiot she discovered in her bed, a creature too shocking to mention, too horrible to allow close.

SMEATON: She does not enjoy the...

GEORGE: ... fucking... no.

SMEATON: Doesn't she want a child?

GEORGE: I dunno. She doesn't want one in her bed, I know that. Maybe a respectable, behatted, responsible grown-up person – with my legs. She likes my legs. I don't want to be grown-up. I want... I want... Shit!

SMEATON: Your legs?

GEORGE: I've got good legs.

SMEATON: Have you?

GEORGE: I am known for my legs.

SMEATON: What do you want?

GEORGE: Positively known. Not to be married.

SMEATON: I would like to be important to you.

GEORGE: Life should be so much more than it is.
It should be constantly expanding, never contracting. When we look into the future the horizon should be endlessly stretching – the narrowness, her narrowness,

marriage! (*He sighs.*) The end. The puddle is small somehow and grey.

SMEATON: Grey?

GEORGE: Stop asking questions. What were you on about?

SMEATON: Declaring love, I think.

GEORGE: Christ, do you think I don't know that? I am irritatingly aware of your brown eyes following me around. Horribly doggy, slatheringly doggy.

SMEATON: Grey – like the puddle.

GEORGE: What?

SMEATON: My eyes.

GEORGE: Are they?

(*They kiss.*)

What you are offering is temptation. I won't be tempted. Freshly newly married as I am. Just what she wants, don't you see – the pleasure this would give her. Can't you hear the nasal whine, the innuendoes? The threat of clergy and holy water. Damn it. I'd owe her, have to keep her quiet. She's the sort of woman that likes furs. I'll not give her the satisfaction.

SMEATON: She has to know?

GEORGE: Not has too. This is too public. She will know and... Shit! She's got eyes like gimlets.

(*GEORGE moves away from SMEATON.*)

SMEATON: A sad song for both of us – and for gimlet eyes.

(*SMEATON starts to play.*)

Scene 9

June 1527.

HENRY: My dear Katherine.

KATHERINE: Am I your wife or am I not? Am I married?

HENRY: Katherine.

KATHERINE: Am I?

HENRY: Look...

KATHERINE: What am I? Your wife or a sewer, running with filthy things, a slut, a whore?

HENRY: Stop it.

KATHERINE: No, a rat in your sewer would have better treatment.

HENRY: I will explain.

KATHERINE: I am nothing to you. Nothing – some dish rag to be thrown on the fire.

(*She starts to sob.*)

These men know, they judge me – and I... I...

HENRY: It's unfortunate we held the court without telling you; but I'm here to talk, to explain, Katherine. Please stop crying.

KATHERINE: I can't. I am nothing to you.

(*Sobs.*)

HENRY: Quiet. Be quiet. You are my wife. No one wants to get rid of you.

(*KATHERINE's sobs intensify.*)

I'm having to come to terms with circumstances that aren't to my liking. Things I thought were sure and settled, certainties for all time – not... I don't know what to think. I haven't come to you because I didn't know what to say. Do you think I don't care for you?

KATHERINE: Lies. Why do you listen to lies? I married a man that listened to lies.

HENRY: Katherine listen to me. You know I love you. You know I always have done. I can't tell you how important you are to me. You always have been and always will be. I respect you as I do no other woman. Katherine?

(*She sobs.*)

HENRY: My life has been built on our love.

KATHERINE: You want to get rid of me.

HENRY: You know that Greek thing, the king that found out he was married to his mother? I'm not saying I am like him but – here was a man who in ignorance married a woman, and had children with her, not realising that she was his mother. I'm not saying you are my mother. But the sin. He killed his father and married his mother in ignorance. I married my brother's wife in ignorance, Katherine.

KATHERINE: No.

147

HENRY: It's true.

KATHERINE: Our marriage was made in heaven.

HENRY: You are not listening to me. Listen to me. Two things. One – I want to impress on you what you mean to me. Two – the Church in dispensing with the natural obstacles to our marriage, contravened divine law. Pope Julius never could make our marriage right.

KATHERINE: No.

HENRY: This hurts me too, Katherine.

KATHERINE: No, no.

HENRY: There's no one else I want to be married to.

KATHERINE: Blood, you saw the blood on the sheets, on our wedding night there was blood. I was a virgin intact. Arthur never broke open my womb. Blood, Henry.

HENRY: Katherine! Katherine, don't look at me like that.

KATHERINE: How? I look at you – how? I look at you?

HENRY: Unpleasant. Like an adder I killed the other day.

KATHERINE: You tell lies if you say there is no blood.

HENRY: I will look after you.

KATHERINE: It's not true.

HENRY: It is true. Wolsey has all of England's most skilled lawyers and theologians working on it.

KATHERINE: They examine private affairs?

HENRY: Yes.

KATHERINE: Then tell them about the blood.

(*KATHERINE sobs get louder. HENRY gives up. He storms out.*)

HENRY: Damn. Blood!

(*HENRY shudders.*)

Water! Water! Wash!

(*SMEATON brings a bowl of water on. HENRY washes himself. HENRY takes a deep breath.*)

Not given to poetry, of naming, spelling out what is. Release. Being set free, removed from a place where grey predominated, everything grey or brown, donkey coloured, and thick with dust, disturbed, got stuck in my throat, and... somewhere where there was ash now, small patches of pollen... colour... fresh air.

(*HENRY starts to sing. SMEATON joins in. THOMAS enters. He hands a letter to HENRY. HENRY reads. He stops singing. SMEATON continues.*)

Quiet! Damn, damn. Quiet. Have you read this? We're stymied, stymied. Rome has been sacked. It's Friday morning. Do you believe that the Holy City's been captured by Spain? The Pope fled? God knows where.

THOMAS: I understand he's imprisoned in Castel San Angelo.

HENRY: The foremost city in Christendom sacked by the troops of his upstartness, overwheeningness the King of Spain and Holy Roman Emperor. What is happening? Armageddon? And we – never mind! I expect we've got crayfish for supper, a great steaming dish of crayfish.

THOMAS: Wolsey will want to see you.

HENRY: I should damn well think he does. My business will be drastically affected by this. What?
(*GEORGE enters with ANNE.*)

Scene 10

GEORGE: My sister, my lord.
(*HENRY looks at ANNE.*)

HENRY: I know who your sister is. I danced with her.

ANNE: I have brought you gifts from the queen. The most exquisite shirts, made all with her hand.

HENRY: Lady Anne, if your mistress had been busy on your behalf, she would have asked me to look out for a husband for you, instead she makes shirts, exquisite shirts. What do you make of that?

ANNE: The queen sews beautifully.

HENRY: Don't you want a husband?

ANNE: What else could a woman want?

HENRY: What else? Do you know who you would like for a husband?

ANNE: I am prepared to leave all that to my father.

HENRY: Haven't you thought about the qualities you like a husband to have?

ANNE: My father must decide.

HENRY: Mumbo jumbo. Gobbledy gook. Give me a
 straight answer.

ANNE: It wouldn't be my place.

HENRY: Wooden – you make me feel all hard, polished and
 finished. And you're quite pretty really. I find court
 etiquette, I think they call it, can be too, too dreary. Is there
 someone, anyone, you've got your eye on? Don't blush.

ANNE: If there was someone would you arrange a marriage?

HENRY: Maybe – provided there weren't conflicting
 interests. You're avoiding answering my question. Is
 there someone?

ANNE: My feelings are unimportant.

HENRY: So there is.

ANNE: No.

HENRY: So what qualities do you want in a husband?

ANNE: Kindness.

HENRY: And? Nothing else?

ANNE: Someone who won't laugh at me.

HENRY: I won't laugh.

ANNE: You're not marrying me. And you are.

HENRY: You're so delicious.

ANNE: I'm not.

HENRY: What else?

ANNE: Well he'll share things.

HENRY: And?

ANNE: We'll ride together – and dance.

HENRY: Is that all?

ANNE: He'll read to me, sing me songs, wrap me in his
 arms when I'm cold, feed me coddled eggs, run through
 the long grass with me, help me climb trees, find birds
 nests, we'll examine beetles, and lie under the stars and
 talk, most of all we'll talk and talk and talk...

HENRY: You'd never know you were brought up in the
 French court. This list of attributes is anaemic – weird.
 The future in some shape or form. Your husband should
 offer you and your children the future. This is not a man;
 he's half nursemaid, half playmate, not even grown-up.

ANNE: He's what I want.

HENRY: And the manly virtues – strength and bravery, wisdom, courage... valour on the battlefield? What about them?

ANNE: Can I go now?

HENRY: Think again, Anne Boleyn. Your poor father has set his heart on founding a dynasty.

ANNE: Does that mean I have to settle for something I don't want?

(*HENRY takes a gold chain off.*)

HENRY: Wait. Take this to my wife – with my love and all the trimmings.

(*ANNE exits.*)

HENRY: Good God, kindness! Did you hear that?

GEORGE: Did she tell you that Mary has had a son?

HENRY: Well bravo. Her husband is a lucky fellow.

GEORGE: I wish I could get sons without...

HENRY: George! You know I was in the garden yesterday taking a recreational and I found that I was standing still, concentrating on a large clump of poppies, all in bud. While I watched splits appeared in those tight green helmets, fissures all down the sides, traces of white then abruptly scarlet, spilling out till the green was a thing of the past and the flower – blazing red, delicate petals falling slowly open – was revealed. Delicious!

GEORGE: I still wish I could get a son without...

HENRY: Fornicating? Well you won't because I'm not attracted to your wife. Not in the way you understand. You can't expect me to service the whole court.

GEORGE: I wasn't asking...

HENRY: I want you to write to the Pope... we have to see if we can get through to the Pope.

Scene 11

ANNE can be heard laughing. She stands in a crowd of men; they play dice or they read poems, whatever. ANNE is the centre of attention. HENRY's attention is caught. He crosses to them. Watches, unnoticed. ANNE laughs. HENRY goes to her. He grips her wrist, and pulls her away.

HENRY: I want to talk to you.

I want to ask you to keep an eye on your mistress.

ANNE: You're hurting me. Hurting me. Let me go.

HENRY: Forgive.

(*He lets her go. ANNE stumbles.*)

HENRY: Sorry –

(*ANNE rubs her arm.*)

ANNE: Why?

HENRY: Why keep an eye on Katherine? I suspect she is writing to Spain.

ANNE: I'm sore. Did you do that?

HENRY: How else was I to get your attention?

ANNE: I was only talking.

HENRY: Laughing.

ANNE: There's no law against laughter.

HENRY: My feelings are all jagged – I visited my wife.

ANNE: You've hurt me.

HENRY: Not intended. Damn.

ANNE: My wrist, it's all red, raw.

HENRY: Let me see. I don't know what came over me.

ANNE: Red.

HENRY: Yes.

(*HENRY kisses her wrist. ANNE steps away.*)

ANNE: I want to leave.

HENRY: No, no don't. My size. I'm so clumsy. I become irritated, cross... I don't know my own strength. Why were you laughing?

ANNE: What?

HENRY: Why were you laughing?

ANNE: I don't know. Because I was happy.

HENRY: Happy?

ANNE: Why else do you laugh?

HENRY: Are you happy?

ANNE: I was.

HENRY: What do you mean "was"?

ANNE: It's gone now.

HENRY: Generally. Are you happy generally? Plenty of young men paying you attention. Do you enjoy that?

ANNE: Yes. I love men paying me attention – I love being the centre. It makes me feel I'm something that I'm not – and I'd like to be. What's so wrong with being happy? I'm not now.

HENRY: I envy you. I'm not happy. And it's your fault.

ANNE: My fault?

HENRY: I think of you all the time; I look forward to seeing you. I dream of you and when I wake in the morning you're in my head like a bumble bee.

ANNE: A bumble bee?

HENRY: Buzz, Buzz!

(*ANNE laughs.*)

HENRY: You may laugh but it's an obsession. Like wearing an iron mask. I can't seem to think of anything else. When I wake my first thought is when am I going to see her? My last thought at night is of you – and all through the day. I'm haunted. You find this strange?

ANNE: Very strange – and unexpected.

HENRY: Unexpected! You don't think of me?

ANNE: What?

HENRY: Do you think of me?

ANNE: Um, no – not more than I might. I mean, seeing that you are the king. I'm sorry.

HENRY: I thought you might think of me.

ANNE: You are the king, I do think of you like that.

HENRY: Like what?

(*ANNE curtsies.*)

ANNE: The king!

(*HENRY goes white. He's angry.*)

HENRY: Mock me if you like.

ANNE: I don't.

HENRY: It seems to me that you do. I am the king.

ANNE: All I am saying is – you are the king. I can't help thinking of you. When my mistress, when you see the queen so often.

HENRY: Do you not think, can't you imagine why I see her so much? Magic when I see you – You have worked some form of magic –

ANNE: I haven't.

HENRY: You are a strange, disparate magical person.

ANNE: I remind you of Mary.

HENRY: Damn Mary!

ANNE: What?

HENRY: Damn her.

ANNE: You are imagining I'm like her.

HENRY: I'm not. This is enough to drive a man completely bonkers. Look, I think about you because you're different, not because you're Mary. I can tell the difference between you and Mary. And you are, you are – what you are is driving me crazy.

ANNE: I don't want to.

(*ANNE moves.*)

HENRY: Don't go.

ANNE: I want to.

HENRY: Stay, stay. Let me look at you. Those dark eyes, that wilful mouth, the hair that cascades, a waterfall. I want to fuck you.

ANNE: No.

HENRY: That's it.

ANNE: No.

HENRY: I want to fuck you.

(*ANNE moves away very startled.*)

ANNE: I don't want this.

HENRY: Stop.

(*He grabs her. ANNE struggles to get free. He hangs on.*)

ANNE: No. Let go. Let go.

HENRY: I'm not going to hurt you.

ANNE: Let go.

HENRY: Don't be frightened.

ANNE: I am frightened. Let go.

HENRY: Promise you'll stay. Promise.

ANNE: Let me go.

(*HENRY lets go.*)

HENRY: Don't run off screaming.

ANNE: Run off screaming?

HENRY: Don't.

ANNE: I must go. You can't do this. You can't.
It isn't right. Because you're big, strong. You can't.

HENRY: I wouldn't hurt...

ANNE: I am hurt. And, beyond, beyond, I'm hurt.
(*ANNE demonstrates where by banging on her chest.*)
Inside... Take my virginity away, destroy me, why
don't you?

HENRY: I didn't, I didn't.

ANNE: I spit on you. I spit –
(*HENRY leaves. ANNE continues to spit after him.*)

HENRY: I didn't mean.

ANNE: – spit – spit. You wouldn't treat a servant, or a slave
or a kitchen skivvy like –
(*ANNE falls on the floor. Stunned. She starts to cry. ELIZABETH
enters, followed by MARY.*)

ELIZABETH: Anne!
(*ELIZABETH goes to ANNE. She puts her arms round her.*)

ELIZABETH: Stop this shaking, stop it. I can't help if you
only shake.

ANNE: I can't. I can't. I... I'm – I am shamed. I... I... can't.

ELIZABETH: Stop it. Shamed? Stop.
(*ANNE starts to sob.*)

MARY: Wrap her up.
(*MARY takes off her cloak and gives it to her mother.*)

ELIZABETH: Darling, darling. There, there.

MARY: Are you ill?

ANNE: Help me. Help me.

ELIZABETH: We can't help you if we don't know.

ANNE: You won't when you know.

MARY: Oh, my God!

ELIZABETH: Tell me.
(*ANNE sobs.*)

ANNE: I was scared. I didn't want him closer. I couldn't let
him touch me – or put his mouth on mine. I couldn't let
him closer.

MARY: I expect he only wanted to kiss you.

ANNE: He didn't only want to kiss.

MARY: What on earth did he do, Anne?

ANNE: I'll become a nun. I'll enter a convent.

MARY: Oh piss, Anne! Who did what?

ELIZABETH: Sh!

MARY: I'll get the guard.

ANNE: No.

MARY: Whoever he is, he shouldn't get away...

ANNE: Don't.

MARY: Don't be stupid.

ANNE: No.

ELIZABETH: Darling girl, tell us. What happened?

ANNE: I spat.

ELIZABETH: Spat?

ANNE: I spat at him.

ELIZABETH: Who?

MARY: What?

ANNE: The king.

ELIZABETH: Henry.

ANNE: He'll kill me.

MARY: Henry!

ANNE: He'll kill me.

MARY: He won't.

ELIZABETH: Sh! The queen.

 (*KATHERINE enters.*)

KATHERINE: What's happened? Anne?

ELIZABETH: She's not well.

KATHERINE: You're white.

MARY: She was attacked – frightened – assaulted.

KATHERINE: Where's the guard? You've called the guard?

ANNE: No! Please.

ELIZABETH: I'll give her some air.

KATHERINE: Anne is my lady. No one must insult my
 ladies. I want the guard.

 (*No one moves.*)

 I want the guard.

ANNE: I can't... please forgive, don't... I'll explain. Oh
 forgive me. It wasn't my fault.

KATHERINE: Who is the man?

 (*Silence.*)

 Well who was he? Elizabeth?

MARY: She spat at him.

KATHERINE: She is not a cat. Henry? Was it Henry?
(*KATHERINE curses in Spanish.*)

MARY: It's my fault.

KATHERINE: You teach her to be a cat?

MARY: She reminds him of me.

KATHERINE: Oh, is that true? My husband is still
dreaming of you. I think not.

ANNE: I didn't do anything. I'll go into a convent. I want
to be a nun!

KATHERINE: This is a test of faith. Not the same as a
calling. We go into a convent to be a bride of Christ –
not escape a man.

ANNE: I know, I know. I didn't realise before. It's what I've
always wanted to be.

ELIZABETH: Her father won't be pleased.

MARY: She needs to be married.

KATHERINE: Oh maybe! I will not be angry if you
become the mistress of my husband, Anne. It seems to
be your family's calling.

ANNE: Please, please no! I wouldn't do that. I couldn't.
Don't think that of me. Please, I'd rather be a nun.
Believe me, then I could become more like you.

KATHERINE: I am not a nun.

ANNE: No, but you are an example, a holy person.

MARY: She's not like me.

ELIZABETH: She is more serious.

KATHERINE: She spat at the king. We will pray that my
husband does not seek revenge, and we will pray for
you, Anne. God will help us, and advise us, and show
us the best things to do. Then we will pray for your
sister, Mary. So she repents and her sins can be
forgiven. Then it will be your mother's turn, it is no
small thing to have a daughter who wishes to
renounce the world and take the veil. Lastly we will
pray for me, your queen. We'll pray that I remain
virtuous and forgiving through all the trials my
husband sets me. I will not abandon him, my grief will

not force me to abandon. And then we will give thanks to our God. This is the best that we can do. God help Henry.

(*They go down on their knees.*)

Scene 12

Summer 1527. HENRY and GEORGE. HENRY paces. He's restless. GEORGE looks at a picture of a woman.

HENRY: Tell me, am I not a bully?

GEORGE: You are not a bully.

HENRY: A bully, I know I am. Not consciously, you understand, but in the most damned unconscious way. I like my way too much, don't step back and say you go first, my friend. I like to be first.

GEORGE: You are – first.

HENRY: It can make a man insensitive. Are you my friend, George? Can I count on you?

GEORGE: I would like to be thought of as your friend.

HENRY: Tell me I'm no bully. We talk man to man. George, what? I'm asking you. Don't we confine in each other? You tell me things, I tell you things. Like equals. Not precious. You aren't completely sycophantic?

GEORGE: I am, but not completely.

HENRY: A butterfly lands on my hand. Visualise its trembling wings, imagine the beauty of them, the colours – rich reds, purples, brown, a flash of blue. It rests, as I said, its wings trembling about to open, yes, to trust – and I – instead of letting it be – close my hand, flatten, squash, squeeze into a pulp its poor fragile frame – mush in my palm.

GEORGE: Oh?

HENRY: A wanton act of violence, you see. Uncalled for.

GEORGE: Only a butterfly.

HENRY: If you think it's only a butterfly then you haven't understood.

(*Shouts.*)

You think it's only a butterfly!

(*Controls himself.*)

The butterfly stands for... you think it's only a butterfly. How could I be so stupid?

GEORGE: Sire, I will be, am completely sycophantic now. Grovel on the floor and apologise for not understanding.

HENRY: Woman – a woman – a female person. Get me your father!

(*HENRY flings himself to the floor. He howls.*)

HENRY: Thunder. Lightning – strike me dead.

(*THOMAS enters.*)

Thomas!

THOMAS: Sire?

HENRY: (*Cries out.*) Oh God! Oh God!

(*HENRY controls himself.*)

THOMAS: You've seen Wolsey's letter from France?

HENRY: He wants me engaged to Queen Claude's sister, what's-her-name? – Madame Renee. But I hear that she's some wretched hunchback. Physical deformity makes me anxious in the extreme, even mild aberrations – a boil on the face, moles with hairs in excess, warts particularly, give me the colly wobbles. And Wolsey thinks I can cope with a hunchback.

THOMAS: If she gives you children.

HENRY: She won't give me children. That's the point, Thomas, I won't be able to go close to her. Forget fathering children.

THOMAS: But...

HENRY: No!

THOMAS: It might all be tittle-tattle. Anne will know.

HENRY: What? Who?

THOMAS: My daughter Anne will know if there are any substance to these rumours. You feel faint?

HENRY: On the contary I feel invigorated.

THOMAS: They were educated together. Shall I fetch her?

HENRY: Anne.

THOMAS: My daughter.

HENRY: I know she is your daughter.

THOMAS: Why don't you speak to her?

HENRY: Why don't I speak to her? Why don't I? Thomas you're a genius.
(*THOMAS exits. HENRY falls to his knees.*)
Thank you, God!

Scene 13

SMEATON: You avoid me?

GEORGE: No.

SMEATON: Liar.

GEORGE: I don't know what this is about.

SMEATON: You know what it's about.

GEORGE: No, I mean about.

SMEATON: For me, it's about seeing someone – and thinking that they are beautiful. I look at you and I think what a beautiful person and then I think what can I do to belong to this person?

GEORGE: You see me every day.

SMEATON: I see that you are unhappy and I keep thinking what can I do to make you happy? There is something about being able to make someone smile a lot, sometimes to laugh. Surely it is the best thing in the world to be able to make someone happy?

GEORGE: Is that possible? Isn't happiness something that is locked inside or at least comes from within? I mean, don't you have to find it for yourself?

SMEATON: If your wife makes you unhappy.

GEORGE: But I keep thinking that's a small thing – as though I'd bruised myself jousting. Like when you lose a bet. Called being grown-up.

SMEATON: That's shit.

GEORGE: One expects one's closest friends to be male. One expects to argue over philosophy or politics... to lend money to pay off gambling debts, to cover for each other where necessary. One expects closeness – dependence – but not physical, nothing physical – not like with a woman. Not intercourse.

SMEATON: So no?

GEORGE: This isn't just something that could get me into hot water with my wife. It goes against the teachings of the Church. It could lose me my position with the king. It involves risk.

SMEATON: Oh well! Oh well!

(*SMEATON exits.*)

GEORGE: Smeaton!

(*GEORGE follows SMEATON.*)

Scene 14

HENRY – enter THOMAS, followed by ANNE.

THOMAS: Sire, my daughter, the lady Anne.

(*HENRY bows to ANNE.*)

HENRY: Ah, the lady Anne.

THOMAS: I've told her to tell you about Madame Renee.

HENRY: Good. Thomas – stay close by – I might need you.

(*THOMAS exits.*)

HENRY: People don't say no to the king.

ANNE: I know.

HENRY: No need to be so damned scared. On my honour I won't... I'll stay here. Rooted to the spot.

ANNE: Why do you want to see me?

HENRY: Sometimes we have feelings, emotions that are inconvenient, that we'd rather not have at that moment or ever even. Strong emotions are, they break through everything in a most inconvenient way. Love is uncomfortable. I would do everything I could to strangle love right now. I am in love with you. I want to be in love with you but – as I said – I would prefer not. I don't want to be here and now begging you to love me, but I am.

ANNE: I'd prefer it if you weren't.

HENRY: What?

ANNE: In – what you said – with me.

HENRY: Love?

ANNE: That.

HENRY: What's wrong with love?

ANNE: I'd prefer it if you weren't.

HENRY: Accept that I am. Why must you be so difficult? Most women would prefer it if I was.

ANNE: Would they, would they? Really?

HENRY: Yes, yes they would really.

ANNE: You assume...

HENRY: Yes? I'm arrogant? You can say I'm arrogant.

ANNE: Yes.

HENRY: Really arrogant?

ANNE: Arrogant people only think about themselves.

HENRY: Listen.

ANNE: Don't shout at me.

HENRY: I'm not shouting. I would have treated you well.

ANNE: And that would have made a difference?

HENRY: Well yes, it would have got it all over with – and you would have become unimportant to me.

ANNE: Unimportant to you and repellent to myself – and God. I have sworn that my husband will have my virginity. (*HENRY groans.*)

HENRY: Forgive me. Please, please forgive – How can you ever be unimportant to me? In the circumstances the best thing to do would be not to see you. To leave you alone.

ANNE: I'd like that.

HENRY: Don't say it.

ANNE: It's true.

HENRY: Say you'll forgive. I desperately want you to forgive me.

ANNE: If that's what you want.

HENRY: Promise me that I am forgiven.

ANNE: I'll pray to feel forgiveness – and for you to leave me alone.

HENRY: Pray?

ANNE: I don't feel forgiving.

HENRY: I must be forgiven. Thomas, Thomas. Tom.

ANNE: I'm planning to become a nun.

HENRY: What?

(*THOMAS enters.*)

THOMAS: Yes?

HENRY: Tom!

ANNE: Enter a convent. I've got a vocation.

HENRY: Tom. I want to woo your daughter – with your
permission.

ANNE: Father.

THOMAS: My permission? Damn it – with respect I don't
know about my permission. Do you think I run some
kind of whore house?

ANNE: You see, you see why I want to become a nun.

HENRY: Damn the past. Damn it. Hell, how was I to
know? I mean, that you had a daughter like Anne?
When you left just now to fetch her I had something
of a revelation. Anne, if you've got a vocation it's to
be my wife. No. I'm rushing myself. You're rushing
me. I'm being rushed. Please God! Please God – help.
It's a brilliant idea. Your inspiration and – the most
inspired, magical, perfect most marvellous f-ing idea
I've ever had. It's pure genius. Worthy of choirs of
angels. I meant, Tom, I want to marry her. I'm not a
man about to do – I'll never do anything to hurt her.
On my honour, Tom. My honour!

(*ANNE starts to laugh nervously.*)

Don't laugh. Stop her, Tom.

ANNE: Can't help it.

THOMAS: Anne!

HENRY: I really want you to marry me. I'm serious.

ANNE: It seems to me you'd do anything to get what you
want. Lie, cheat – but marry me!

THOMAS: Stop it.

HENRY: On my honour.

ANNE: Is that what he said to Mary?

THOMAS: Sh!

ANNE: You're married.

HENRY: Not forever.

ANNE: The Thames flows into the sea forever.

HENRY: Tom, help me.

THOMAS: I'm trying to think about it.

ANNE: You're married. You've got a daughter. Marriage is
forever. It's like, like the Thames was going to change

direction and flow out of the sea. Why would God want it to flow backwards when he made it flow forwards?

HENRY: God wants us to be married.

ANNE: I don't believe it.

THOMAS: Anne, there are circumstances that you don't know about.

ANNE: All I need to know is that he is married.

HENRY: All you need to know... all she needs to know is that I hope to be free to marry by Christmas. Thomas, I'm asking you. You know I've written to the Pope.

THOMAS: Anne – in the light of the circumstances that I know about and that you don't – we'll have to listen, consider.

HENRY: Sweetheart, there are all kinds of things about me that you don't know. Like I wasn't educated to be king. When my brother was alive I was meant to go into the Church – so I speak and write Latin, I understand theology, and I take some pride in my understanding of the Bible. All things that have given me the confidence to question the validity of my marriage. Your father knows that and he knows how hard I'm working to free myself from a relationship that is now anathema to me. My clergy are deliberating, I've written a book, and petitioned the Pope for an annulment. It's such a strange position to be in – married and yet not. It must seem odd to you. What I really don't believe is that I've ever been seriously in love before. Not like I am now. I've always felt that I was capable of a great love, a passion. I'm here before you with the blood pounding through my body and I tell you that I love you. Don't turn away from me. Please, dear lady – Anne – do you think you could love me?

ANNE: Love you when this is all mad? What does Katherine think? Does she know? Does she know even? She hasn't said – oh, but she has, she's been ill and sad. She's been too sad to say! This is all without her agreement, isn't it? Without her consent? She is my mistress, my friend.

HENRY: She doesn't see it as I do.

ANNE: A proposal of marriage should bring happiness and joy. I couldn't agree to something that's made her miserable. How could I live with that?

(*KATHERINE enters. ANNE goes and falls at her feet.*)

HENRY: Katherine!

KATHERINE: I heard that you had sent for Anne so I came to see what it was about. I must beg you not to offend my waiting woman.

HENRY: You told her!

THOMAS: What's this?

KATHERINE: She told me you make a suggestion that it brings shame to me to describe.

THOMAS: Is this true?

HENRY: I was foolish, in the heat of the moment – Anne has accepted my apologies.

KATHERINE: You've sent for her to make an apology?

ANNE: No, no. He didn't.

HENRY: Katherine, you have always understood that there are similarities between myself and King David. Didn't David take two wives? I have written to the Pope to ask if he will allow me to take two wives until our marriage is annulled.

KATHERINE: Two wives?

HENRY: I have come to understand that Anne is the woman God plans for me to marry. The wife that I am destined to have.

KATHERINE: Her? Anne?

(*KATHERINE explodes in Spanish.*)

ANNE: I said no. I said no... I can't understand – I don't understand any of this. Please.

HENRY: I will explain.

ANNE: But I don't understand what's happening.

KATHERINE: What's happening is that my husband thinks that I am not worth considering. That my feelings, and my sensibilities and my honour count for nothing. He thinks that because he is disappointed that I have not given him a son, he can tear up our

marriage contract. That he can humiliate me whatever way he wishes. He can stand here married to me, my husband, and promise his hand to a girl, a mere girl, a woman with no history, whose family are small English nobility, and count for nothing. A woman who has caught his eye because he knows her sister in the body. He makes these promises whilst still swearing to me that he would love me were it not for the circumstances of our marriage. This is betrayal. You do not care about me. You do not care about people. You think that what you want counts above everything else. There's no rules, no sense of shame, nothing prevents you.

HENRY: I won't abandon you. The example of David shows –

KATHERINE: David! (*More Spanish.*) What do you plan to do? Kill me? Poison me? Cut my head off? You cannot have another wife unless I am dead.

ANNE: I didn't say I would, I haven't agreed. I...

KATHERINE: What do I care if you agree or not? What do I care if you say yes? There will be no annulment. The Pope will not give it. I have Charles's promise.

HENRY: You've written to Spain!

KATHERINE: My family.

HENRY: You betray me.

KATHERINE: I betray you!

HENRY: When I want you to wash my dirty linen in full view of the market place of Europe I'll tell you.

KATHERINE: Spain must help me.

(*HENRY crosses himself.*)

HENRY: Give me patience.

KATHERINE: You ask me to say that my daughter Mary is not legitimate. That she has no right to the English throne?

HENRY: She is a girl, woman. God punishes us by not giving us boys.

KATHERINE: A girl can become queen.

HENRY: A girl can't rule.

KATHERINE: My mother was Queen of Castille.

HENRY: She doesn't see it as I do.

ANNE: A proposal of marriage should bring happiness and joy. I couldn't agree to something that's made her miserable. How could I live with that?

(*KATHERINE enters. ANNE goes and falls at her feet.*)

HENRY: Katherine!

KATHERINE: I heard that you had sent for Anne so I came to see what it was about. I must beg you not to offend my waiting woman.

HENRY: You told her!

THOMAS: What's this?

KATHERINE: She told me you make a suggestion that it brings shame to me to describe.

THOMAS: Is this true?

HENRY: I was foolish, in the heat of the moment – Anne has accepted my apologies.

KATHERINE: You've sent for her to make an apology?

ANNE: No, no. He didn't.

HENRY: Katherine, you have always understood that there are similarities between myself and King David. Didn't David take two wives? I have written to the Pope to ask if he will allow me to take two wives until our marriage is annulled.

KATHERINE: Two wives?

HENRY: I have come to understand that Anne is the woman God plans for me to marry. The wife that I am destined to have.

KATHERINE: Her? Anne?

(*KATHERINE explodes in Spanish.*)

ANNE: I said no. I said no... I can't understand – I don't understand any of this. Please.

HENRY: I will explain.

ANNE: But I don't understand what's happening.

KATHERINE: What's happening is that my husband thinks that I am not worth considering. That my feelings, and my sensibilities and my honour count for nothing. He thinks that because he is disappointed that I have not given him a son, he can tear up our

marriage contract. That he can humiliate me whatever way he wishes. He can stand here married to me, my husband, and promise his hand to a girl, a mere girl, a woman with no history, whose family are small English nobility, and count for nothing. A woman who has caught his eye because he knows her sister in the body. He makes these promises whilst still swearing to me that he would love me were it not for the circumstances of our marriage. This is betrayal. You do not care about me. You do not care about people. You think that what you want counts above everything else. There's no rules, no sense of shame, nothing prevents you.

HENRY: I won't abandon you. The example of David shows –

KATHERINE: David! (*More Spanish.*) What do you plan to do? Kill me? Poison me? Cut my head off? You cannot have another wife unless I am dead.

ANNE: I didn't say I would, I haven't agreed. I...

KATHERINE: What do I care if you agree or not? What do I care if you say yes? There will be no annulment. The Pope will not give it. I have Charles's promise.

HENRY: You've written to Spain!

KATHERINE: My family.

HENRY: You betray me.

KATHERINE: I betray you!

HENRY: When I want you to wash my dirty linen in full view of the market place of Europe I'll tell you.

KATHERINE: Spain must help me.

(*HENRY crosses himself.*)

HENRY: Give me patience.

KATHERINE: You ask me to say that my daughter Mary is not legitimate. That she has no right to the English throne?

HENRY: She is a girl, woman. God punishes us by not giving us boys.

KATHERINE: A girl can become queen.

HENRY: A girl can't rule.

KATHERINE: My mother was Queen of Castille.

HENRY: Queen of Castille! Till she married. Then she
became a wife first and a queen second. Whoever Mary
marries – Oh, for God's sake, I'd be giving England
away! This French betrothal; France will have England
on a plate. I hate the thought – a Frenchman on my
throne. I tell you a daughter is a cross.

KATHERINE: May God forgive you.

HENRY: A man gives everything away when he leaves
only a daughter to inherit.

KATHERINE: God gives us a daughter. It is his blessing to
us. This is wrong you are doing.

HENRY: It is the only right thing to do.

KATHERINE: I am your wife, Henry. I am your wife.
(*ANNE moves towards KATHERINE.*)
And she is your whore. Whore. Mistress. Concubine
that you foist on me. God's truth is that I am your wife.
I will not look after your dirty linen. Whore! God will
not bless such a union.

ANNE: No.

KATHERINE: Whore!
(*KATHERINE exits. ANNE goes to follow KATHERINE. HENRY
holds her.*)

HENRY: Stay. Damn it.

ANNE: Don't touch me.

THOMAS: My daughter is no whore. My family aren't
nothing. Henry, I give you permission to woo my daughter.

ANNE: No.

HENRY: Let me talk to her alone.

ANNE: No.

HENRY: I want her consent given freely. I promise not to
harm her.

THOMAS: Anne! I beg you – listen.
(*THOMAS goes.*)

HENRY: She shouldn't have said that. I must apologise for
Katherine. I started out with such high hopes. It's become
a mess. I felt sure I could convince you. No, please listen
to me!
(*Pause.*)

What to say? Anne, when you become my wife, you'll be my queen. Have you thought of what that means? You will eat off gold plate. And you will have your own household, and lands. I will make you rich beyond belief. Jewels. I'll dress you in jewels from top to toe, you'll be like a jewelled mermaid. Anne, you dazzle me now. My head is full of all the things I need to say and silence. Say something.

ANNE: I can't become your wife.

HENRY: I hate to see you so hurt.

ANNE: Hurt? Me? When you've done that to her? I admire, I love her and she calls me whore. I owe her my duty, my loyalty. She can't think that of me. I can't believe she thinks that. That's what you've done – made her hate me. You asked me to marry you and said nothing about anything to her, Katherine. She'll always hate me. And you still expect me to take you seriously! Two wives! No, no I don't want to hear about David. That's rubbish. I couldn't agree to that – whatever my father says. Bigamy. What Christian person has two wives?

HENRY: I love you. I'm clumsy because I love you.

ANNE: I'll kill myself.

HENRY: Don't. You don't understand what it is to be in love.

ANNE: Do you? I never want to be in love – not if it makes you behave like this. What are you? Some sort of monster? What do you think women are for? You treat us as though we felt nothing, like eiderdowns or blocks of wood, goods, things. No, no, don't say anything. Of course I want what you offer me. But does that mean I shouldn't care about her? That I should say yes, simply because I want those things, like everybody wants those things. If someone says to you – "would you like to be queen?" You say yes, yes! Because you do. I know it is a dream. I know right from wrong. At least I pray I do. I have all sorts of feelings inside me, I know that, a great mixture of difficult good and bad chopped up feelings, that fight with each other and pull me apart, and make

me want to scream, but I pray to be able to conquer the difficult ones and not go mad, and ignore the ones that don't matter, so that I'm only left with the godly ones. The ones that do me good. Isn't that why we pray to be led out of temptation? So we are better people? Oh God forgive her for calling me whore and God forgive me for hating her for it.

HENRY: I'm sure he does.

ANNE: When I marry, I will try to please my husband in every detail; he will have all my good thoughts, except for those that belong to God. Isn't that how women should lead their lives? And isn't that how Katherine has tried to lead hers? You can't take that away from her.

HENRY: Would it make any difference if I could convince you that my case was right? I'll have a scholar explain it all to you. It all depends on the translation from Hebrew to Latin.

ANNE: I am familiar with the idea that the Church can make mistakes. But we are talking about a life.

HENRY: If I can prove that this is what God wants. Let me arrange to show you.

ANNE: I don't want to know.

HENRY: You're scared in case I am right; that this is truly according to the Almighty's wishes.

ANNE: You aren't right in your treatment of Katherine. You can't just say however many years you've been married – they don't matter.

HENRY: Years wrongly married are years wasted. I've tried, Anne. I did my best to make it work, but how can something work that's not meant? Anne, listen, I want to start again. I want a fresh start – with you. You give me hope, and make my life worth living. Without you I might as well give up.

ANNE: There are other women. Find someone else.

HENRY: No one like you. You are the future. Your youth, your bravery. I love it all.

ANNE: No.

HENRY: What will you do?

ANNE: I told you – go into a convent.

HENRY: You can't do that. You know as well as I do that that would be an escape. You'd be doing it not from inner conviction but because it would be a way out of a difficult situation. An easy way out. You know this is difficult for me as well. But I know it's not going to go away and I'm not going to go away either. I'm not going to give up. And God help any man that gets in my way.

ANNE: I thought you wanted to win me fairly.

HENRY: Win you? Yes I want to win you. If you'll give me a chance. Please, Anne...

ANNE: I'm helpless, aren't I?

HENRY: Not helpless. Love me.

ANNE: I don't want to marry where I can't love.

HENRY: I won't marry you – unless you can love me. That's a promise. I won't have you unless you love me.

ANNE: Well, I won't be able to love you.

HENRY: Do you know what my idea of hell is at this moment?

ANNE: No.

HENRY: Living like this without an heir, knowing it's going to go on and on. That's hell. Knowing I can't give my people any faith in the future. That everything is for nothing, will be wasted, all my achievements lost at my death. And England thrown into chaos. If this is too much to ask of you, I want you to know that I'm not just asking for my own sake. But for all our sakes.

ANNE: You're the king, I know that I ought to love you but that doesn't help if I can't.

HENRY: Another clumsy, blundering thing! I shouldn't have said that.

ANNE: I'll keep on saying no, even though I know that to say no will mean holding my breath, not living because I won't be able to have anyone else. But I don't want to say yes. I can't say yes.

HENRY: Will you accept a gift?

ANNE: No, please.

HENRY: Look at it.
(*ANNE takes the gift – a ring.*)
What do you think?

ANNE: What a lovely thing.

HENRY: Take it, take it.

ANNE: The colour I've never... like sea, changing all the time. Moving; deep, deep blue, the colour of drowning, and splattered with white like wild horses – oh brilliant emerald green! It's lovely.

HENRY: It's for you. A sapphire!

ANNE: Full of mysterious whispers.

HENRY: Put it on. You're supposed to wear it. And you're certainly not supposed to think of drowning.

ANNE: But I do.

HENRY: If you must, try to think that you are drowning in my love. You must try to believe that for every person there is the perfect partner and that you are mine. I'll go now but I will be back. You'll find I am faithful, terribly, endearingly, obsessively faithful. Wear it. Thomas! God bless you.
(*HENRY goes. ANNE looks at her ring. She tries to pray.*)

ANNE: I want my mother to approve of me.
(*ANNE gets up unable to pray.*)
But I do think of drowning. Help me.

Scene 15

Autumn 1527. SMEATON enters. He plays. He is followed by HENRY, ELIZABETH, MARY, GEORGE, SMEATON and THOMAS.

HENRY: No words, you see. Complete failure. I've been trying to write you a song. Beautiful music but no words. It's as though they were alive and they wouldn't be caught and trapped in a song. They wanted to fly to you of their own accord, and settle like butterflies on your shoulders. Is that one?

ANNE: Henry.

HENRY: I'm not going to hurt it. Stay still. I've got it.

ANNE: What is it?

HENRY: Glorious.

ANNE: Oh.

HENRY: Oh and that must be melodious.

ANNE: Melodious what?

HENRY: As in my Anne's voice rippling along like some glorious melodious stream.

ANNE: And you couldn't find words?

HENRY: I was going to get Smeaton to furnish me with some. Then I thought this is my love, I must be the one to put my feelings into words. And I can't, I – It should be easy to. I know it's strong and powerful. Therefore. That's it! I'm opening and shutting my mouth, aren't I? No words coming out. I'm blabbing. Can't stop. A fish out of water – a great pike, stranded on a river bank, mouth opening and shutting, gasping for air.

ANNE: Poor fish.

HENRY: Was that another butterfly? Or a dragonfly?

ANNE: Where?

HENRY: In your mouth? You see words are inadequate; they cripple my feelings somehow. And my love is like whoosh – a cloud of stars. A shimmering mass of wonderful stars or the tail of a comet.

ANNE: That was beautiful.

HENRY: And is that one in your mouth?

ANNE: This one is. Stay still. If we're clever and ever so gentle I might be able to give it back to you. Don't move. (*ANNE kisses HENRY.*)

HENRY: More.

ANNE: More what?

HENRY: Butterflies, words. More kisses.

ANNE: You'll scare them off.

HENRY: Anne, Anne. You've completely dumbfounded me. And I came to ask you something. I've forgotten what it was.

ANNE: You came to play me the music for the song you couldn't write.

HENRY: Is that a butterfly? Just there on the corner of your lips.

(*ANNE rubs her lips.*)

I think it was a crumb.

HENRY: Anne! You can't kiss me and expect everything to go on as before.

ANNE: I don't see why not. Greed is not a virtue you know.

HENRY: Greed! Is to want more than anything to be kissed by you, greed?

ANNE: You came to play to me.

HENRY: You kissed me.

ANNE: You played, I kissed. Isn't that enough?

HENRY: Damn it. Damn it. Anne, does this mean that...

ANNE: What?

HENRY: That you could, you might feel...

ANNE: It means only...

HENRY: A favour. That's what I wanted. To wear in my helmet at the jousts this new year. I want all the world to know whose heart I wear above mine.

ANNE: What do they call women who hand out too many favours?

HENRY: Please! I'm not asking for too many favours – one. Thank God you can't take that kiss back. Give me something to wear.

ANNE: Mother, what favour shall I give the king? My mother is going to have to intervene, and stand between us so I don't get burnt by comets and stars.

(*ELIZABETH helps ANNE take something she is wearing off. ANNE hands it to HENRY.*)

Be brave for me, my knight.

Blackout.

ACT TWO

Scene 1

Christmas 1527-28. HENRY dressing with the help of SMEATON. GEORGE waits with a dog.

HENRY: Ever tried it?

GEORGE: What?

HENRY: Celibacy.

GEORGE: Can't say I have.

HENRY: Well you might – for my sake – to keep me company. It's your sister I'm planning to marry. And for two years – almost – I don't count the marital coupling – I've been celibate. Say something.

GEORGE: What?

HENRY: How the hell should I know what?

GEORGE: Katherine's made another shirt.

HENRY: I'm losing it. Our Holy damned father, the Pope, is trying my patience to the utmost. Pissing shilly-shallier. "Will-I-won't-I give the King of England an annulment?" I'm seriously afraid for my health – They are talking of convening a court here – because he can't make a decision. The court has to come here. What are you thinking about?

GEORGE: A dog. You know it has an amazing sense of smell – a velvet nose. You go out with it, and before you know where you are it's clamped on to the scent – and it sticks with it, through water, mud, shit, anything and everything. Now it's got a cold – won't stop sneezing.

HENRY: Damn it, George. Damn it.

GEORGE: I'm afraid it'll die.

HENRY: You've mated it. Well then. Before you know where you are you'll have dozens of hounds with velvet noses.

GEORGE: Has Anne sworn to marry you? I mean, far be it – she is my sister and all that –

HENRY: She can't, won't, the annulment has to come through before she promises.

GEORGE: Then it's no good me saying anything.

HENRY: Sympathy wouldn't come amiss. Companionship.

GEORGE: Companionship. Then there'd be two of us wandering around like, as though –

HENRY: What?

GEORGE: Are you going to wear that shirt? She is my sister. You know, I mean there are ways with a woman of um, getting relief without the full bit. I mean – if she'd agreed to marry you – it would be alright to explore those. Because you would be married eventually and therefore her honour – and my family honour – wouldn't be called in question – insulted. But since she hasn't... then, I guess, she won't. And um, what can I say?

HENRY: Sweet nothing. Sweet, flat on the floor, arse over tit, screaming, absolutely nothing.

Scene 2

January 1528. ANNE dances by herself. SMEATON enters. He carries gifts from HENRY. He puts these down.

SMEATON: The king sends you a dressed swan, two silver candlesticks, half a dozen candles, a plate of sweet meats, a jug of sweet sherry and a cushion – with a motto on it. What's wrong, little witch?

ANNE: Nothing. And don't, don't, don't ever call me that.

SMEATON: Little witch?

ANNE: No!

SMEATON: I always –

ANNE: Always doesn't mean it's all right, it's never been. You... we... friendship doesn't mean you can call people names – I've always asked you not to. You don't you listen. What sort of friend doesn't listen?

SMEATON: I'm sorry.

ANNE: I hate it.

SMEATON: I'm sorry.

ANNE: You do know what they do to witches?

SMEATON: I wasn't being serious.

ANNE: They burn them. Or they strap them to ducking stools and sling them in icy water. Kill them like rats. It's not funny.

SMEATON: No, I realise.

ANNE: I suppose you think I hear voices. Or the devil visits me at night. Or I speak to, I don't know, to familiars, in strange languages – cats, toads, dogs, snakes. Well do you?

SMEATON: Anne...

ANNE: Or maybe there's a mark on me somewhere – a devilish sign? Something that makes you think she's odd, she's inhuman, she's alien? A birth mark, eyebrows that meet in the middle? An extra finger – on one of my hands...?

(*ANNE holds her hands out.*)

Which one? Show me. Show me.

SMEATON: You know I don't think of you like that. It was a joke. You haven't extra fingers.

ANNE: Never in fun, ever even think.

SMEATON: I know you wouldn't hurt anyone.

ANNE: Katherine. I hurt her.

SMEATON: You do believe me? Anne?

ANNE: How did I get to be here? Sitting in her shoes? – almost. She wants to think evil.

SMEATON: I don't.

ANNE: She'd accuse me of witchcraft if she could. I stole him from her. Covered her sun with a black cloud. I've kept him. Look, he sends me presents. Proof, proof of my evil, malicious magic. I've enchanted him...

SMEATON: He loves you.

ANNE: She doesn't believe that! He loves her.

SMEATON: You must.

ANNE: He says he does but... He says he does! I still think of Mary. I still think of Katherine. And then I think not does he love, but can he? Can he?

SMEATON: You must stop this.

ANNE: He's dancing with her. In front of the court – smiling, kissing her hand. The contented husband.

Doing his duty by his wife. If I had power I'd – if I was a
witch – I'd be married, wouldn't I? She'd be dead.
(*ANNE crosses herself.*)
I didn't say that, I didn't say that.

SMEATON: I didn't hear you.

ANNE: I am becoming what I'm not. This whole thing is
changing me. I am coming to want what he can give
me. To believe that I can be queen. That I should be,
that I would be if only she... Is this love? And what
happens if nothing ever changes, Smeaton?

SMEATON: Look at what he's sent you, for God's sake.

ANNE: I keep thinking of death. That there is no way out
of this except by death.

SMEATON: I love your brother. You know they say that
men that love each other have entered a pact with the
devil. I know that's not true.

ANNE: I thought you loved me.

SMEATON: I do. I meant George and I, we are lovers.

ANNE: What do you mean?

SMEATON: We are lovers.

ANNE: George? George, my brother George?

SMEATON: You're shocked.

ANNE: I don't know what I am. Why tell me?

SMEATON: We make each other happy, Anne, what's
wrong with that?

ANNE: I don't know. The Bible says...

SMEATON: We should love one another.
(*We hear HENRY approaching.*)

ANNE: We should love one another. Henry – !
(*SMEATON exits. ANNE shows no excitement. She stands still.
HENRY enters.*)

HENRY: Where's the lady that rules my heart, the dearest
light of my life?
(*HENRY pauses.*)
I am here. Me, the king, your Harry – not some dark
and lonely stranger. Why no greeting?
(*ANNE goes into a deep curtsy.*)
What are you doing?

ANNE: Learning to live with confusion.

HENRY: Did you like my gifts?

ANNE: Inanimate things. I am not a child that has to be showered with gifts.

HENRY: You are the lady-that-I-love-to-shower-with-gifts.

ANNE: Beautifully put.

HENRY: Why are you like this?

ANNE: God give me strength! Love, I thought you loved me. If you do, why do you leave me alone?

HENRY: Smeaton was here.

ANNE: Smeaton! I've been dancing by myself.

HENRY: Dance with me – now.

ANNE: Don't patronise me.

HENRY: I'm not.

ANNE: You've been dancing – with her!

HENRY: Yes, yes, I've been hopping and skipping and twirling around – I wanted to be here. Anne, I thought of you. I left as soon as I could. Believe me. She wanted me in bed with her.

ANNE: So do I. No, no I didn't say that. I didn't mean, I meant – I hate this. I want all this waiting over –

HENRY: When two people love one another... They believe, my darling, just a little that the other one is thinking of them when they're apart. I am reminded sadly that you don't love me since you don't have any faith in me.

ANNE: Me not love you?

HENRY: You can't love me. You say you don't.

ANNE: This wouldn't be loathsome, horrible and foul to me. I want, I want to go and live on my own in a wood somewhere.

HENRY: Then I wouldn't see you.

ANNE: Then we wouldn't make each other miserable. I am miserable, miserable, when you're with her. I come second, or third, fourth, fifth in your affections. You forget me.

HENRY: Sweetheart.

ANNE: It's awful being alone. I'm lost.

HENRY: Jealous?

ANNE: Idiot. Stupid, stupid gargoyle man. Jealous. I'm insanely jealous. I'm going mad with it. It hurts. "Wish it would bloody go away", "don't know what to do with myselfly" jealous. Hurts, hurts.

HENRY: Where does it hurt?

ANNE: Here.

HENRY: You do love me?

ANNE: You lied to me.

(*Pause.*)

You didn't tell me I'd have to wait. This waiting is hell.

HENRY: I didn't know. Do you love...

ANNE: Stop asking! You've known for months and months and months – forever. Such terrifying confidence. And you laugh at me.

HENRY: You didn't say.

ANNE: There's no... no... comfort in it.

HENRY: Darling, dearest! Comfort. Aren't I a comfort? Come here. Now that you love me, are you going to agree to marry me?

ANNE: I'll marry you.

HENRY: We should swear to love each other – become betrothed – in secret. Love is forever, Anne. Do you love me like that?

ANNE: Love is forever. It scares me to say so but – yes.

HENRY: Come here.

(*Pause.*)

I do swear before God, that when my marriage is annulled, to marry you, Anne.

ANNE: And I swear before God to be your wife, Henry – when your marriage is annulled...

(*They kiss. ANNE breaks it off.*)

HENRY: Don't you like my kisses?

ANNE: Oh, yes.

HENRY: They are almost married kisses.

ANNE: We're not.

HENRY: In law betrothal is binding and we will marry.

ANNE: You are still married.

HENRY: It seems, sweetheart, that you should allow me to be more – more closer, intimate...

ANNE: What?

HENRY: Trust me.

ANNE: Trust you?

HENRY: Darling.

ANNE: I say I love you. I say I adore you. I say I'm madly, wildly, excruciatingly jealous. And all you can think of is – is what you've always thought of – my sex. When you're going to get in there. When you are going to deflower me! You don't love me.

HENRY: Don't say that.

ANNE: It's true.

HENRY: It's not.

ANNE: You are, you are, you are.

HENRY: What have I got to do, Anne? No, listen. Trust between two people. It's about trust. My darling, if you trust me – I won't let you down. I swear solemnly on the night sky, the stars, the owl's hoot, not ever, ever to let you down. Trust me with yourself, your body, and I will show you, give you all the pleasure a man can without – damn it – and show you how to – damn it.

ANNE: What? What? What?

HENRY: God give us some relief from this dryness, this forced dead nothingness, this frustration – eternally waiting.

ANNE: It goes on and on. Then you say – damn it, trust me, let me – I don't know. What's changed?

HENRY: Everything!

ANNE: Nothing. You're still the same man that thinks he can push me over onto my back. I am the one who has to give all the time.

HENRY: I didn't mean...

ANNE: What did you mean?

HENRY: I don't know.

ANNE: You don't know.

HENRY: Come here. Let me show you.

ANNE: No.

(*ANNE exits.*)

HENRY: Trust me. Trust me, God damn you, why don't you trust me?

(*HENRY hurls something across the room. GEORGE and SMEATON appear.*)

SMEATON: Don't do anything.

GEORGE: Think about something else.

(*HENRY screams – as if in great pain.*)

There's a letter to be written to the Pope.

HENRY: Thank God for that. Get me my night clothes. Katherine!

(*HENRY heads for KATHERINE. Time passes.*)

Scene 3

ANNE, MARY and ELIZABETH. MARY is dressed in black.

MARY: Death is supposed to bring grief. I can only think of practical things. Like how will we live?

ANNE: And love is supposed to bring happiness. Instead it brings uncertainty, misery. I'm not going on with this. You can have this, these...

(*ANNE takes off some jewellery.*)

MARY: They're from Henry.

ANNE: Yes. You can have him back now.

MARY: I don't want him back.

ELIZABETH: Stop bickering. Take the jewels.

ANNE: I'm not going to go back to him. She might as well have him back.

MARY: I want William back!

ELIZABETH: See what you've done.

ANNE: I won't be able to get her a pension now.

ELIZABETH: What on earth's gone wrong?

ANNE: Everything. You've got to help me. Explain to Father. Henry keeps on, he keeps on.... and I won't.

MARY: Why don't you become his mistress?

ELIZABETH: Mary!

MARY: Why doesn't she? It's such a mewling stupid thing to go crying on about your virginity. Once it's gone, it's gone. It doesn't mean anything.

ELIZABETH: Of course it means something, Mary.

MARY: Whatever it means, this hanging on to it is dangerous. Can't you see that? We've got enemies.

ELIZABETH: Shush, Mary.

MARY: People who'd, not just who'd like to see us dead, but who'll actively plot to see us under seven feet of thick soil.

ELIZABETH: We have to trust God. Anne is trying to do what she thinks is right. I'd like this whole sorry situation over with. It's completely ruined my friendship with Katherine. But we have to think about Anne, and what the Church says, as much as we have to try and lead godly lives. A woman offers her virginity to her husband on her marriage bed. It's a sign of her purity, and the blessedness of her marriage vows. I shouldn't have to remind you, Mary. We also have to acknowledge our vulnerability as women. And there's no question but virginity is an important asset when a marriage is being arranged.

MARY: Mother! Katherine will never give in and Anne will be left with nothing. You're not going to be able to arrange another marriage while he... Oh, Mother! You can't bargain with her virginity.

ELIZABETH: She has to live with herself, doesn't she? And Anne won't be able to if she becomes Henry's mistress. You wouldn't see that because you don't care what the Church thinks. She'll lose her self-respect, and if she loses that then she really does lose everything. She becomes that man's creature.

ANNE: You don't like him.

ELIZABETH: He's the king.

MARY: I want her to be happy, and happiness should be seized with both hands. He could make her happy.

ELIZABETH: You can't say that and expect it to happen. Happiness isn't predictable. It's complicated. Why do we insist on thinking it's uncomplicated?

ANNE: You want me to give him up?

ELIZABETH: This isn't what I want for you, neither of you. Mary a widow, and you... You a...

ANNE: Concubine.

ELIZABETH: The word sticks in my throat but yes. I can't understand Henry's reasoning. It might be very clever. How can he put Katherine aside? You'll always be a concubine.

ANNE: I don't have your blessing.

ELIZABETH: What would happen if your father wanted to marry again?

ANNE: You weren't married to his brother.

ELIZABETH: Henry has too much power. I wish you didn't love a man with so much power. I wish he wasn't the king.

MARY: It's because he's a king that he'll be able to make her happy. Mother, can't you imagine what it is like to be loved by him? Imagine being queen.

ELIZABETH: No, I can't.

ANNE: Bless me!

ELIZABETH: Dear God, bless my daughters.

(*Time passes.*)

Scene 4

1530. HENRY, GEORGE at work.

HENRY: Do you think it would be too much to expect the Pope to deliver a verdict this Christmas?

GEORGE: What do you want me to be? Optimistic? Pessimistic? Realistic?

HENRY: Realistic, realistic.

GEORGE: Pope Clement has digestive problems.

HENRY: When does the Cardinal Campeggio expect to fetch up here? Clement swears he's given his legates, Campaggio and Wolsey, the authority to make a decision on his behalf.

GEORGE: Campeggio's problems are legendary! He's a very sick man. It'll take him half a year to manoeuvre his aching limbs across Europe, and then there's the channel and...

HENRY: Damn you. I said no pessimism. What's that Smeaton? (*SMEATON brings in a model silver boat.*)

SMEATON: A present from Anne, sire, in Hever.

HENRY: From her! Put it down. I'm quite overcome.

GEORGE: I smell an allegory.

HENRY: What?

GEORGE: Anne likes allegories, all that classical speaking through pictures.

HENRY: I know what an allegory is. Explain this to me.

GEORGE: I'll start with the boat. Since the Ark, you know Noah and all that, a boat equals safety. The sea is crazy, raging, there's a storm but she, this lone female places herself in this boat and sails to you. The diamond signifies... (*ANNE appears behind GEORGE.*)

ANNE: The diamond signifies my heart. Hard as a diamond, strong, true...

HENRY: Trust, my darling. You trust me!

GEORGE: Look at that wave.

HENRY: Go away. No, come Anne, we must talk in private.

GEORGE: And Cardinal Campeggio?

HENRY: Campeggio? We've established he's not going to deliver himself in a whirlwind. Clement wants us to feel every breath Campeggio draws. Well fine, good. Gives us time together. You carry on. (*HENRY and ANNE exit.*)

GEORGE: You know how people turn into things they're not, by close association? Well I'm becoming a lawyer, a scholar, a cleric, a man of parchment.

SMEATON: No time off?

(*Time passes.*)

Scene 5

Autumn 1528. SMEATON and GEORGE.

SMEATON: So where is Campeggio now?

GEORGE: In bed –

SMEATON: – with gout?

GEORGE: Gout and disappointment. He went to tell Katherine that the Pope wants, suggests she becomes a nun...

SMEATON: And?

GEORGE: Predictably she refused. If one is waging a moral crusade against one's husband, one doesn't enter a convent even to please a Pope.

SMEATON: So what now?

GEORGE: Nothing. Katherine's saying masses for Henry's soul.

SMEATON: No wonder Campeggio's gout gets worse.

GEORGE: Worse, and worse. I dare say his limbs are swollen and aching, but this general inability to get out and about and on with things, buys time. Campeggio brilliantly illustrates the art of procrastination.

SMEATON: I thought that was your province.

GEORGE: Thank you. Parent?

(*THOMAS enters.*)

THOMAS: Campeggio. Campeggio, wretched man! Says the court can't possibly sit until after Christmas. After Christmas!

(*GEORGE and SMEATON exchange looks.*)

GEORGE: He's too sick.

THOMAS: Pray God he doesn't die! And Wolsey says that the Pope hasn't given them the authority they need anyway. It's unbelievable.

GEORGE: Have you told Henry?

THOMAS: Judgement still has to come direct from Rome.

GEORGE: Do you want me to?

THOMAS: No.

(*Pause.*)

He promised he'd give them the authority. A Pope break a promise? A Pope deceive! Popes aren't supposed to... there should be a law against it.

GEORGE: I will if you want me to.

(*THOMAS crosses himself.*)

THOMAS: I said I'd do it.

(*THOMAS exits.*)

GEORGE: Me? Procrastinate? What do you mean? Come here.

(*SMEATON goes to GEORGE. Time passes.*)

Scene 6

HENRY roars on.

HENRY: Get me Wolsey! Wolsey! Get me Wolsey!

GEORGE: He's told him.

(*He goes to the piles of papers.*)

HENRY: Shit!

(*HENRY knocks the papers over. ANNE enters.*)

I give up.

ANNE: What?

HENRY: I give up. They are all against me. Everything. Everyone. Except for you, my darling. I'll retain some sanity – at least.

ANNE: Give up!

HENRY: Oh God, and I believed that a Pope could be impartial. This isn't justice. He hasn't the courage to swat a fly let alone be a Pope!

(*ANNE pulls herself away from HENRY.*)

ANNE: You believe your marriage is wrong?

HENRY: What's the point if no one else believes what I believe?

ANNE: God is on our side. I thought that is what you believed.

HENRY: I do.

ANNE: Then how can you give up?

HENRY: I'll go mad if I don't. Do you want me mad? Katherine will finally send me cuckoo.

ANNE: She won't.

HENRY: No, no. No, no. Her infuriating, eternal no!

ANNE: So you'll give in to her. She knows you will.

HENRY: Nan, Nan come here. Kiss me.

ANNE: Nan, come here, kiss me! So you can go back to her?

HENRY: Don't be stupid.

ANNE: Stupid! Who wants to give up? You give up if that's what you want. I want you to know that I feel I've wasted my time, my youth. Everything! Squandered… Why didn't you rape me? No one will touch me now.

HENRY: Sweetheart.

ANNE: Look at me! I'm getting old. I've got crow's-feet

round my eyes. My chin is all squashy, disgusting, flabby. My neck wrinkled...

HENRY: For God's sake.

ANNE: My breasts are about to droop and sag like old wax. My womb to dry up. Soon I won't be able to conceive. It will all have gone. All my best years, my child-bearing years will have been thrown away. Give up. Give up but find me a husband before it's too late.

HENRY: I'll find you a bloody husband.

ANNE: Good. Then I can have children – nurseries full.

HENRY: Like a bloody hen. Don't, don't pressurise me!

ANNE: Well how can you be so feeble. "I give up." You sound like an old man.

HENRY: If they won't let us.

ANNE: If they – Are we dependent on them entirely?

HENRY: Yes.

ANNE: So speaks Henry, King of England. I wish I'd known, I wish you'd told me years ago that you gave up. That you had no stomach for a fight. I love you, damn you. I never dreamed you'd give up.

HENRY: I haven't.

ANNE: You have.

HENRY: I haven't.

ANNE: You will. You don't care about me.

HENRY: I love you.

ANNE: What is the point of love that, that peters out, wilts?

HENRY: Wilts? I don't wilt!

ANNE: You do.

HENRY: Wilt!

ANNE: Henry, you've gone soft, weak. If you give up I'll kill myself.

HENRY: Daft tousled headed woman! Soft!

ANNE: Don't sweet-talk me. How can you say give up? It feels like you're heaving a tombstone, dumping the end on me.

HENRY: Darling, darling, don't weep. Sweetheart. Forgive me, sweetheart, dearest, love of my life – and soon to be mother of my children. Be brave. Forgive me, crazed creature. I won't, I'll never give up.

ANNE: Swear?

HENRY: I swear it.

ANNE: If this all goes against us? This court case – if the Pope finds for her – then you will.

HENRY: I won't.

(*ANNE goes to him.*)

We've still got Wolsey on our side and he's as much a cardinal as Campeggio. He'll have to write to Rome to arrange things. He'll get the annulment. He's sworn to. I can't live without you.

ANNE: Henry, I'd give my life for you.

HENRY: It won't go against us. George! George write to Wolsey. Get him to write to the Pope.

(*Time passes.*)

Scene 7

ANNE and HENRY sit and wait. GEORGE works. Letters are delivered.

HENRY: (*To GEORGE.*) Well?

GEORGE: Katherine won't recognise the authority of a Legantine court in England. She says the case has to be heard in Rome. She walked out of the court.

(*HENRY crosses himself feverishly.*)

HENRY: I know. God help me if I don't blast her into the everlasting bonfires of eternity! She has no right!

(*GEORGE hands HENRY some letters.*)

GEORGE: You better look at these.

HENRY: What?

GEORGE: There's one from Rome.

(*HENRY circles the stage then exits with his letter. GEORGE goes back to his desk. He starts to write. ANNE takes a pile of books from the desk. She sits and looks through them.*)

My Lord Cardinal Wolsey...

(*THOMAS enters cursing.*)

THOMAS: Mary, Mother of God, save me from the most filthy, uncharitable thoughts that a man could have rotting his brain. Campeggio's a crust pot, Campeggio stinks of sour mustard. Yes, Campeggio, three bags full Campeggio.

GEORGE: Parent?

THOMAS: What are you doing? Working! Listen to this –
Campeggio says we should all have a holiday! He's
broken the court for a holiday – They have holidays in
Rome! So put that pen away. (*To SMEATON.*) Haven't you
got a song to write?
(*SMEATON exits.*)

THOMAS: Who are you writing to? The Pope?

GEORGE: No I thought I'd write a sonnet to Katherine.

THOMAS: Do you think Wolsey has any idea what the
Pope is playing at?

GEORGE: Does anyone?

THOMAS: Jane has been to see me.

GEORGE: Jane?

THOMAS: You don't see her. What's wrong with you?

GEORGE: I work, Father, I spend nights tied to this desk.
They bring in cushions so I can get a few hours sleep in
the corner. Jane knows I work.

THOMAS: You're not impotent, are you? What is it then?
She complains that you prefer the company of that
fellow to hers. Damn it you should be getting sons.
At your age, your rank. Is there anything between you?
Jane says... I won't repeat what Jane says.

GEORGE: I can't give her the attention she demands.

THOMAS: I want heirs, grandchildren.

GEORGE: Am I not doing my damnedest to help Anne
marry the king? Am I? Am I?

THOMAS: At this rate neither of you'll have children.
(*SMEATON off has been practising his instrument. HENRY off, roars
at SMEATON.*)

HENRY: Stop that eternal racket. Jesus Christ, can't I even
have a musician that plays in tune?
(*HENRY glares at everyone and exits.*)
Idiots!
(*SMEATON enters, scared.*)

SMEATON: Mother of Christ!
(*THOMAS looks at GEORGE then at SMEATON. They look at ANNE
who ignores them, picking up another book to examine.*)

THOMAS: I'll go after him.

(THOMAS exits. GEORGE goes and picks up the letter that HENRY threw. He smoothes it out and puts it back on the desk.)

GEORGE: It's from the Pope. The Parent has cottoned on.

SMEATON: What?

GEORGE: About us. The Pope agrees to all Katherine's demands, and calls the whole circus back to Rome. Briefly. In a nutshell.

SMEATON: I'm sorry, I can't quite take this in.

GEORGE: Katherine has won.

SMEATON: Fuck.

GEORGE: It's amazing the poverty of language at times like this.

SMEATON: Fuck.

GEORGE: And again. Fuck it all.

SMEATON: Henry go to Rome?

GEORGE: He can't

SMEATON: He can't. Shit.

GEORGE: Can't leave England. Can't go all across Europe and can't wait on the pleasure of a Roman court who don't know the first thing about procreation or speed. They'll procrastinate until we have civil war or a full-scale foreign invasion and Henry will still be sitting on the Vatican steps twiddling his thumbs. And he forbids Henry to marry again – without a divorce.

SMEATON: You said something about us. Are we over?

GEORGE: Not now.

(HENRY enters, followed by THOMAS. HENRY is ripping up a shirt.)

THOMAS: What are you doing?

HENRY: Not given to destruction but –

THOMAS: Give them to me. I'll wear them.

HENRY: I'll bloody destroy her shirts if I want to. She accuses me, in court before everyone, the whole world, of being ungenerous to her. She says all I want to do is get rid of her – and then she lumbers back to her rooms, calls for needle and cotton and continues sewing! The witch is stitching me a shroud. She'll have me in it and laid out on an altar so she can pray over me. As if I am the one that is sinning!

(*HENRY removes his shirt and rips it in two.*)
No more shirts. And this. Blast it. Here, take this to her,
tell her I won't receive any more – and not more of
anything, no gifts! Not in any shape or size. Understood?
(*Bellows.*)
Wolsey!
(*Silence.*)
Take a letter to Wolsey. No, call my council. I'll have
them see he's stripped of all authority, and left like a
naked babe to howl at the stars. God and I believed that
man! Get him to hand over the seal, and return – back
to York. Send him to York. I cannot and I will not –
damn it!

GEORGE: Next?

HENRY: Next?

GEORGE: Something must happen next.

> (*HENRY sends GEORGE's papers flying. He ends by tipping the desk over.*)

HENRY: We obliterate the past.

> (*Pause.*)

Don't have anything to do with what was. Get a new
chancellor. Sir Thomas More will do! Dowager the
dowager queen for once and all, finally. Katherine!
(*KATHERINE materialises.*)
You are our past. Bye bye.
(*KATHERINE starts to cry and plead with HENRY in Spanish, saying how much she loves him, and will only love him etc. She has to be carried off.*)
Go and rot in some distant castle. Peterborough. Love!
What? You? I revile, I spit on your love. It wouldn't
even keep a tortoise warm! I'll have nothing more to do
with a person who shows by her every damned action,
that she does not care for me. Only for her own
damned skin.
(*KATHERINE is taken off.*)
My love? Come, come. Stop your studies.

ANNE: Are you free?

> (*HENRY looks around as if for KATHERINE.*)

HENRY: Free as the wind to billow around my love. We
should rejoice.

ANNE: How?

HENRY: Every how – with music, dancing, jousts. Hunting.
All our lives will be spent rejoicing.

ANNE: But are you free?

HENRY: Smeaton, I need new shirts.

(*ANNE goes back to reading.*)

GEORGE: Wait and see?

THOMAS: Prayer?

HENRY: Prayer! As David rested in faith, in trust that the
Lord would protect him, knowing that his cause was just,
so I will put my faith in our Father. For he is my
protector and in him will I trust. Wait and see.
"Unto thee will I cry, O Lord, my rock, be not silent to
me: Lest if thou be silent I become like them that go
down into the pit." (Psalm 28)
"As the hart panteth after the water brooks, so panteth
my soul after thee, O God." (Psalm 42)
Isn't there anything in that pile of paper? George?

(*GEORGE and THOMAS rifle through the papers.*)

THOMAS: So?

GEORGE: I will try and pay more attention to her.

THOMAS: Good.

GEORGE: There are still avenues to be explored. The great
thing is to continue to put pressure on Rome...

THOMAS: Pressure on Rome? What sort of pressure?
You're not talking armies?

GEORGE: Intellectual, academic pressure. The Pope
doesn't have a monopoly on ideas and interpretations.
There are great intellects out there in the universities,
and a case to be proved.

THOMAS: I suppose I have to go to Spain to try to prove it.

GEORGE: You're the best there is. We could do with
French support.

THOMAS: I can't be everywhere at once.

GEORGE: Have you ever wondered if the Pope actually
has the power to judge what is, after all, a domestic case?

THOMAS: God help you. Questioning the authority of the Pope is heresy, George. We aren't doing that.

GEORGE: Maybe we should.

THOMAS: Things are bad enough without you spouting heresy. Anyone would think you'd been reading Luther.

GEORGE: It's called being informed. Besides what else can we do? Look into the abyss, see a blank nothing and despair? Or do we invent a future for ourselves? And a future for our family.

(*Time passes.*)

Scene 8

ANNE gives a book to HENRY.

ANNE: William Tyndale's *Obedience of a Christian Man and How Christian Rulers Ought to Govern.*

HENRY: Anne!

ANNE: In it he says all the things that you think.

HENRY: What? What do I think?

(*HENRY picks up the book.*)

"A ruler is answerable to God alone; the obedience of the subject to the ruler is an obedience required by God." In other words kings rule by divine right. "And for the Church to rule the princes of Europe is a shame above all shames and a notorious thing." That's what I think! Will you let me touch you now, only touch?

(*ANNE and HENRY proceed to explore each other. Time passes.*)

Scene 9

GEORGE and SMEATON. GEORGE is writing to the bishops.

SMEATON: My Lord Rochford.

GEORGE: Hello.

SMEATON: Shuffle, shuffle.

GEORGE: Won't be long.

(*GEORGE explains what he's doing. Consults some papers.*)

SMEATON: Won't be long. Cough. Cough. Scream. Scream.

GEORGE: In a minute.

SMEATON: Are all those to the Pope?

GEORGE: No idiot, against the Pope, these are ammunition against the Pope. These relate to the *Collectanea Satis Copiosa*. These to the Determinations from the universities. And these are to our bishops, asking them who do they think heads the Church in England.

SMEATON: Endless.

GEORGE: What?

SMEATON: When will it all be over?

GEORGE: Soon, I hope. Parliament has to sit. I know what you're going to say; you never see me. I never see me. I am becoming a thing of the past. I'm transmogrifying, turning into a button on my sister's dress.

SMEATON: I should find someone else.

GEORGE: Yes. When and if Anne marries Henry – when and if Anne becomes queen – God knows what will happen. I think it will have to be over. But I think it's over now.

SMEATON: You'll be the king's brother-in-law. I'll be his musician – still.

GEORGE: I'll still have to work. Damn it, I'll still have work to do.

(*SMEATON exits. Time passes.*)

Scene 10

HENRY and ANNE come in from hunting.

HENRY: Where's your cap, you wanton creature?

ANNE: Blown away.

HENRY: Your hair is all mussed up around you – like Medusa's locks.

ANNE: Watch out I don't turn you to stone.

(*HENRY stays still as if turned to stone.*)

I'm hungry. Harry, Harry come on. Move! What's wrong?

HENRY: Turned to stone.

ANNE: You! What are you, marble? Granite?

(*She kisses him. HENRY remains still.*)

I'll have to find another suitor. Did Lot find another wife?

HENRY: Salt!

ANNE: Salt, stone. A statue is no good to a woman.

HENRY: You call yourself a woman! I've never seen a woman bond with her horse like you.

ANNE: Sometimes you have to imagine you're flying. Or caught up and tossed, spinning towards the clouds like my cap. When I'm on the ground I can't think. It seems as if I'm always being whittled down to something practical. Something you can put in your pocket and carry away. I'm going to my room.

HENRY: Don't leave me.

ANNE: My hair is absolutely a disorderly mess.

HENRY: Absolutely adorable. I want to talk to you. Send for your ladies, they can tidy you here. Glorious, disorderly creature.

ANNE: Gloriously muddy.

HENRY: I want to talk to you. I thought we'd discuss scripture.

ANNE: I have to send for my mother.

HENRY: Your mother?

ANNE: I want her to chaperone me.

HENRY: We don't need a chaperone.

ANNE: We do.

HENRY: I've ridden with you all day.

ANNE: Henry. Me – me. Don't you think that you might be the one that needs protecting from me?

HENRY: Anne!

ANNE: From my wanting, my passion. I feel so alive and happy. We should be able to live our lives now. When everything is so astoundingly beautiful, and fulfilling. I want. I want.... and I want to... Mother!

HENRY: No, no, Nan. I'm teasing. I've never wanted anything more than I have, until I have a right to it and I promise you, I will have that right soon. Darling, believe me, I want to make you the happiest woman in the world.

ANNE: The happiest! To love you. And to be loved by you. How could I be happier? – Except when I fulfil my destiny and give you sons. Sons, Henry!

HENRY: I can't wait.

ANNE: Not wait?

HENRY: No.

ANNE: Then we won't. Not any longer.

(*HENRY kisses her. They start to undress.*)

Scene 11

Winter 1532-33. THOMAS and GEORGE. THOMAS walks up and down. GEORGE struggles to keep working.

GEORGE: Cold feet, Parent?

THOMAS: What? Cold feet? No! Bit late for that. They're either there or they've dropped off. I am trying to recognise it all. The landscape is different. You never think when you grow up that you'll end up living on the moon.

GEORGE: Please, not the moon, Parent.

THOMAS: Why not the moon? We live, we breathe by the rules of the Church. Our lives have been constricted, confined by Church. How we live; it's all been prescribed – blessings, feasts, fasts, penances. What the Church says makes us what we are.

GEORGE: That's philosophy, Parent!

THOMAS: Philosophy my arse. It's true. Now all of a sudden my daughter is in bed with my king, and they claim that this is God's will, not the Church's – God's. Separate. What are we to think?

GEORGE: It's a new age.

THOMAS: So I've got to stop living as I've always lived? Find some other way of being?

GEORGE: I don't see why.

THOMAS: Use your head.

GEORGE: He's made her Countess of Pembroke. She takes precedence over the king's sister.

THOMAS: This is not just about us benefiting. Henry can only marry Anne if he breaks with Rome. Then the Pope can either agree that he has done the right thing or he can excommunicate him. And if he excommunicates him then Henry takes the country with him.

GEORGE: You sound like Katherine.

THOMAS: I'm not talking about marriages made in heaven. We'll be asked to choose between two sets of rules – ones we've known all our lives or Henry's! Do you understand? Are you listening to me?

GEORGE: I'm listening. You're scared none of this will happen. She'll stay his mistress.

THOMAS: No, I'm not, I'm realising.

GEORGE: Listening, understanding, realising – what?

THOMAS: The implications. We've made Henry into a monster. "The ruler is answerable to God alone; the obedience of the subject to the ruler is an obedience required by God." Henry will become an absolute monarch. Aren't you scared?

GEORGE: No, no, I'm not. Not if he marries Anne, Parent, not if she gives you grandchildren. Grandchildren that will sit on the throne.

(*Time passes.*)

Scene 12

ANNE and ELIZABETH. HENRY enters halfway through.

ANNE: I feel – dizzy. I want to... queasy. I must have eaten too much rich food.

ELIZABETH: Greasy food can make you feel sick.

ANNE: Sick! I can't stop throwing up, well, wanting to. I might feel better if I had some fruit.

ELIZABETH: A nice apple?

ANNE: Oo!

ELIZABETH: A beautiful green apple with just a little red on it.

ANNE: How do you know?

ELIZABETH: I just know.

ANNE: My nipples are sore.

ELIZABETH: They get very sore. And you feel clumsy, swollen, heavy?

(*HENRY enters.*)

ANNE: A bloated wanting to eat an apple, fearing to be sick, a sore-nippled person.

ELIZABETH: It was the same when I was pregnant.

HENRY: And it was the same with –

ANNE: Don't, don't, don't! Do you think I am? Henry!

HENRY: We'll marry – in secret.

ANNE: In secret?

HENRY: Why not? Marriage is a private event – between us and our God. We need parliament to ratify the Act of Appeals before Archbishop Cramner can declare against my marriage to Katherine, and we can announce it publicly. But public it shall be, must be, has to be. Will you find it strange that this private pleasure, this happiness that we have found will be shared by thousands and thousands of people? Not just now but in the future?

ANNE: Oh Henry, I'll pray to be worthy.

HENRY: You can't stay a private person.

ANNE: You will still love me? Privately?

HENRY: And publicly. I'll have you crowned Queen of England, with all the pomp and ceremony that London can offer. As my wife you will be honoured. There will be no more pretending in public and hiding the private. You do want to be crowned?

ANNE: I'll be the most happy, the most fortunate woman alive. Wife first, queen second. And mother of your son last but not at all by any means least. I carry England's future here under my heart.

(*HENRY laughs.*)

ANNE: You can laugh. But I can't believe it.

HENRY: Why not? Why not? You've always known I'm the king.

ANNE: I've never known such happiness.

HENRY: Come, let's thank God. We must offer up our prayers.

ANNE: Kiss me.

HENRY: Kiss you?

(*HENRY does so.*)

My darling, this child of ours will make our joy in being together complete, but we must take every care to look after it. I promise you it will seem only a small thing not

to be able to be close to each other in the physical sense
– until after the birth.

ANNE: Kiss me.

HENRY: I would spend my life in your arms, happily.
George! George! Rescue!! My darling, I must save
George from his desk and he must save me from ruining
everything. I'm putting him in charge of my sanity.
Another kiss. Then I must get back to thinking, eating,
sleeping, breathing – celibate.

(*ANNE and HENRY kiss. GEORGE comes to HENRY.*)
George! George, we must talk dogs, and hunting. We must
put jousts, bear-baitings, cock fighting, entertainment, top
of our itinerary. George put all that stuff away. Let
Cromwell do it. He has an excellent team. And we need
you to keep us sane. Show me the new breed.

GEORGE: What of?

HENRY: Dogs, man, dogs.

GEORGE: Shouldn't I be writing to the Pope?

HENRY: Writing to the Pope? Whatever for?

GEORGE: What happens if you're excommunicated?

HENRY: I'm excommunicated. I can do what no Pope can
do. I can father children. George, I can father children.
And that's one up on you, George. You can't even keep a
breed of dogs together.

GEORGE: I had your affairs to sort out.

HENRY: They are sorted now. You must get some more
dogs, and Thomas Cromwell is an excellent fellow, he'll
see to the writing of letters and affairs of court. He's
even got a team poking around the monasteries – taking
inventories, turning up all sorts of papal treasures we'll
confiscate – if the Pope excommunicates us.

(*Time passes.*)

Scene 13

ELIZABETH carries the baby. MARY and ANNE.

ANNE: She's not a boy – and Henry... a son. He wanted a
son. I promised him a son. All the same she's a miracle.
Unexpected. Like looking for something you want –

a chamber pot under the bed and finding, I don't know, a book of poems. No, no hunting for strawberries and finding thrushes eggs – or altogether lucky – having a hen that laid rubies, when eggs are scarce.

MARY: Chamber pots are useful, and eggs less painful to lay than rubies, I dare say.

ELIZABETH: She is beautiful.

ANNE: What's wrong with her being a girl?

ELIZABETH: A boy would have been lovely. Safe – solid – secure. We've been through hell and a boy would have meant the end of it all.

MARY: I had a son.

ELIZABETH: Anne will have a son.

ANNE: Why can't she be queen?

MARY: Not a fairy child, a changeling.

ANNE: She's not a fairy child!

ELIZABETH: Queen? Queen Bess?

(*HENRY enters. He stands looking at ANNE.*)

HENRY: Can I see my daughter?

(*ANNE takes the baby and gives her to HENRY.*)

What gorgeous red hair! Now you better go to your grandmother and learn a few lullabies.

(*ANNE takes the baby and gives it to her mother, who exits.*)

HENRY: And my son? My son?

(*ANNE strips for HENRY. HENRY watches her. There is a pause before he goes to her. Time passes.*)

Scene 14

THOMAS, SMEATON, GEORGE, MARY and a cradle. They wait for ANNE to give birth. MARY talks to SMEATON.

MARY: I'm getting married again. I'm not telling anyone else because they'll stop me. He's not grand enough or even grand at all. But I want a chance to be happy.

SMEATON: Good for you.

MARY: Someone should warn you... I don't know what about but I feel a warning is in place.

SMEATON: He needs me here. I would leave if I cared enough about myself. I am in that strange position when you can see

that there is nothing down for you with someone, but you can't see how you could possibly benefit by leaving. He has all of me. There's nowhere else I can be.

(*ELIZABETH comes on. They all look towards her expectantly. She shakes her head. Time passes.*)

Scene 15

ANNE and HENRY.

ANNE: She was on your knee! She was sat on your knee. In front of everyone.

HENRY: Speak to me.

ANNE: You're hateful to me.

HENRY: Don't I get a kind word?

ANNE: A kind word when all your kind words are spent elsewhere? You know very well what I mean.

HENRY: I don't know what you mean.

ANNE: She was on your knee. You were flirting. You say you love me.

HENRY: I do. That doesn't mean that I can't respond to a pretty face.

ANNE: Bastard.

HENRY: It doesn't mean anything.

ANNE: I am insulted. One of my own ladies.

HENRY: You are insulted. Why the hell should you be different from any other woman? A man gets a woman with child – then what? He can't fuck her so why can't he indulge in a little harmless flirtation?

ANNE: Harry!

HENRY: Sorry.

ANNE: It tears me up inside. I need you here to be with me. To love me. To care about me – to support me...
(*ANNE weeps.*)

HENRY: Don't blame me for the miscarriage. No one blames you for miscarrying. So don't blame me. I was only behaving like all other men. Anne, I grieve to see you grieve. We'll try again.

ANNE: I can't stand you looking at anyone else.

HENRY: That's alright then – you dismissed her.

ANNE: I hated her.

HENRY: Your cousin?

ANNE: Oh! Oh! Oh! (*In rage.*) There'll be others.

HENRY: No, there won't.

ANNE: Henry, I have learnt that to be a wife and pregnant means to be vulnerable. Other women become attractive to you because I can't, because I am with child. I don't want another child if it means losing you.

HENRY: We must try again.

ANNE: Now?

HENRY: God damn it.

ANNE: Henry, there's still time.

HENRY: Where's my son? I must have a son, sons.

ANNE: Stop saying that.

HENRY: What else is a man to say? Desperation sets in. And you think it's alright, that we don't try again? You think we should cuddle up together and doze and tell the world to go poo? Well, I tell you we need to go at it. Again and again and again.

ANNE: I'm saying there's time. Time to spend time with each other. Time to love.

HENRY: I don't know if I can do it.

ANNE: That's crazy. Of course you can.

HENRY: What if I can't?

ANNE: I know you can. Shouldn't we go hawking? We do need to find a way back to each other.

HENRY: What if I can't?

ANNE: You the king, my husband, my lover – of course you can. Look at me. Aren't I the same woman that I was before?

HENRY: You are.

ANNE: Then come here.

HENRY: I don't know if I can try again.

ANNE: It's not trying again. It's about love. Pleasure – which is why we should allow ourselves to feel the wind in our hair, hear the rush of wings, first.

HENRY: Pleasure! I'd rather swim a pond in midwinter.

ANNE: Henry?

HENRY: At least I'd know I could do that.

ANNE: You can, you have. Why can't you?

HENRY: I don't want to.

ANNE: We love each other, we understand and share, God has bound us together. You are my other better... You are bigger, better, braver than I am. We are found for each other. Two halves of a walnut. I need you.

HENRY: All of these things, my love, but damn it. It's stifling in here. Damn it. I don't know that I can. Don't look at me like that. I want you to understand.

ANNE: I do understand.

HENRY: Come here then. Let's get it over with.

ANNE: Gently, Harry.

(*HENRY rapes ANNE. Time passes.*)

Scene 16

GEORGE prays – as if talking to ANNE.

GEORGE: Don't be jealous, little sister. Your jealousy is terrifying. You've got to be, cold, rational, calculate... This is politics. Not just about the two of you but about all of us. The survival of the family. We have to watch him – we have to judge. You have to manage him. Please, little sister, be clever – don't let your feelings get the better of you. One more pregnancy, one more –

(*SMEATON enters.*)

SMEATON: The queen, the dowager queen, is dead.

GEORGE: – one more –

SMEATON: Aren't you pleased? I thought you'd want to celebrate. Henry is.

(*ANNE enters.*)

ANNE: They've covered her coffin in candles, a thousand candles blaze over her tomb. She's won.

GEORGE: What do you mean?

ANNE: A martyr, a saint – blessed. You always called me witch.

SMEATON: As a compliment, in affection...

ANNE: Did I kill her?

GEORGE: Don't give up. Not now. Have this child.

(*ANNE puts her hands on her womb. She exits. The cast come on bringing the cradle. They watch the door as before – in silence. ELIZABETH enters. She wheels the cradle off in the opposite direction. Time passes.*)

Scene 17

Spring 1536. HENRY and ANNE. ANNE has miscarried.

HENRY: A boy. My son – and you lost him.

ANNE: I never meant to.

HENRY: I fell from my horse. I lay unconscious for some little time. Two hours. You were scared!

ANNE: Oh, Henry!

HENRY: I was the one close to death. You had no reason to miscarry. All the more reason for you not to; if I had died there would have been a son. You heard that I was flirting. You don't miscarry because a man flirts.

ANNE: Please be reasonable. It happened, I couldn't help it.

HENRY: You are being unreasonable – I might have been a little insensitive, you were pregnant, I couldn't... A man can tire of celibacy. I am trying to be logical. I am trying to be reasonable.

ANNE: We are two people facing misfortune, Henry.

HENRY: A king has a certain judgement in certain matters. Do you accept my judgement? Not just as your king but as your husband? Well then, it seems to me that you aren't able to give me sons.

ANNE: No.

(*HENRY ignores her.*)

HENRY: One daughter, one miscarriage and now another loss. Lost. Another loss – Anne? Why? We know Katherine's babies died because God couldn't bless us. Our marriage was an abomination. Then why was this child born dead? What's wrong with our marriage? Did you see him? They told me that he was malformed. Malformed? What does that mean? How can a child of mine be anything but perfect? Did you see him? Did they show him to you? What was wrong with him?

How was he imperfect? My son? You do know what this
signifies? God is angry. Who with? You? Me? A blasted
child is the result of some filthy thing. Why should God
damn us? I flirted – only. This is not because I flirted.
You cannot lay the blame for this at my feet. He doesn't
judge me. Not his servant, no. Through me he breathes.
Perhaps you've forgotten that my authority comes from
him? He blesses me. So how can I be the one at fault?

ANNE: This sadness, this misery is for me, mine alone?
You blame me. A woman who loses a child should be
pitied. Not blamed. I would do anything I could to bring
back that child. If you are against me then everything is
against me – there's nothing for me. How can you think
I would hurt those I love? I wanted that child! Henry
smile at me!

HENRY: There are two explanations for this: either you can
not give me sons because you are somewhere deep down
inside unwholesome, a cesspit, a stinking trough of evil.
God knows, I've had to listen to enough people telling me
that you have enchanted me, in simple terms – you are a
witch. I scorned them. Tell me, isn't it true that witches are
unable to bear male children? And isn't it also true that
they can affect a man's performance in bed? You know
how hard that child was to conceive. What am I to
believe? That I have been put under a spell?

ANNE: God knows...

HENRY: The second explanation for this debacle and the
one I prefer, is that poor blighted babe was not my son.
I was not the father. He was the product of some sin,
some licentious thing, some disgusting adultery – such
as witches perform with the devil. You were, have been
unfaithful to me.

ANNE: With whom?

HENRY: You ask me that?

(*HENRY exits. ANNE babbles.*)

ANNE: No, Henry, no. I live for you. Every, everything is
for you. I've given you everything. Unfaithful! How
could you be so cruel? Oh, my God, he'll kill me.

He'll kill me. He must want me dead. I'm no use to him
now. Why can't I die?
(*ANNE puts her hands round her neck.*)
My neck feels so small, so slender. He'll kill me.
Adultery! How can he think? Adultery! He doesn't think.
He'll kill me. Henry, this isn't you. You've been so good
to me. Go on loving me! He'll kill me.
(*Enter GEORGE and SMEATON.*)

GEORGE: What do you mean, you confessed? What to?
Jesus, Jesus. When have you ever? Have you ever? Jesus
Christ this is mad. This is crazy. We were lovers. I never
fucked my sister – nor did you. Nor any one of them.

Scene 18

1536. THOMAS and ELIZABETH and MARY.

ELIZABETH: If this was a folk tale, or a fairy story, a tale
from the Bible – a Greek myth – any sort of story –
you wouldn't understand it because it doesn't fit
together. It's not like a puzzle. There are no
consequences. No rhyme or reason. You'd think it was
far-fetched. Some crazy thing a child had made up.
A passionate love affair. Henry marrying Anne against
all odds and then accusing her of adultery with five
men! Not one, but five. One of them George, her
brother. I don't want to hear that they were all known
libertines, that they therefore are in league with the
devil. That the whole plot they were engaged in was
controlled, made up by Satan. My children, my dear
children. I know that it is not, cannot be true. George
and Smeaton! You said, you knew this and you didn't
tell me and you trusted Cromwell! This would never
have happened if it were not for Cromwell. I should
feel sorry for Brereton, Weston, Norris, the king's
friends. What a man if he can believe this of his friends!
If he can believe this of his wife!

TIIOMAS: We're ruined. All our grants of land returned to
the king. Hever Castle gone.

ELIZABETH: Never mind ruined. Ruined! They'll be killed. Accused of treason. Tried for treason. Our children. And you, you! They excuse you from sitting in judgement – because they couldn't expect you to deliver judgement on your children. Not the judgement they want. Henry demands. Everyone afraid of the king, knowing he wants them guilty. He wants her dead – so he can marry again. You should be there, you should be, to scream, holler, unloose her innocence.

THOMAS: And die with them?

ELIZABETH: Why not? Why not? You're no earthly use to anyone – alive.

(*ELIZABETH exits. Leaving MARY and THOMAS. MARY is peeling an apple. A priest enters. We see the five men receive communion.*)

MARY: Only Smeaton confessed. They had their heads struck off with an axe. For her they used a sword... A long blade that flashed in the sunlight, almost a graceful thing, a thing of poetry. They say that when her head was separated from her body the eyes still moved, the lips still struggled to form words, prayers. She must have been praying, they said. For what? I'd have cursed.

THOMAS: You. You!

MARY: Yes?

THOMAS: You're all I have left.

(*MARY looks at him. She gets up and leaves.*)

The End.